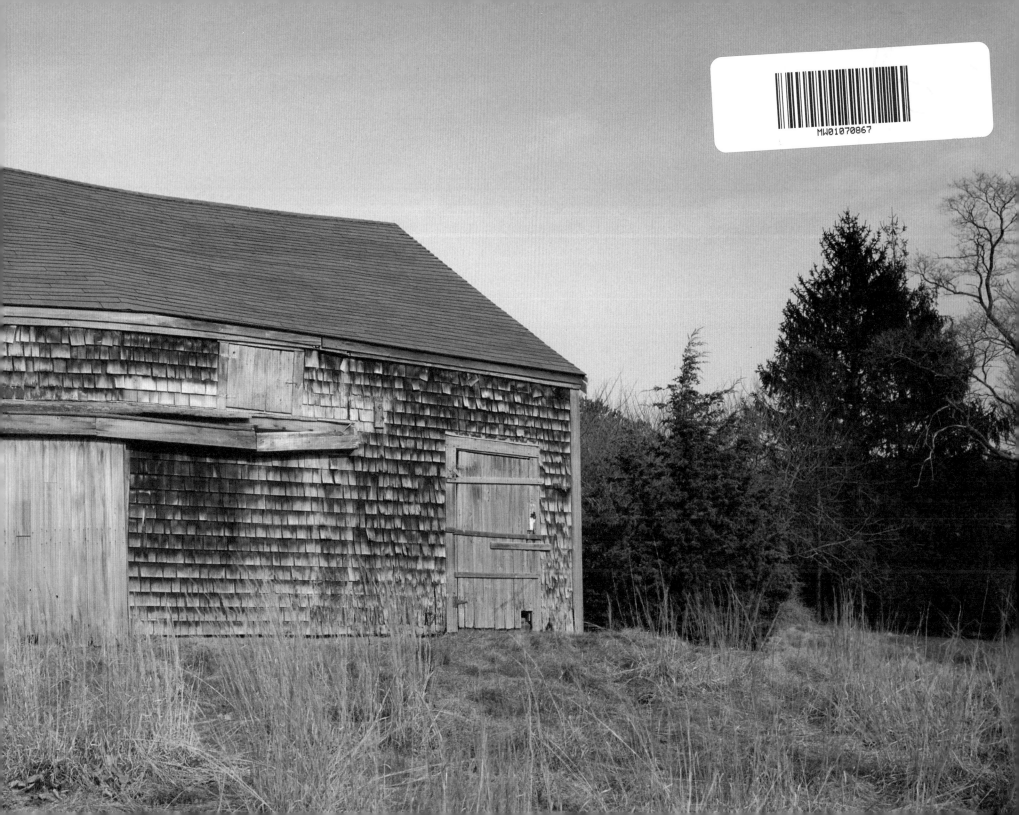

Barns of Cape Cod

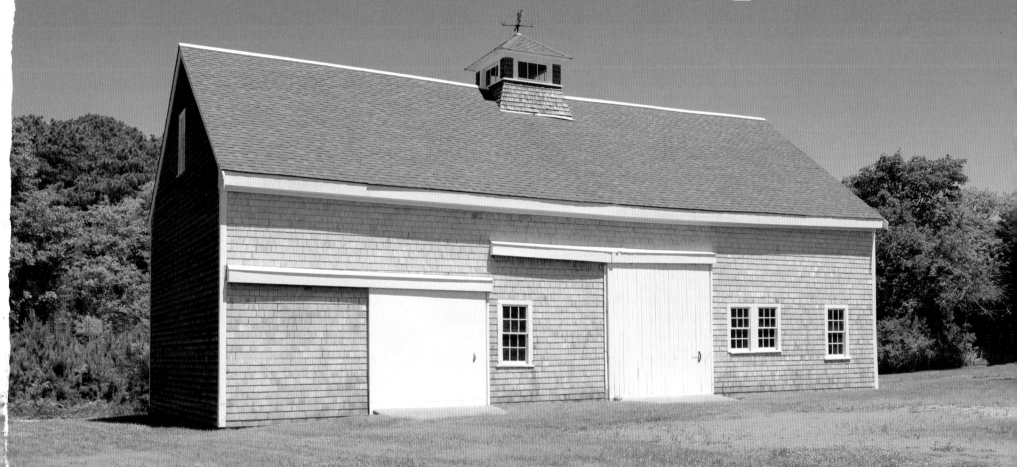

Schiffer Publishing Ltd®

4880 Lower Valley Road, Atglen, PA 19310 USA

Other Schiffer Books on Related Subjects
American Barns. Stanley Schuler.
The Birds of Cape Cod & the Islands. Roger S. Everett.
The Cape Cod House. Stanley Schuler.
Joseph C. Lincoln's Essential Cape Cod Reader. Joseph C. Lincoln.
Lighthouses of Cape Cod & the Islands. Arthur P. Richmond.
Living Barns: How to Find and Restore a Barn of Your Own. Ernest Burden.
Old Barns - New Homes: A Showcase of Architectural Conversions. E. Ashley Rooney.
Provincetown Discovered. Edward V. Gillon.
Saltbox and Cape Cod Houses. Stanley Schuler.
Yesterday's Structures: Today's Homes. Lucy D. Rosenfeld.

Copyright © 2007 by Joan Dillon
Library of Congress Control Number: 2006928315

Designed by John P. Cheek
Cover design by Bruce Waters
Type set in Geometric 231 Hv BT/Souvenir Lt BT

ISBN: 0-7643-2564-7
Printed in China

Published by Schiffer Publishing Ltd.
4880 Lower Valley Road
Atglen, PA 19310
Phone: (610) 593-1777; Fax: (610) 593-2002
E-mail: Info@schifferbooks.com

For the largest selection of fine reference books on this and related subjects, please visit our web site at **www.schifferbooks.com**
We are always looking for people to write books on new and related subjects. If you have an idea for a book please contact us at the above address.

This book may be purchased from the publisher.
Include $3.95 for shipping.
Please try your bookstore first.
You may write for a free catalog.

In Europe, Schiffer books are distributed by
Bushwood Books
6 Marksbury Ave.
Kew Gardens
Surrey TW9 4JF England
Phone: 44 (0) 20 8392-8585; Fax: 44 (0) 20 8392-9876
E-mail: info@bushwoodbooks.co.uk
Website: www.bushwoodbooks.co.uk
Free postage in the U.K., Europe; air mail at cost.

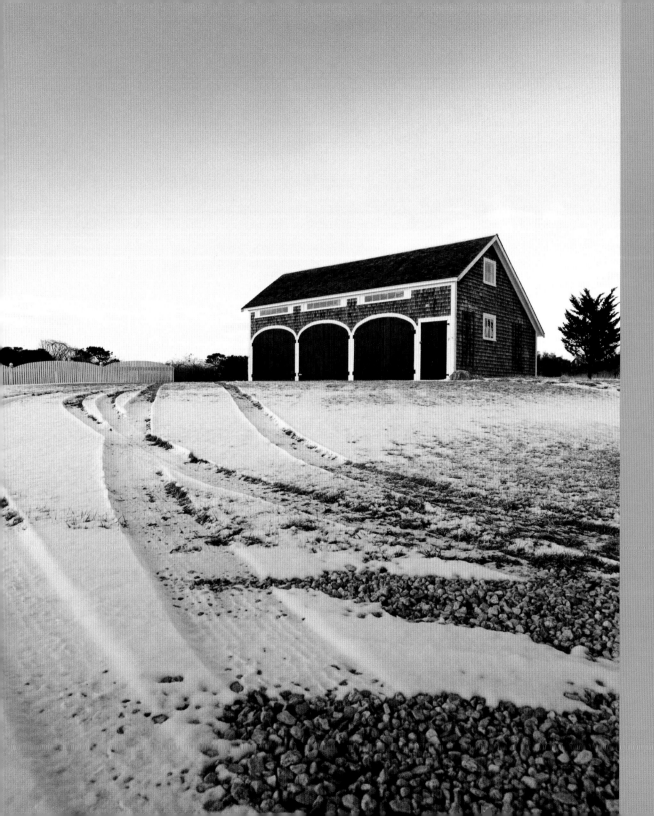

Contents

Introduction

From Provincetown to Woods Hole, barns dot the landscape of Barnstable County, more commonly called "Cape Cod." Fifteen townships make up Barnstable County: Falmouth, Mashpee, Bourne, Sandwich, Barnstable, Yarmouth, Dennis, Harwich, Brewster, Chatham, Orleans, Eastham, Wellfleet, Truro, and Provincetown. With the exception of Mashpee, every town on the Cape has barns that contribute to the history of the area. Despite the fifty square miles of land given to the Wampanoag Indian tribe in 1660, there is no historical evidence that the Indians ever built any barns on Cape Cod. Only a contemporary horse barn owned by the Wampanoags could be found.

The Pilgrims built their homes and barns along the shores of Cape Cod Bay, Nantucket Sound, and fewer built along the ocean side. The first settlers built in Sandwich, Barnstable, Yarmouth, and Wellfleet where there were protected ports. The middle areas of the Cape were not developed as the land and forests were too far from their mainstay of fish and shellfish. The settlers also took advantage of the salt hay available free in the marshes. The hay served as fodder for animals and was often used as insulation when stacked up around house and barn foundations.

One of the first chores an early settler undertook was to build a barn. As a contemporary builder has said in *Preservation Magazine*, "Barns are even more important than houses ... until you had a barn, there was no way to get ahead in the world." A surprising number of barns built in the 1600s and 1700s still exist today. All barns undergo changes, ranging from minor re-shingling to complete renovation into a house. The original purpose of a barn was to shelter the cows and horses and to store grains such as rye, wheat, corn, and hay, as well as farm equipment. A typical early assessors list recorded "… one cow, a horse, some pigs, chickens and a wood lot plus the number of acres of tillable land." The numbers varied from farmer to farmer and additions such as an ox or a dozen ducks could be found listed in many small towns. As more settlers populated Cape Cod in the 1800s, barns were also used for assembling cranberry boxes, to store boats or to house machinery. Barns have been used for crop storage such as strawberries, turnips, and asparagus as well as housing animals: cows, horses, goats, pigs, chickens, oxen, and sheep. Small dairy farms were located in nearly every town on the Cape in the 1800s. Chicken and duck hatcheries were numerous

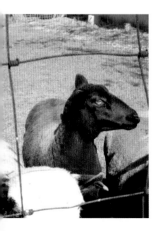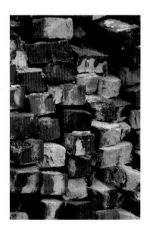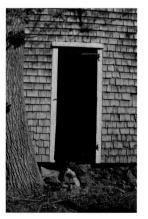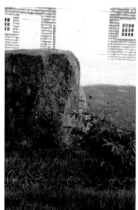

up until the end of the Second World War. Even if a man was primarily a carpenter or a shell fisherman, he would maintain a small farmstead of crops and animals to feed his family.

Usually a successful farm consisted of the house, a sheltered wood bin attached or near the house, a back house containing a shop and a privy, and then the barn. The pigsty was often put the farthest away from the living quarters.

Almost all barns on the Cape were built of wood, due to the ready availability of trees. Most of the wood used for New England barns was of local origin. The frames were often made of pine and hemlock, as they were easy to hew and shape the joists. In time, cedar shingles replaced the horizontal siding that had been used in most early barns. Fieldstone foundations were prevalent in the early years, but were replaced by brick or cement block foundations just after the turn of the twentieth century.

Weather vanes perched on barn ridge lines ranged from a simple whale to an elaborate vessel under full sail. Cupolas were also often used to provide ventilation for the hay and grains store in the second story lofts. Barns storing grains were also more susceptible to fire; so proper air circulation became important to prevent spontaneous combustion.

Cape Cod developed a thriving sea salt industry that supplied salt for the fishing business. The first salt works were built in 1776. When salt production ceased to be economical, the salt works were abandoned in the 1850s. Local people took advantage of the opportunity to reuse the salt boards for barn construction.

Another source of lumber for the townspeople, especially in the outer Cape, came from shipwrecks. Chatham, Orleans, Eastham, Wellfleet, Truro, and Provincetown benefited from the lumber and cargoes that floated ashore. Many barns sport a ship's name over the barn door, on boards called quarterboards, which originally were boards attached to vessels bearing the ship's name and were recovered from shipwrecks to be attached to barns. Quarterboard is a term used only on the East Coast. Today anyone can have a board cut to mount on their barn.

Up until the 1800s, most barns were post and beam construction. They were of the English style, with the big barn door centered on the long wall. The English-style barn commonly had three bays, counting the cartway down the middle. By the mid-1800s, the big entry doors had been moved to the gable end and that style came to be called New England-style barns (sometimes called Yankee-style barns). The New England-style barns are the most prevalent on Cape Cod. They can be of various shapes depending on the interior framework. One very large barn, which has since been razed, was of balloon-style construction, which allowed for maximum use of the interior space.

Large or small, Cape Cod barns add a distinctive character to the architectural landscape.

ENGLISH TYPE BARN, SIDE-DOOR ENTRY

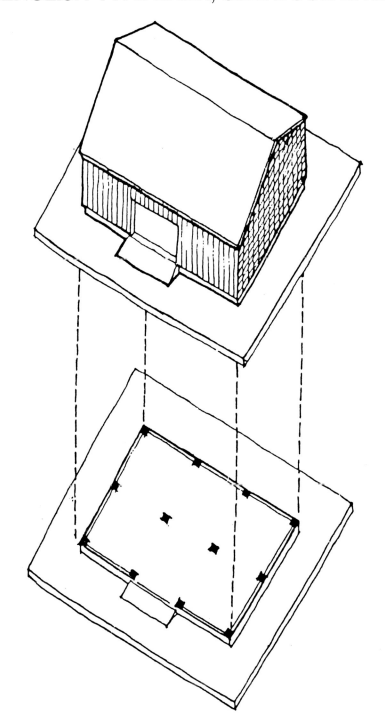

NEW ENGLAND BARN, GABLE-END ENTRY

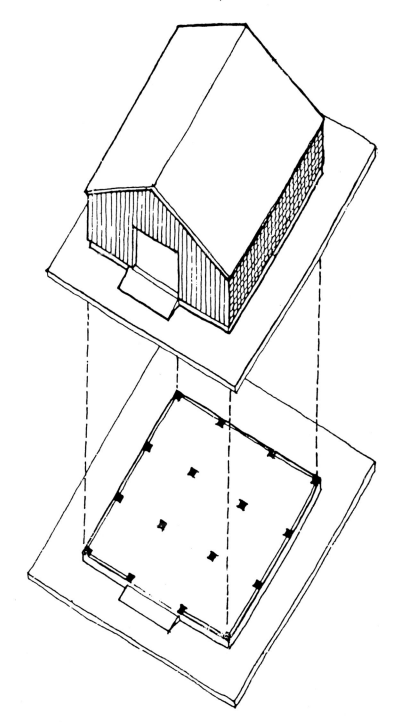

7

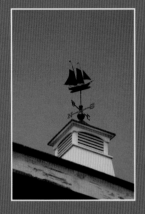

Falmouth

Falmouth is composed of the villages of Falmouth Village, Woods Hole, North Falmouth, West Falmouth, East Falmouth, Davisville, Hatchville, Waquoit, and Teaticket. Falmouth was one of the earliest towns established on the Cape, incorporated in 1686. It has many small harbors and beaches. Every year thousands of people travel through Falmouth and Woods Hole, on their way to the islands of Nantucket and Martha's Vineyard, never realizing that many lovely old barns are scattered along their route.

With a year-round population of over 30,000 people, Falmouth has rolling hills and level areas near the water that became prime farming land. It still has a few strawberry farms, but many less than in the 1800s when Falmouth was the berry capital of New England.

Barns were always plentiful in areas of Falmouth like Davisville, Teaticket, and West Falmouth. The Cape's only remaining stone barn is here also, a product of a nearby nineteenth century stone quarry.

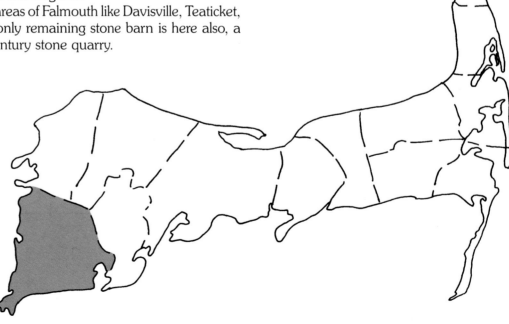

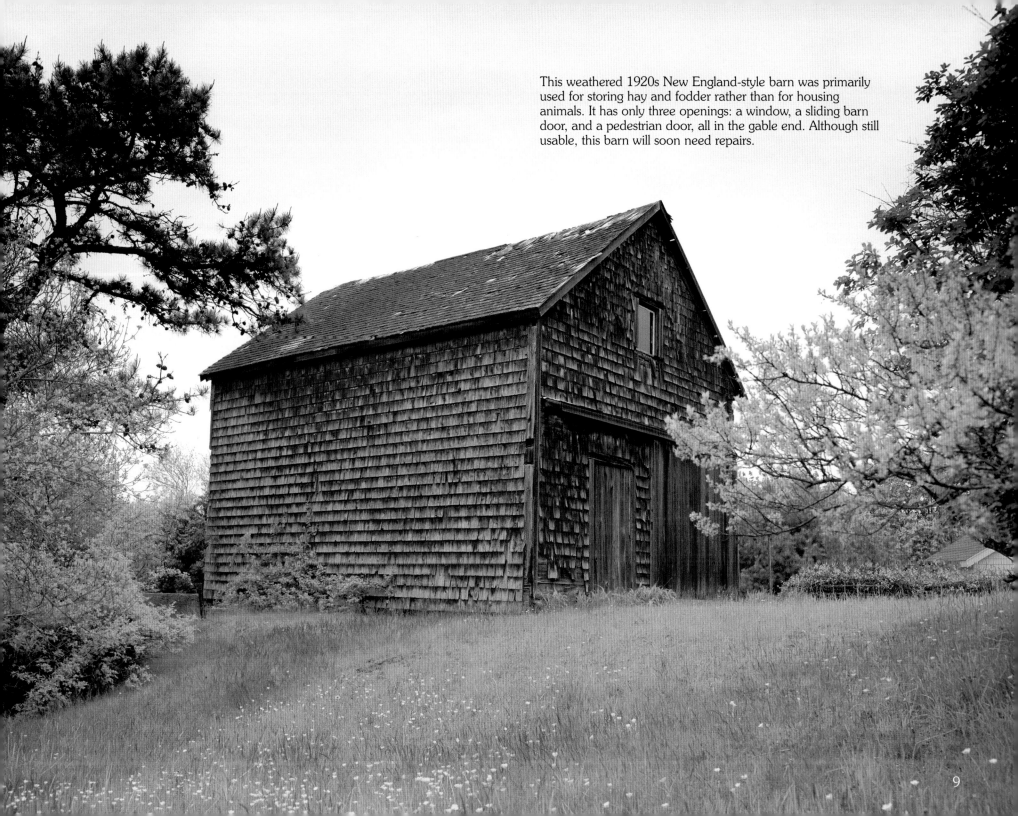

This weathered 1920s New England-style barn was primarily used for storing hay and fodder rather than for housing animals. It has only three openings: a window, a sliding barn door, and a pedestrian door, all in the gable end. Although still usable, this barn will soon need repairs.

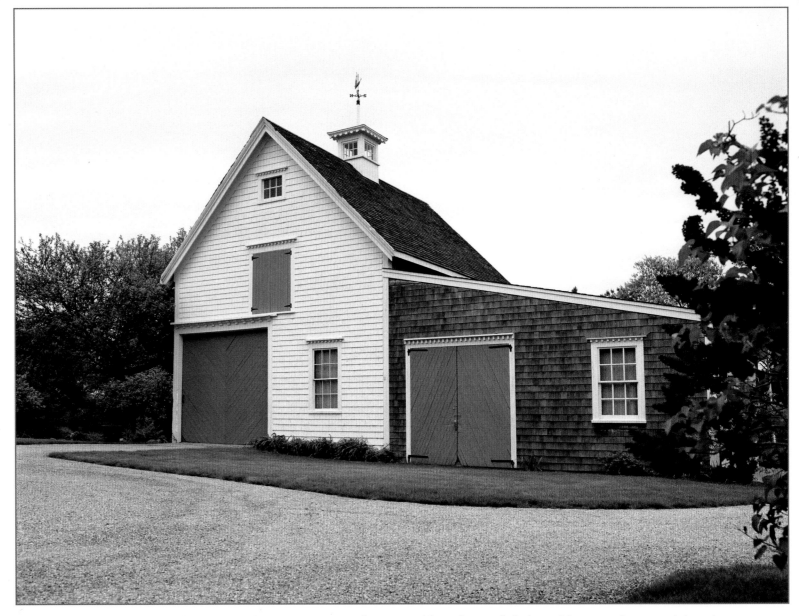

A handsome, well-maintained late nineteenth century two story barn, its gable end is nicely balanced between the main sliding door, two windows, and the small door defining the hay area. A lean-to shed is attached but is shingled rather than clap-boarded as is the barn face. An attractive cupola with a ship weather vane tops the building.

Opposite page:
In the 1860s and 1870s there were two stone barns within a half-mile of each other. Today, one has been converted into a home while the other is known as the George Weeks Barn for its mason-builder. Kept in excellent condition for over one hundred and forty years, it is an English-style barn with distinctive Norman arches framing the lower carriage level, where there is still a dirt floor. A unique stone arch is repeated above the main barn door. This appears to be the only full-size nineteenth century stone barn on Cape Cod.

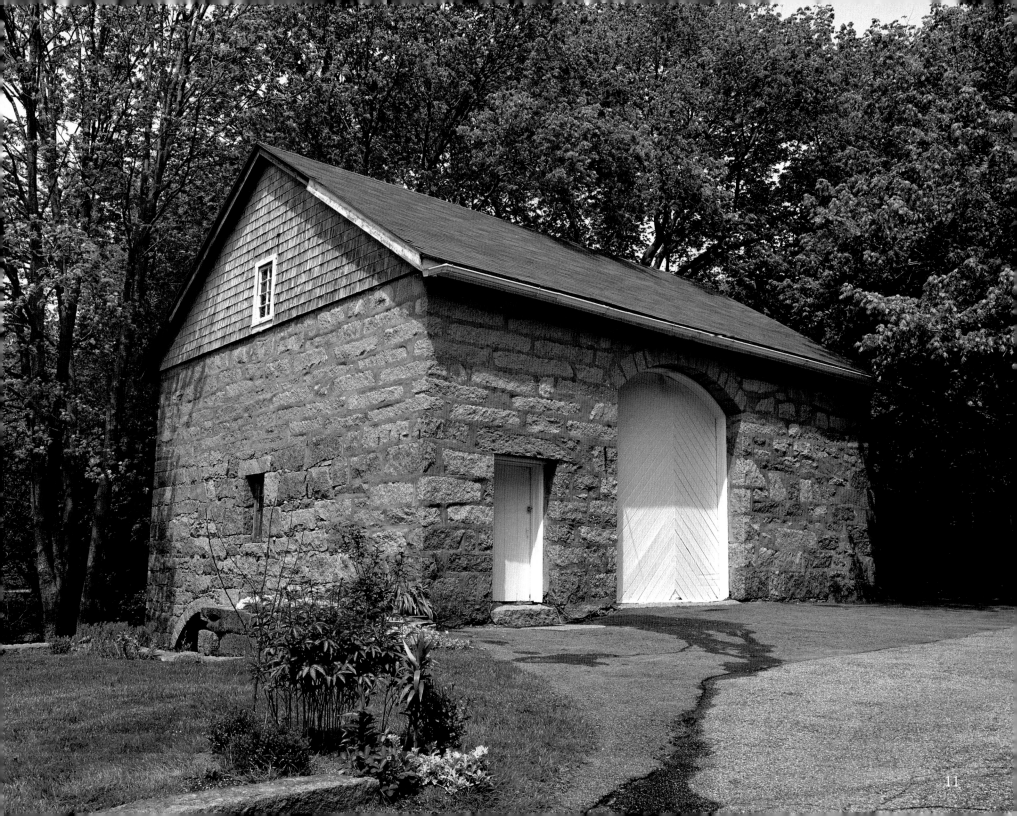

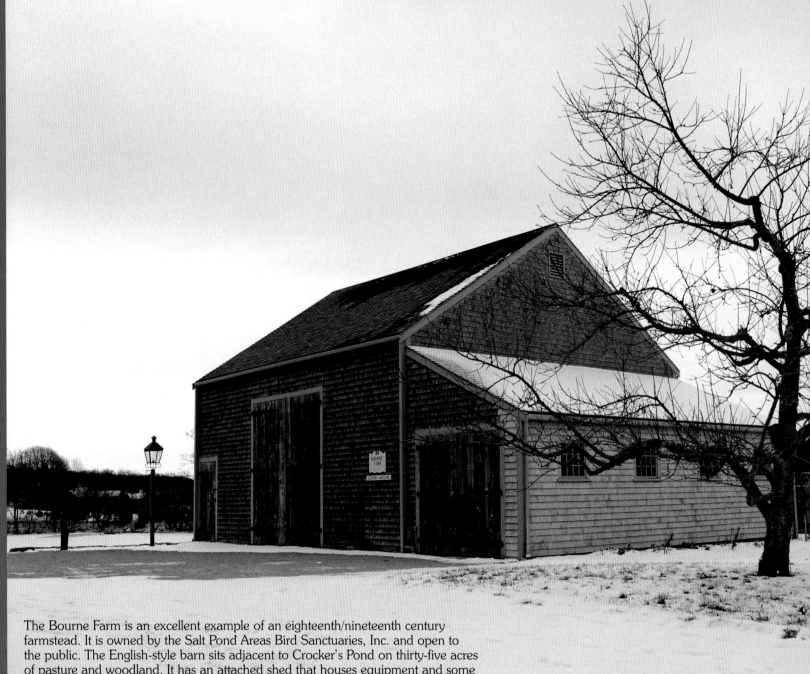

The Bourne Farm is an excellent example of an eighteenth/nineteenth century farmstead. It is owned by the Salt Pond Areas Bird Sanctuaries, Inc. and open to the public. The English-style barn sits adjacent to Crocker's Pond on thirty-five acres of pasture and woodland. It has an attached shed that houses equipment and some of an antique tool collection.

As Candice Jenkins has written in her book on West Falmouth, *Between the Forest and the Bay,* the Bourne Farm consists of "...a house, one barn, two outbuildings, three cows, thirty acres of pastureland, four acres in tillage, four in English mowing, and a storehouse of ryes, oats, corn, and hay."

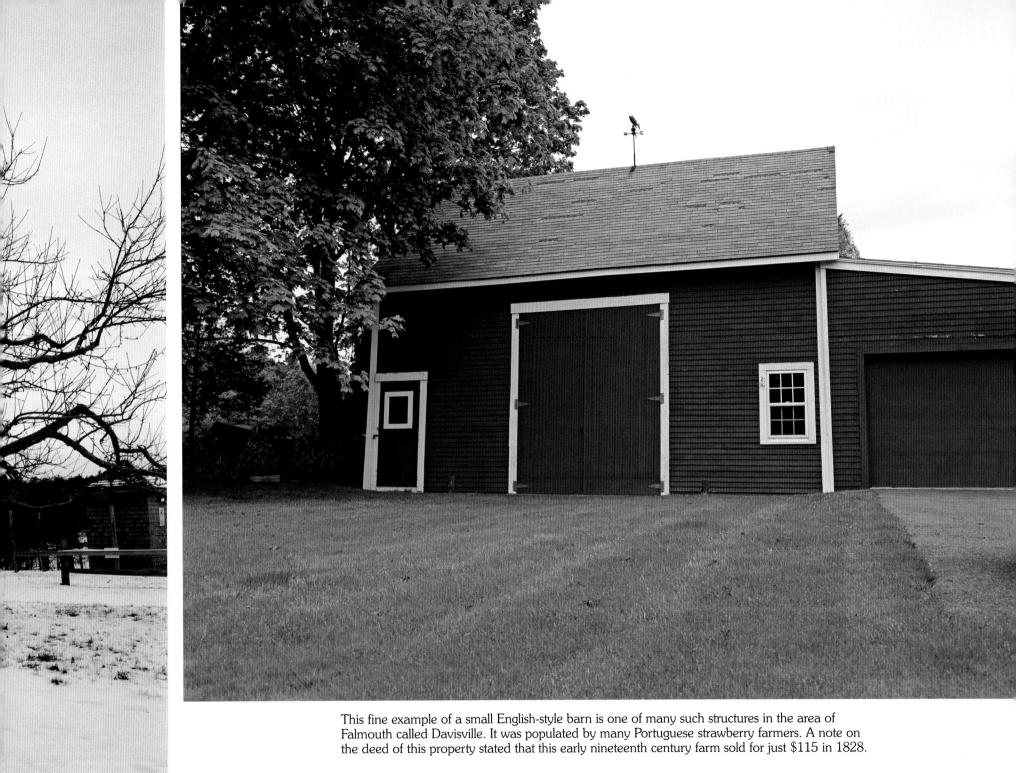

This fine example of a small English-style barn is one of many such structures in the area of Falmouth called Davisville. It was populated by many Portuguese strawberry farmers. A note on the deed of this property stated that this early nineteenth century farm sold for just $115 in 1828.

FALMOUTH

Many Portuguese fishermen settled on the Davisville peninsula in the early 1900s and took up strawberry farming. This small barn is typical of the size and style built in that era. The two sliding doors in the gable end indicate that it is a typical New England-style barn. Horizontal siding covers the frame.

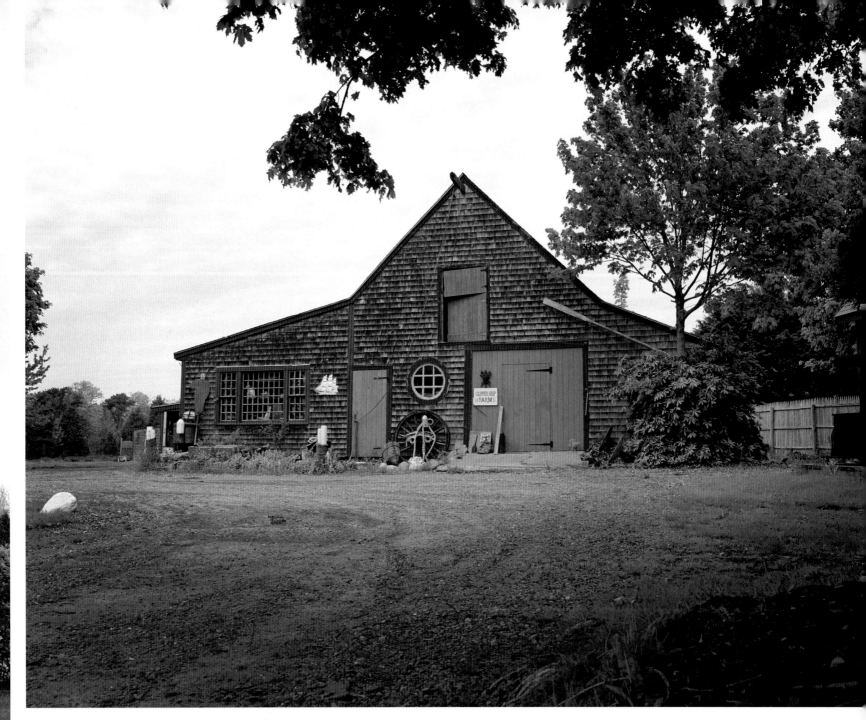

This late nineteenth century barn originally housed equipment for strawberry farming – a major crop in the Falmouth area. At the time, over 600 acres were planted for strawberries. By 1913 Falmouth farmers banded together and sold wholesale. Portuguese farmers grew tomatoes in addition to the strawberries. The barns were used to assemble the boxes for shipping as well as housing farm equipment. The split hay-loading door at the top of the gable was used to ventilate the hay storage area.

FALMOUTH

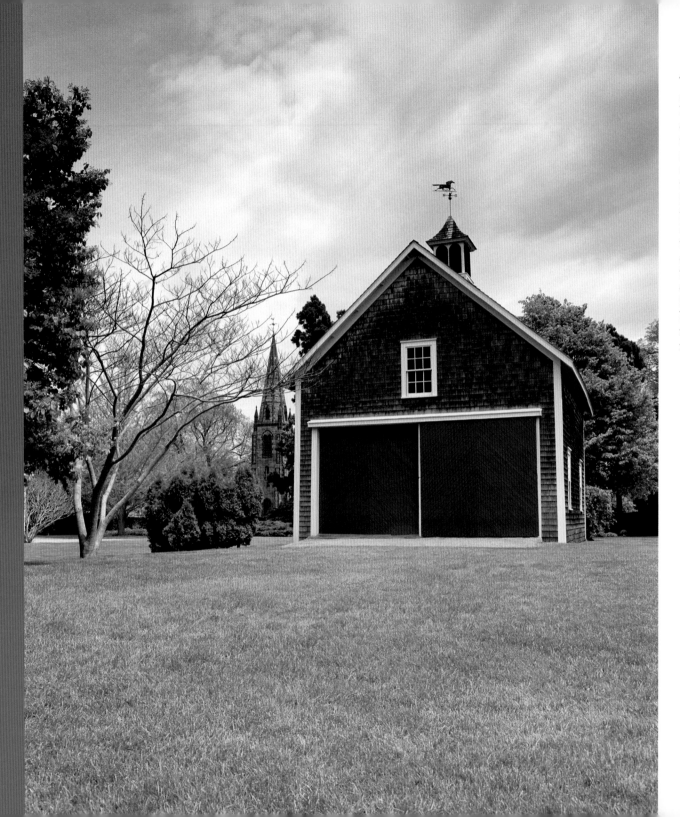

This small eighteenth century New England barn sits in a wide expanse of lawn next to an elaborate nineteenth century church, just off the town square (which in Falmouth is a triangle.) A running horse weathervane tops the elegant cupola. Used today to store boats and equipment, the barn, in the middle of a busy town, is a quiet reminder of an earlier rural way of life.

With the bog in the background, it is not surprising to find that this barn housed the boxes for packing cranberries. The workers in the bogs brought their filled baskets to the barn for sorting and packing. These barns were called "Box Barns" because they often housed the small shop that assembled the cranberry boxes. The pond seen in the distance supplied the water needed to flood the bogs in the winter.

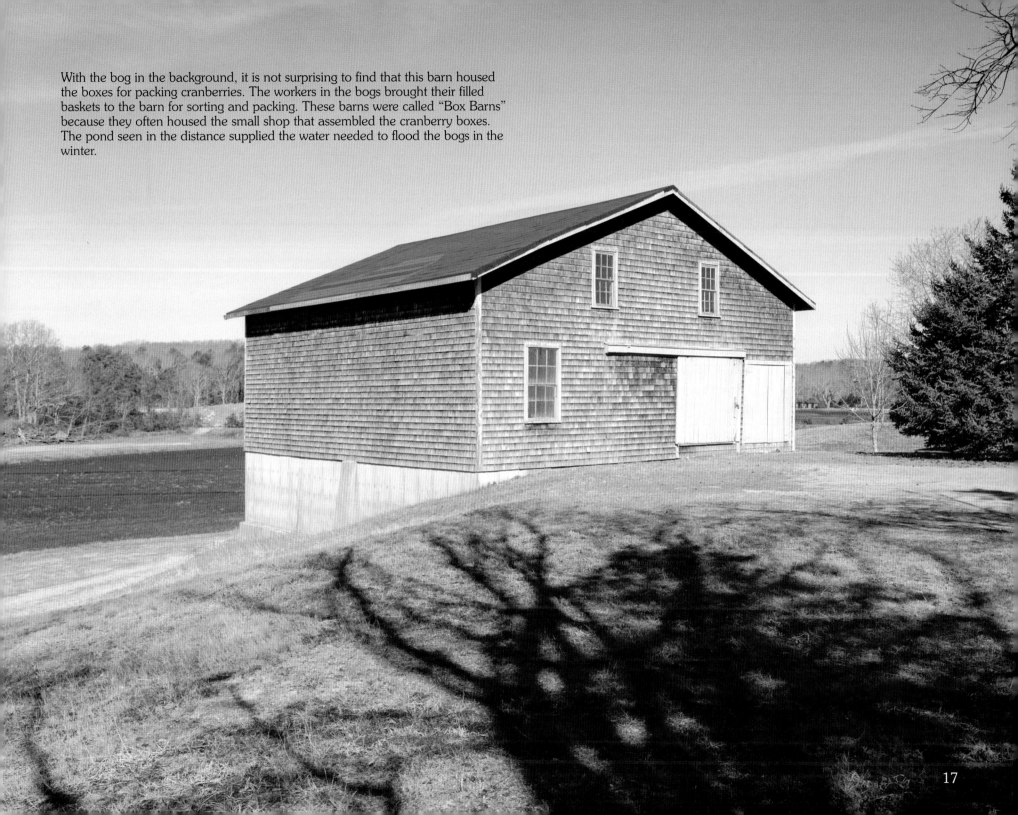

17

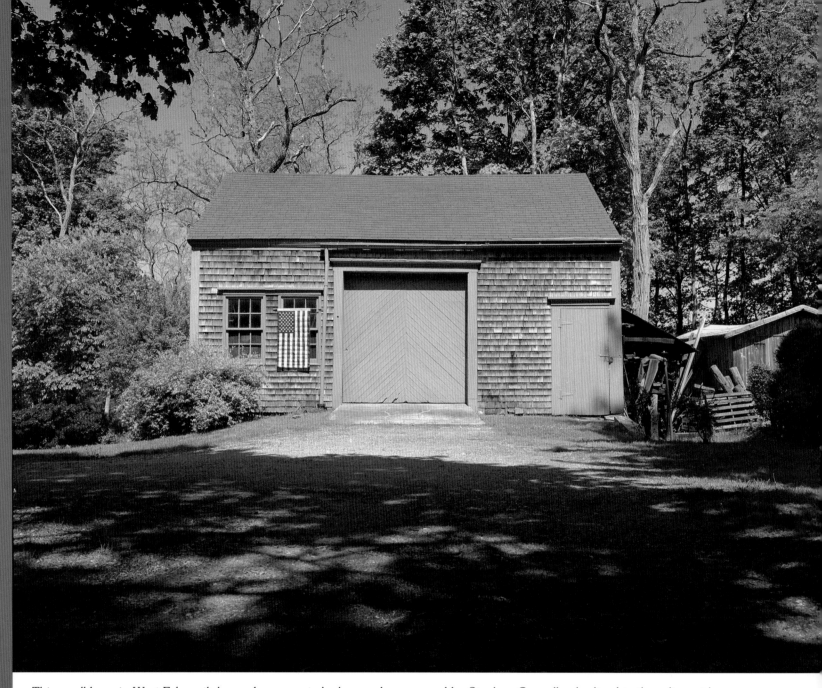

This small barn in West Falmouth housed a carpenter's shop and was owned by Stephen Crowell, who lived in the adjacent house. This barn is typical of many of the small shops set up in barns by carpenters and masons who also worked their farmsteads.

This three level New England barn was originally built between 1732 and 1740. It has matching lean-to additions on either side of the main gable ends. There are also additions to both lower and main levels. This barn still has the hay pulley and rack that runs the length of the ridgeline, which was used to help load the hay into the top level of the barn. It is one of only three remaining hayracks found in over 250 Cape barns.

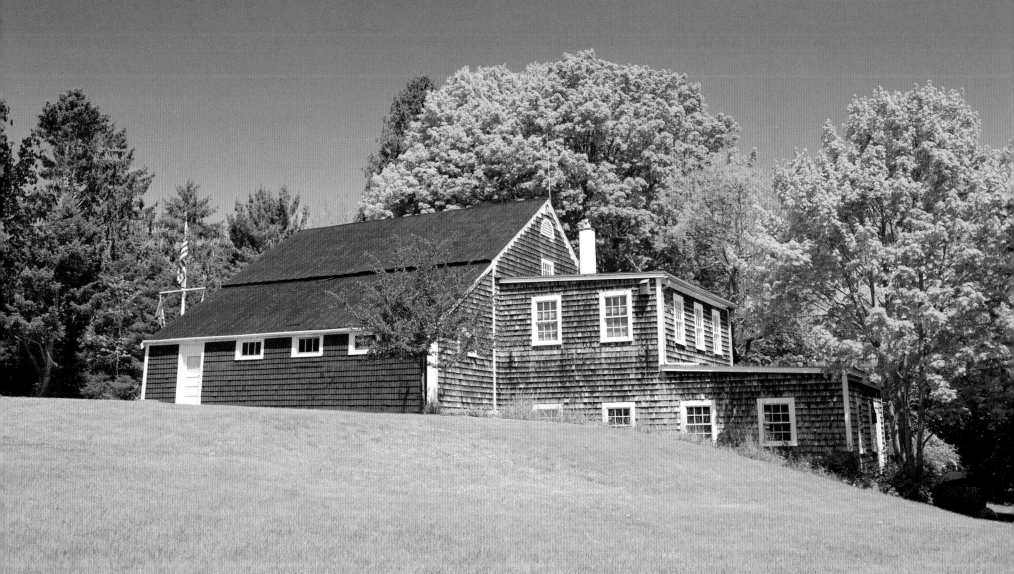

FALMOUTH

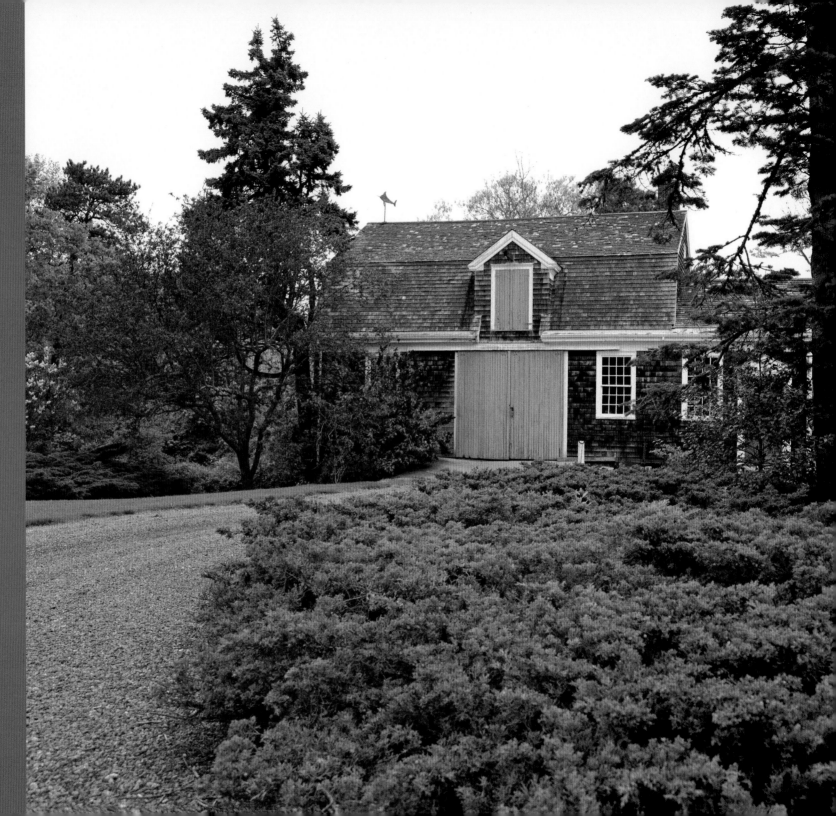

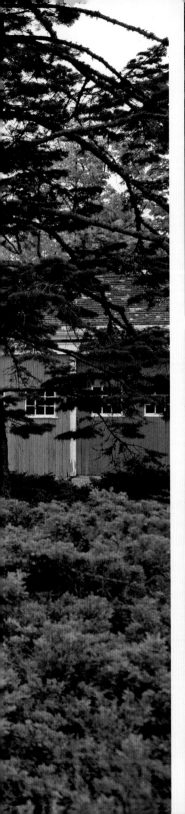

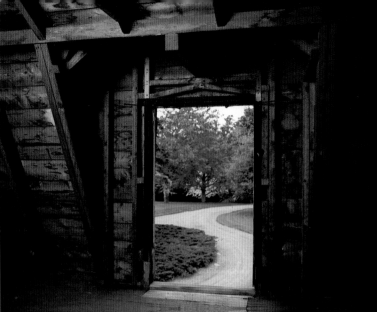

Built in 1820, this handsome hip-roofed barn was owned for many years by Dr. Lombard Jones who made all his house calls by horse and buggy. The barn has stalls, a carriage bay, a tack room, hayloft, and tool room. There is an attached outhouse and basement level dirt-floored area for other animals. Among the doctor's patients were the Indian families who came in the spring to the ponds on the property. The fresh water, spring-fed pond was used by the Indians for their ritual cleansing. They camped by the pond, fishing and clamming until the fall. Dr. Jones cared for the Indian families who paid him in baskets, pots, and other artifacts. This was the beginning of an extensive collection of Indian material that Dr. Jones assembled over many years and is now in Harvard's Peabody Museum. The barn is an eloquent testimony to Dr. Jones' life as a rural doctor.

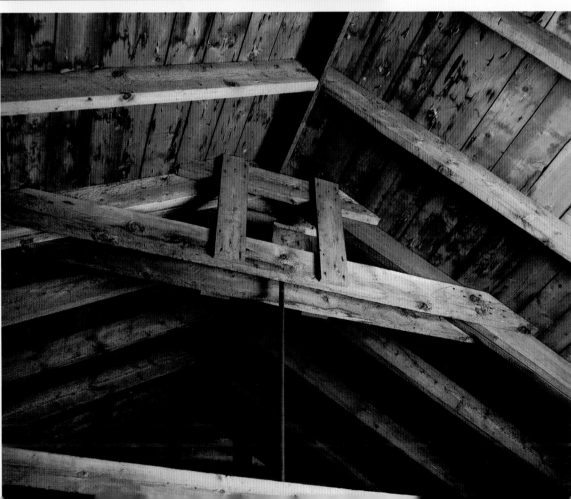

BOURNE

Bourne

Bourne consists of seven villages: Sagamore Beach, Sagamore, Buzzards Bay, Bourne, Cataumet, Pocasset, and Monument Beach. Bourne has the distinction of being the only Cape town split in half by the Cape Cod Canal. It is a mixed blessing for the nearly 20,000 people who live there because they have to battle constant traffic. Both bridges spanning the canal are inadequate to handle the holiday traffic on and off the Cape. Settled originally as part of Sandwich, Bourne now has its own identity. It has scattered farms and good seashore access for shell fishermen and visitors.

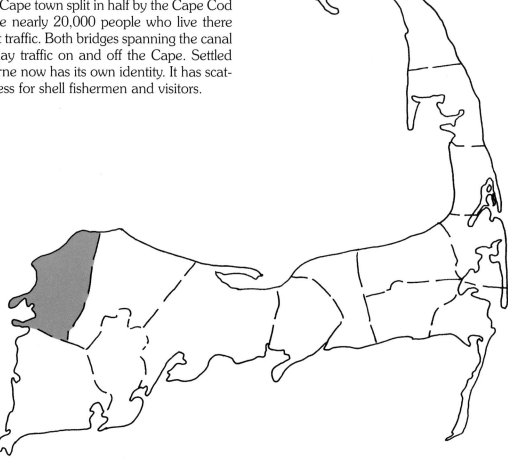

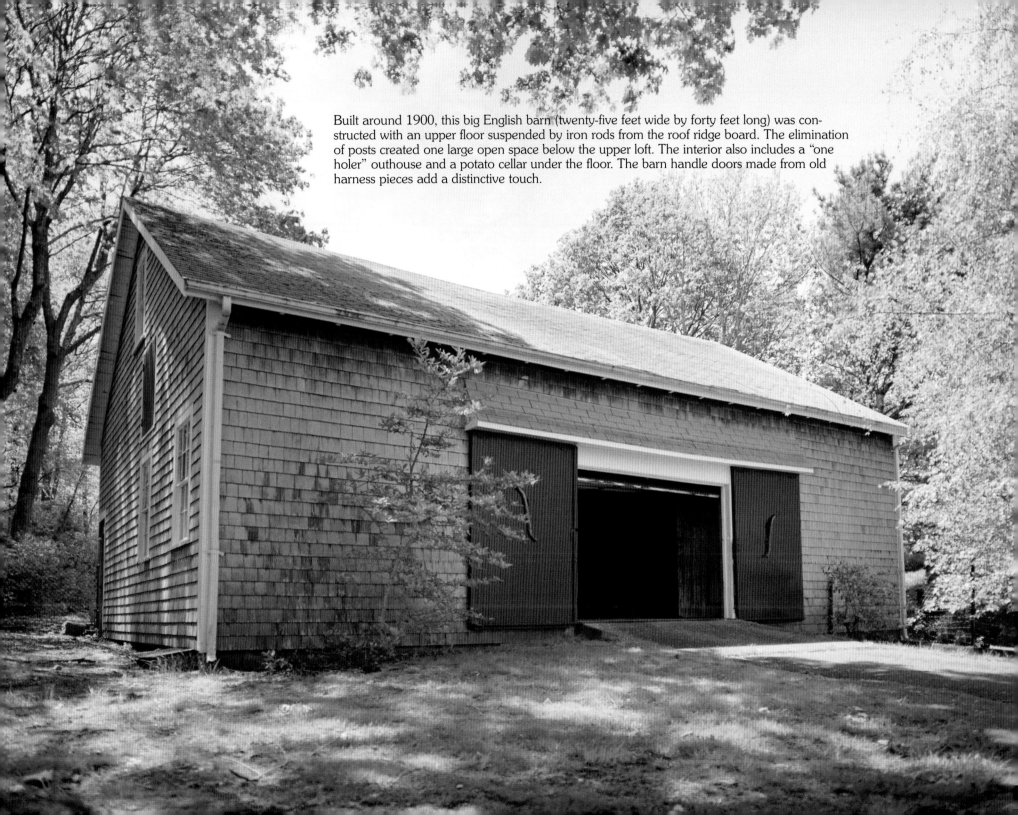

Built around 1900, this big English barn (twenty-five feet wide by forty feet long) was constructed with an upper floor suspended by iron rods from the roof ridge board. The elimination of posts created one large open space below the upper loft. The interior also includes a "one holer" outhouse and a potato cellar under the floor. The barn handle doors made from old harness pieces add a distinctive touch.

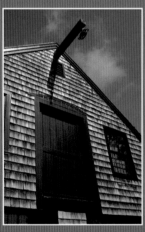

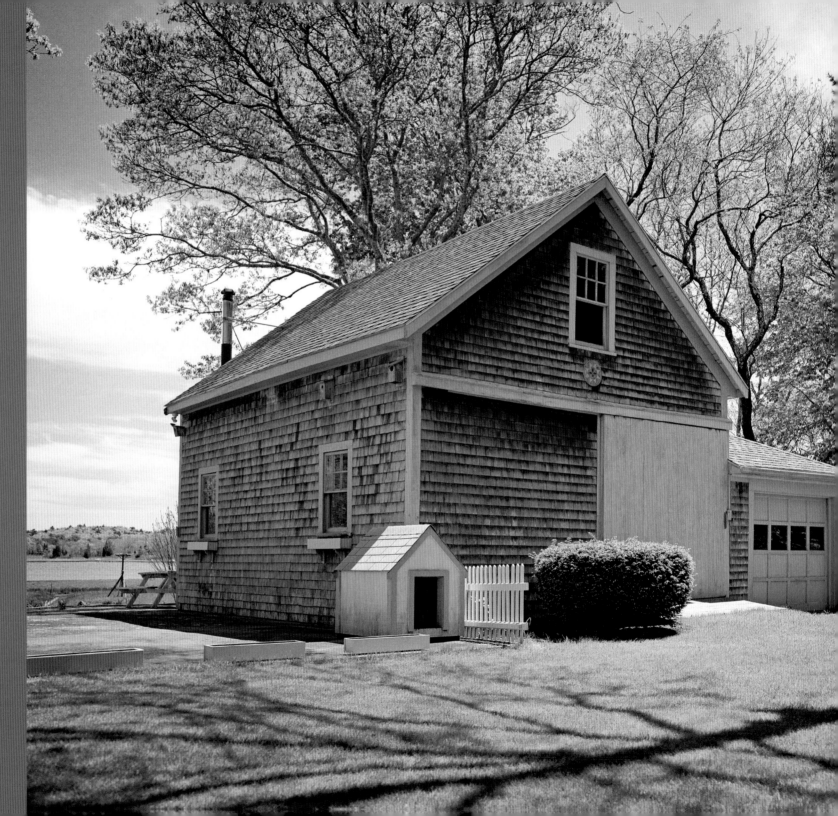

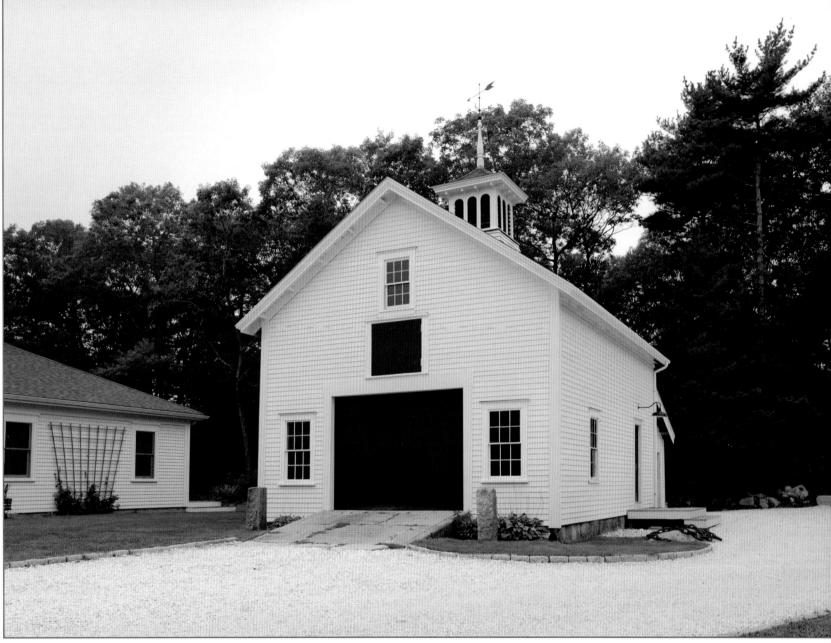

This stately house and barn was the boyhood home of General Leonard Wood, physician and army officer. He was a great friend of Teddy Roosevelt, who put him in charge of the Rough Riders. Wood was active in Republican politics and had the military Fort Leonard Wood in southern Missouri named for him The barn is adjacent to the main house, which is currently a bed and breakfast lodging.

Opposite page:
Built around 1904, this barn housed a shellfish shucking operation. The shellfish were brought in from the marsh behind the barn, then cleaned, shucked, and put up for sale in a small cart at the end of the driveway. Known as Berry's Market, vegetables were also sold here. The barn is a gable-ended New England barn.

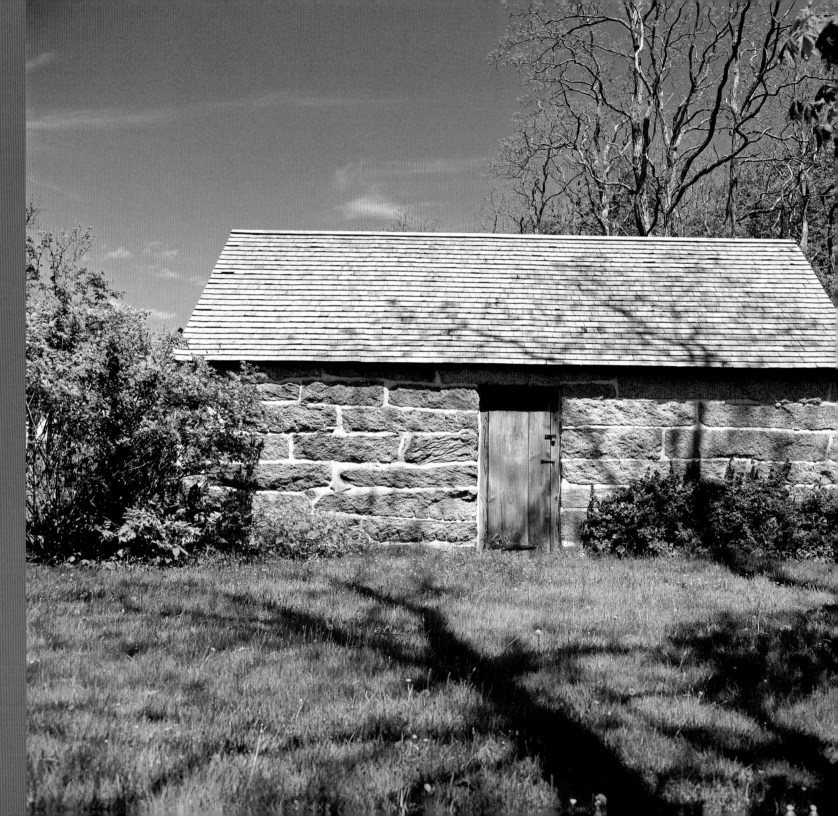

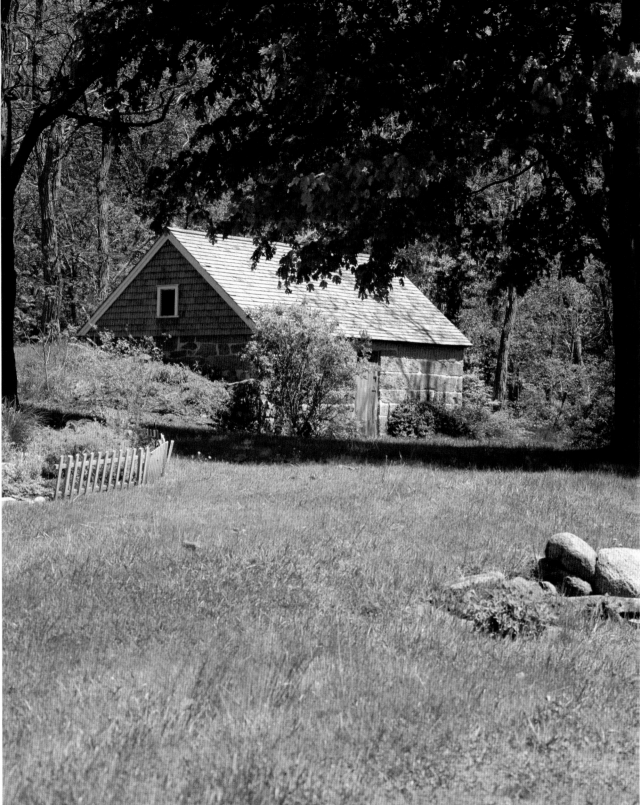

The Bourne Society for Historical Preservation manages the Briggs-McDermott house, blacksmith shop, and springhouse, which is one of the few stone buildings remaining for farm use on the Cape. Constructed from pink granite cut-stone blocks, the structure was used to chill milk, butter, and cream by placing the vessels in the cool running water from the stream that flowed though the building. It was built low into the ground, giving protection for the water source. One of the few stone buildings for farm use left on the Cape, this small springhouse is unique.

27

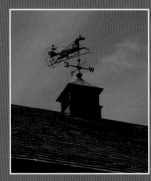

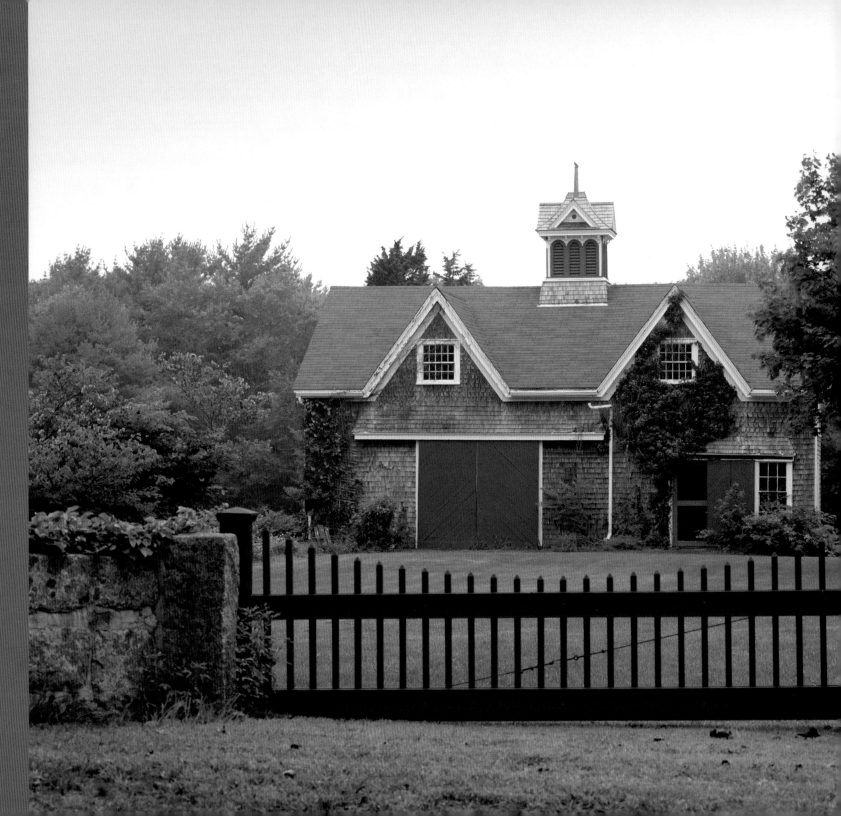

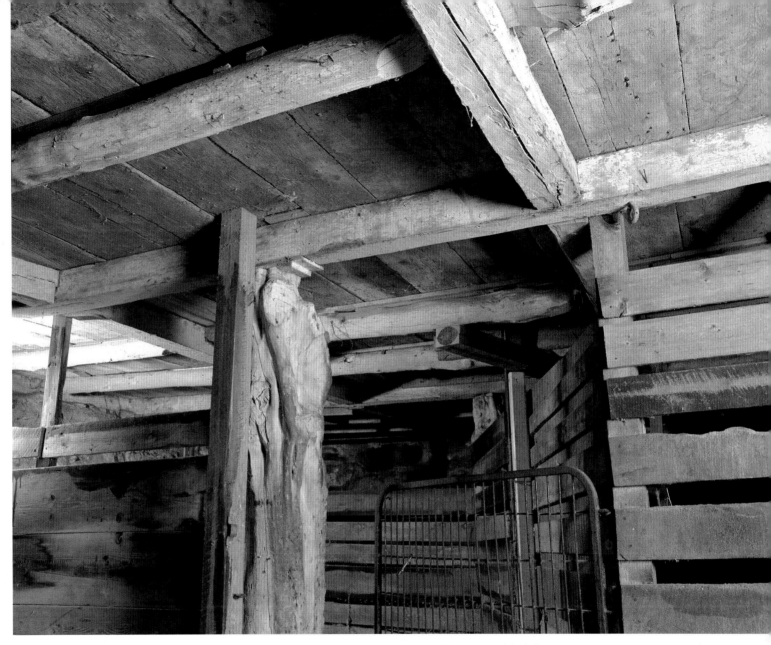

The barn on this large property is an elegant example of Victorian architecture. The two gabled dormers contain ten-over-ten panel windows and the elaborate cupola gives a final flourish to the barn. Inside, hay is packed on the main floor for the horses stabled below. A peeled tree trunk was used as the main post in the stable. This handsome barn is still used for its original purpose, lacking only a carriage to complete the turn-of-the-century picture.

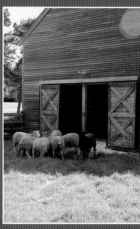

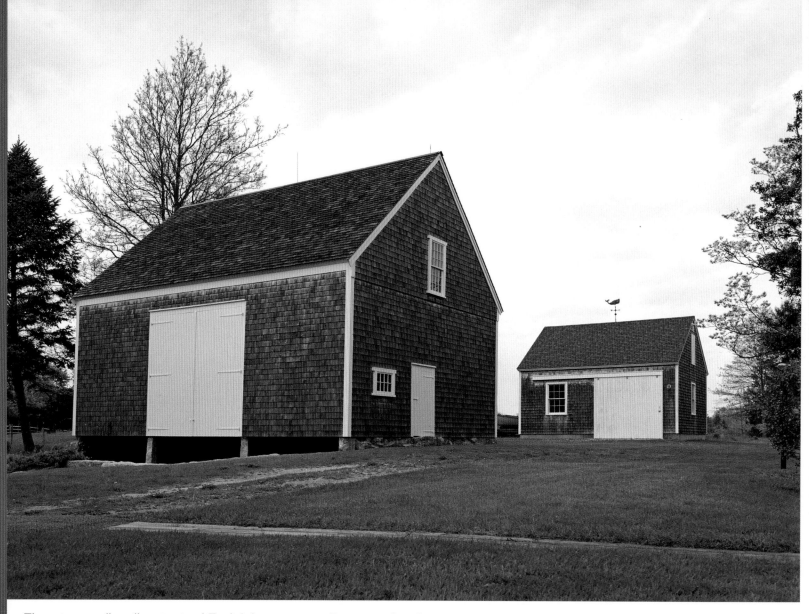

These two small, well-maintained English barns are excellent examples of a nineteenth century farmstead. Built in 1810, the larger barn rests on one long wall with granite posts, allowing space for a wagon to load and unload grains at the door. The interior has three bays, or sections, used to store grains such as rye, wheat, and oats as well as hay. The second smaller barn is a pump house and originally a windmill presided over the site. The property has been owned by the same family for generations.

Opposite page:

This colorful barn reflects the owner's interest in cranberries. The wholesale berry business was well underway when this barn was built in the 1890s. Barns were needed to house culling and sand spreading equipment as well as the boxes needed to ship the berries off Cape. The barns are still used in today's cranberry industry.

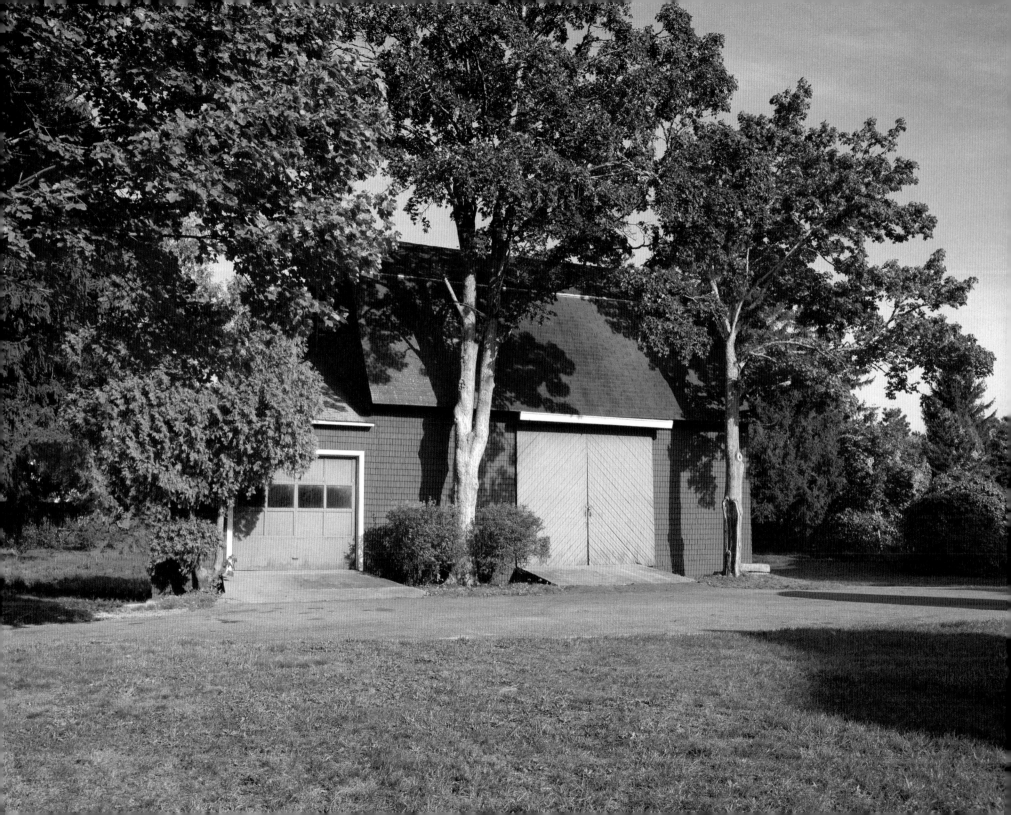

Sandwich

Sandwich is composed of East Sandwich, Forestdale, and Sandwich Village. Because it is a popular tourist town, Sandwich doubles its 20,000 plus population in the summer months. It is blessed with fine beaches and developable land. It is the site of the earliest Pilgrim settlement on the Cape in 1637. Basically begun as an agricultural economy bolstered by fishing and trading, today it has made a successful shift to a thriving tourist economy. Visitors flock to Sandwich, visiting its museums and other historic attractions, including the Grist Mill. Many of Sandwich's roads reveal barns of all sizes and shapes, including the oldest barn on Cape Cod.

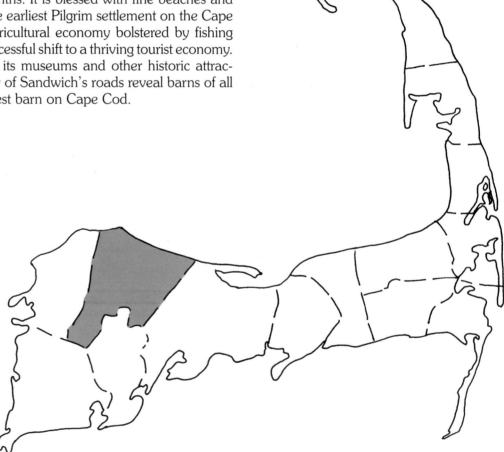

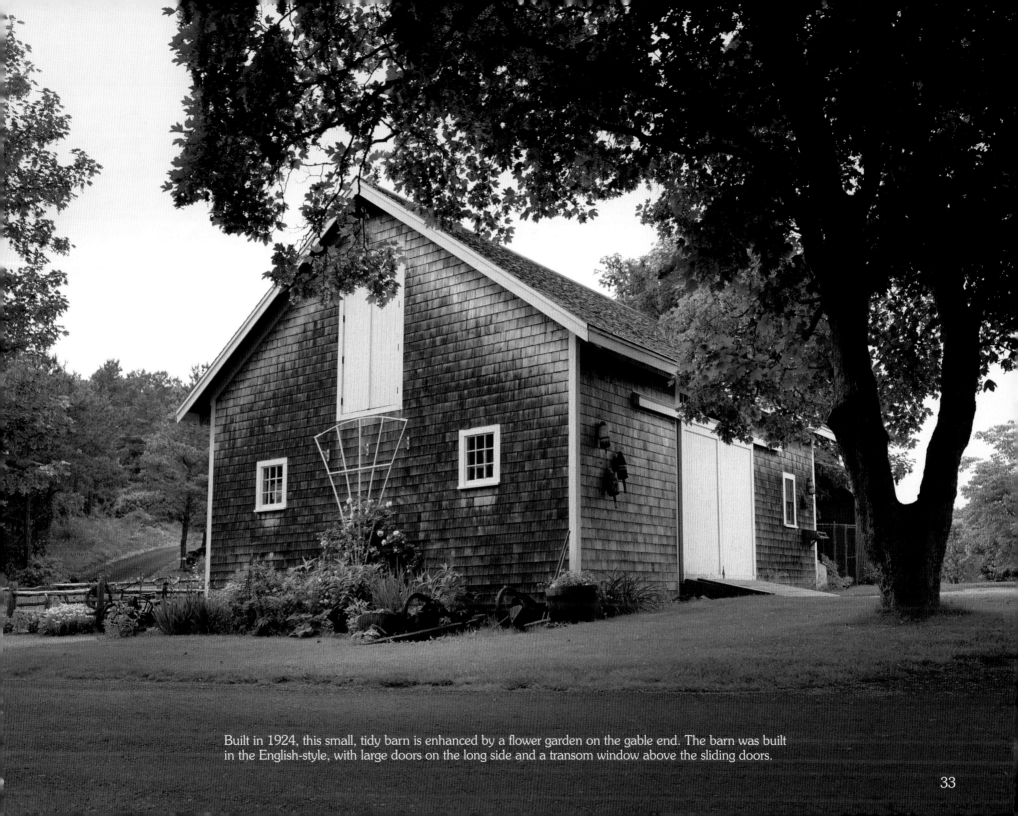

Built in 1924, this small, tidy barn is enhanced by a flower garden on the gable end. The barn was built in the English-style, with large doors on the long side and a transom window above the sliding doors.

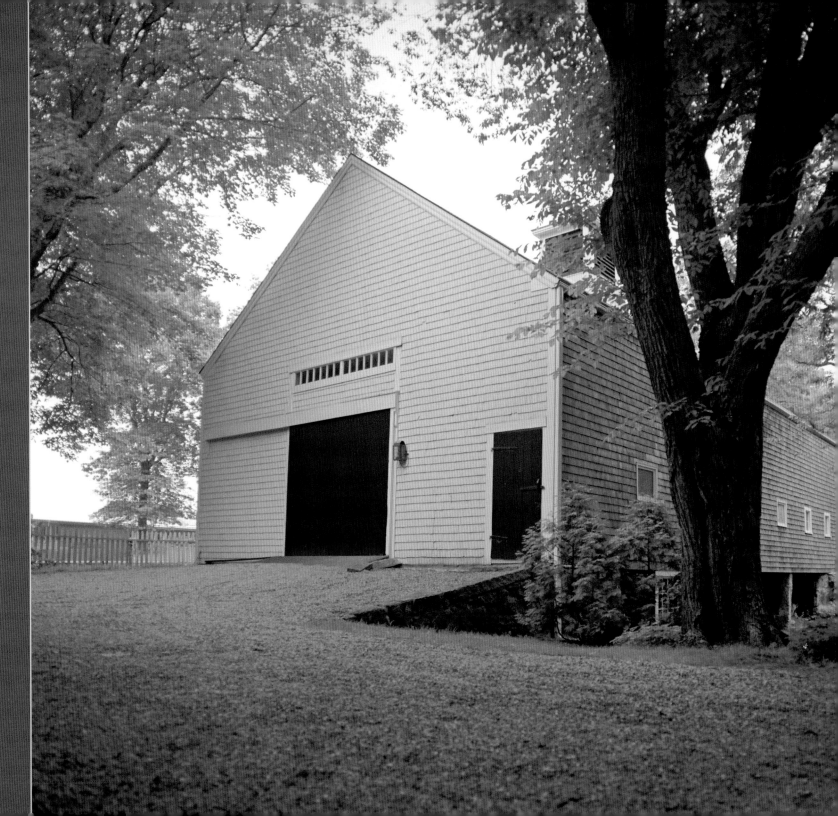

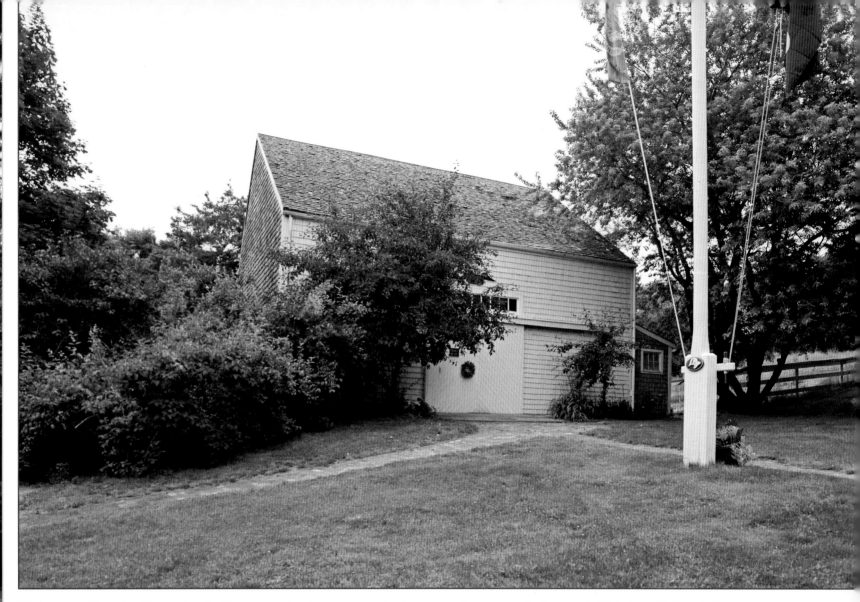

Wingscorton Farm is still populated with many animals: pygmy goats, sheep, one llama, one donkey, and all kinds of birds – ducks, chickens, and geese. The original barn was constructed around 1763 and has been in active agricultural use since then. It is a mid-sized English-style barn surrounded by outbuildings and is significant because it is one of the oldest farms remaining in Sandwich today.

This large barn in the center of Sandwich was originally built in 1724 and rebuilt in 1810. It is a drive-through barn, with large doors at both ends. At one time, there was a produce store attached to the barn. A small pond nearby is the home for serenading bullfrogs.

SANDWICH

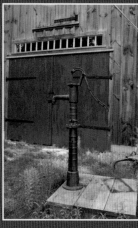

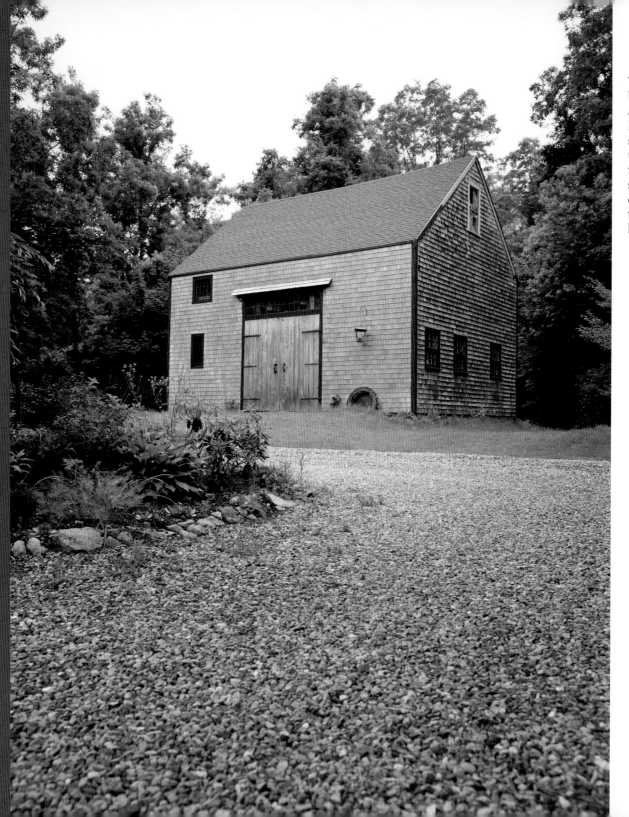

This 1742 English-style barn was known for years as the "Jelly House." Two English ladies made and sold jams and jellies, using the barn to store their products. The structure is a handsome one, with a prominent transom, covered by a hay bonnet.

This late nineteenth century barn was used as a stable for horses and a boathouse. The barn abuts a small waterway, allowing boats to float nearly up to its back door. In addition to horses and boats, the building has stored feed and grain.

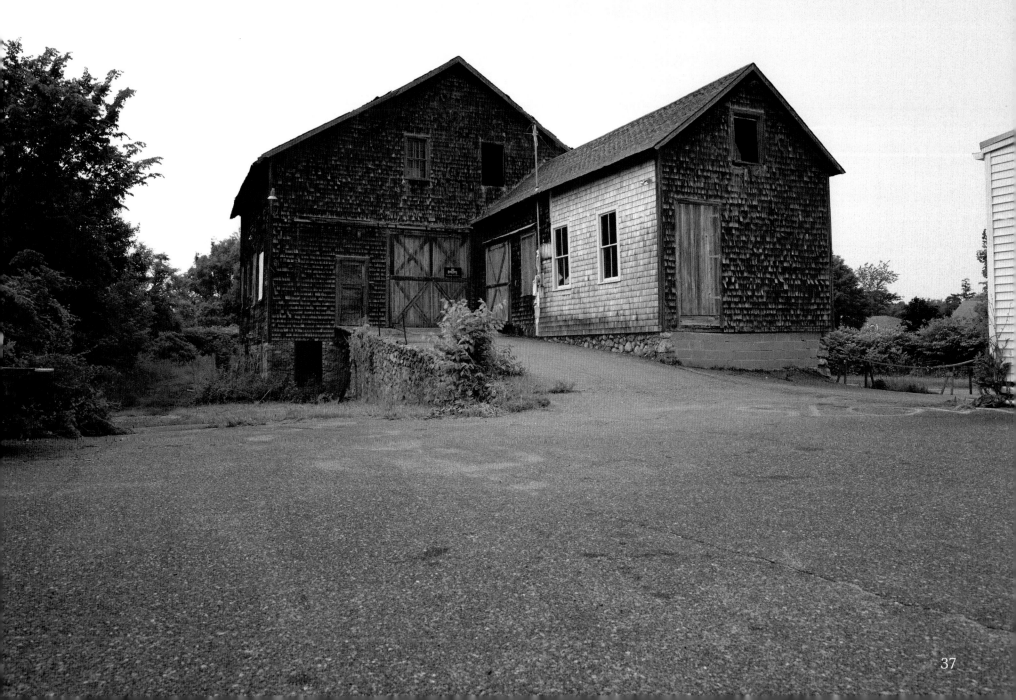

SANDWICH

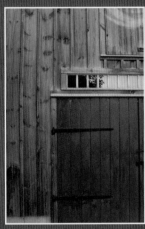

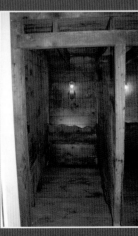

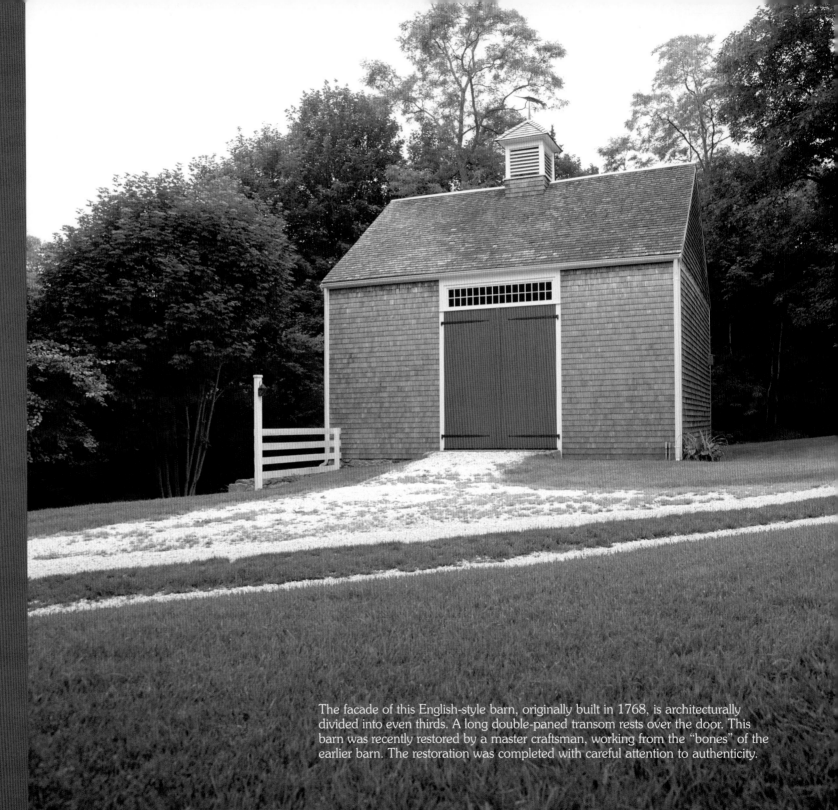

The facade of this English-style barn, originally built in 1768, is architecturally divided into even thirds. A long double-paned transom rests over the door. This barn was recently restored by a master craftsman, working from the "bones" of the earlier barn. The restoration was completed with careful attention to authenticity.

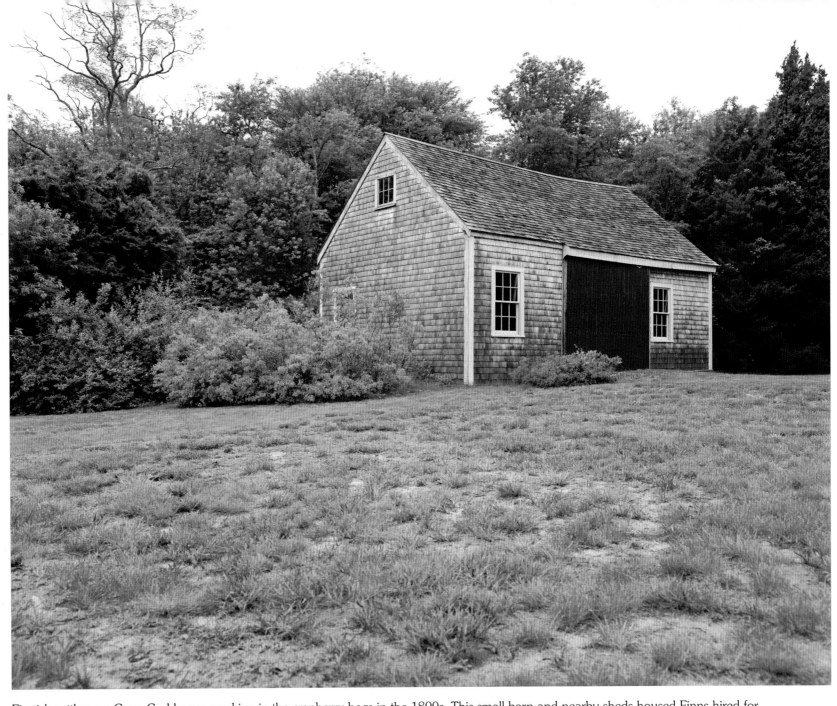

Finnish settlers on Cape Cod began working in the cranberry bogs in the 1800s. This small barn and nearby sheds housed Finns hired for harvesting the cranberries. Inside the barn, the walls are papered with newspapers headlining the Gold Rush of 1848, indicating when the barn was built. Later, when the bogs were leased to Ocean Spray, most of the Finns returned to the north of Boston. A small number remained in the Sandwich area and became successful farmers.

SANDWICH

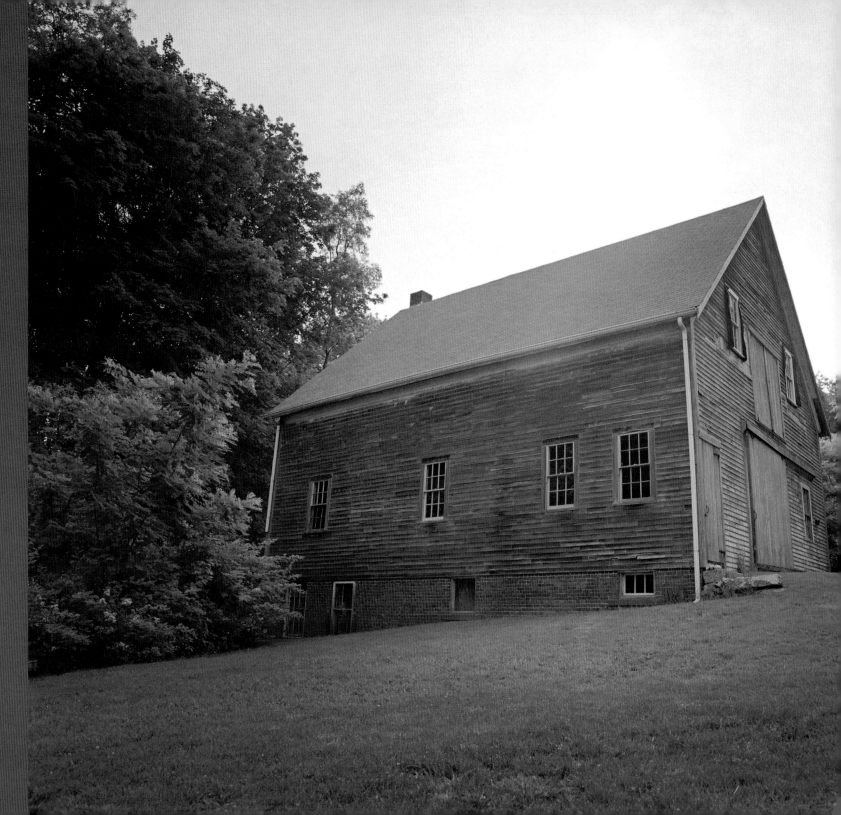

Regally sited on the top of a hill, this large barn is enhanced by faded blue doors and a red brick foundation. This New English-style barn is clad in horizontal siding rather than the typical shingle siding. A very large second story hay door is on the gable end.

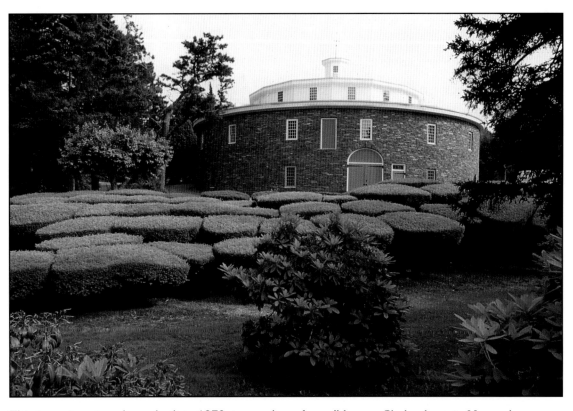

This imposing stone barn, built in 1970, is a replica of a well-known Shaker barn in Hancock, Massachusetts, that had been built in 1826. The three-level building is open to the public on the grounds of the Heritage Museum and Gardens, 67 Grove Street, Sandwich. The second level of the interior of the barn houses an extensive collection of antique automobiles. Of special interest is the detailed woodwork in the building, which is enhanced by the light from the large clerestory windows.

SANDWICH

The last working dairy farm on Cape Cod was said to be this one in Sandwich. Known as the Roberti Dairy Farm, it was built in the 1950s. It has a gambrel roof and shingled sides. The large barn housed over sixty cows, whose milk production supplied a good part of the Upper Cape. Even though it is in a dilapidated condition today, the property still has an imposing group of barns and silos. The town of Sandwich owns the barns and currently has no plans for the site's preservation or development.

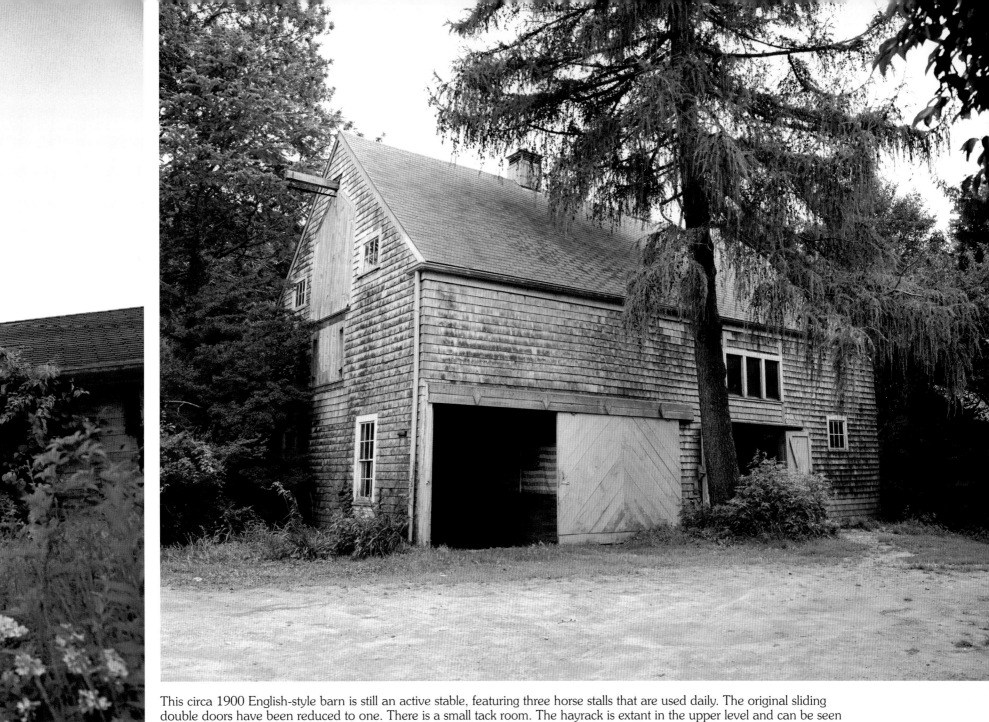

This circa 1900 English-style barn is still an active stable, featuring three horse stalls that are used daily. The original sliding double doors have been reduced to one. There is a small tack room. The hayrack is extant in the upper level and can be seen outside on the gable end. This property, sited on the top of a hill, is enhanced by a profusion of azaleas and rhododendrons.

SANDWICH

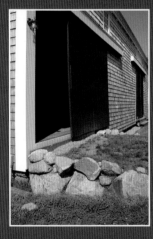

Three centuries of the Wing family have lived in this house in Sandwich, constructed in 1640-1641. It is now open to the public during the summer months. The date of the small, attached one-story barn is not known, but it was probably built around 1740-1741 when a large barn on the property burned. The barn is thought to have been used as a threshing floor and, as indicated by double walls, an icehouse. A fieldstone foundation supports the structure. The door at the gable end is an odd size but allows entry for tall items. Most of the windows of the barn are on the rear elevation.

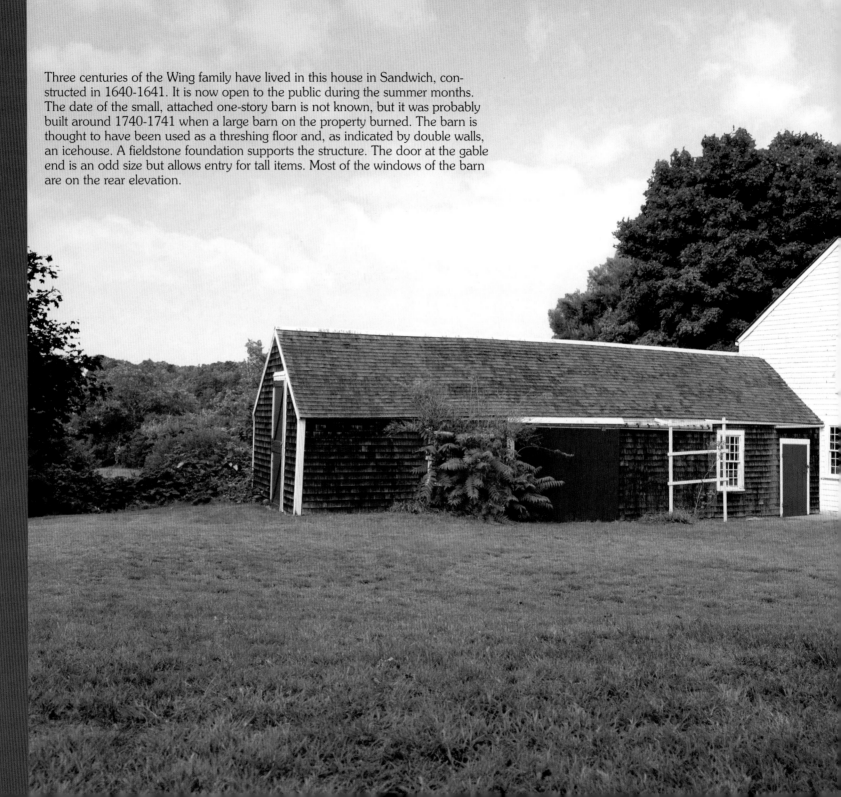

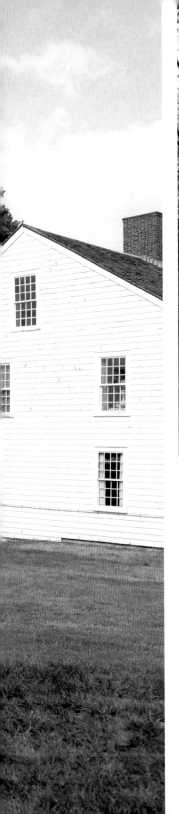

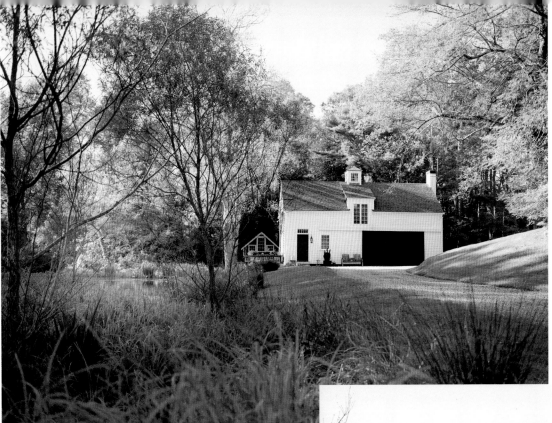

If a setting makes the picture, this barn must be one of the most beautiful on the Cape. Nestled next to a small pond ringed with iris and mature shade trees, this is a barn with every enhancement. It is a faithful reconstruction of the original barn on the property and was finished just twenty years ago.

A lovely stream-fed pond flows through the center of Sandwich Village. On the banks of this stream is an eighteenth century barn with an unusual feature: it was the town's jail. Suspects and felons were detained in a small room behind the white double doors.

Mashpee

Mashpee has only two villages: New Seabury and Mashpee. With a year-round population of nearly 13,000, Mashpee has some of the most popular beaches on Cape Cod and a most unusual history. In 1660, the Wampanoag Indian tribe was given fifty square miles of land in Mashpee. As the Indians customarily did not settle into permanent housing, they moved to the shore in the spring and inland during the winter. The development of Mashpee only began after World War II, so very few farms with barns were built in the area. Mashpee is now making up for lost time with the construction of a large shopping center, Mashpee Commons, and the New Seabury housing developments.

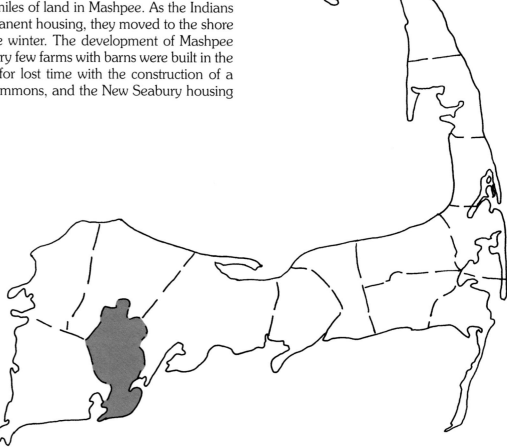

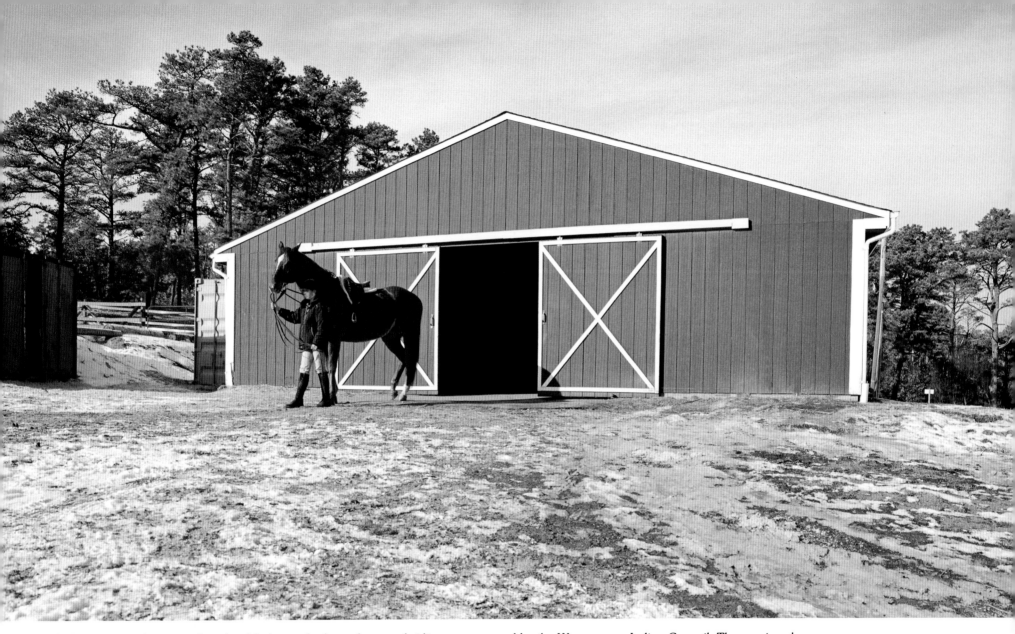

Only one active barn was found in Mashpee, the horse barn and riding arena owned by the Wampanoag Indian Council. The spacious horse barn and show ring were built in the 1980s to accommodate eighteen horses. The tribe purchased the barn in the 1990s. The Wampanoag were given fifty square miles of land in 1660, which has shrunk to twenty-four square miles, as the Indians have sold over half of their land over the years. The tribe is working to improve their holdings to increase their viability as a legally recognized Indian tribe.

Barnstable

Barnstable is comprised of seven townships: Barnstable, West Barnstable, Centerville, Cotuit, Hyannis, Hyannisport, West Hyannisport, Marstons Mills, and Osterville. For those not familiar with Cape Cod, the name Barnstable can refer to the county, the town or the township. As the largest town on the Cape, Barnstable's population triples in the summer months. The town of Barnstable is the largest of the nine townships, with sixty square miles. The town of Hyannis is the major commercial center on Cape Cod.

In the nineteenth century, there were nearly 800 sailing ship captains who resided in Barnstable and many built houses and barns. Barnstable has more barns than any other town on Cape Cod.

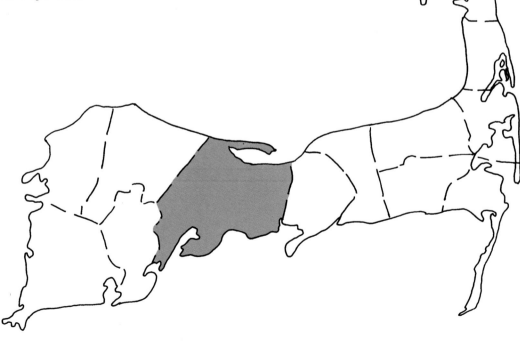

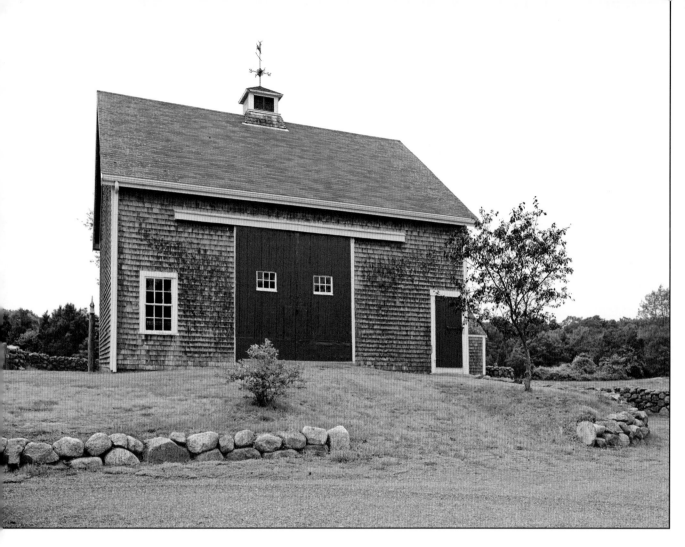

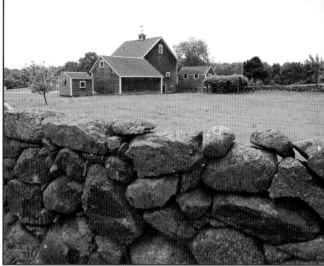

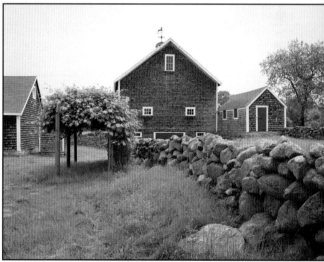

This farmstead in West Barnstable is one of the most complete on Cape Cod. It not only has a main barn, but it also has all of the original outbuildings, stone walls, a pond, trim fields, and nearby cranberry bogs. Built around 1895 for $500, the barn and property have remained in the same family for over 110 years.

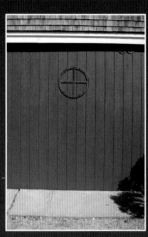

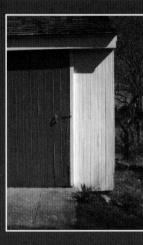

Many Cape barns have been converted to living spaces, especially in the last twenty years. Many conversions took place after the Second World War, when adequate housing was severely lacking. This big structure sits prominently on Main Street, with a drop-off in the rear that allows access to the lower level. Its foundation is built from very large, precisely cut granite blocks. This is an excellent example of a successful barn conversion into a house.

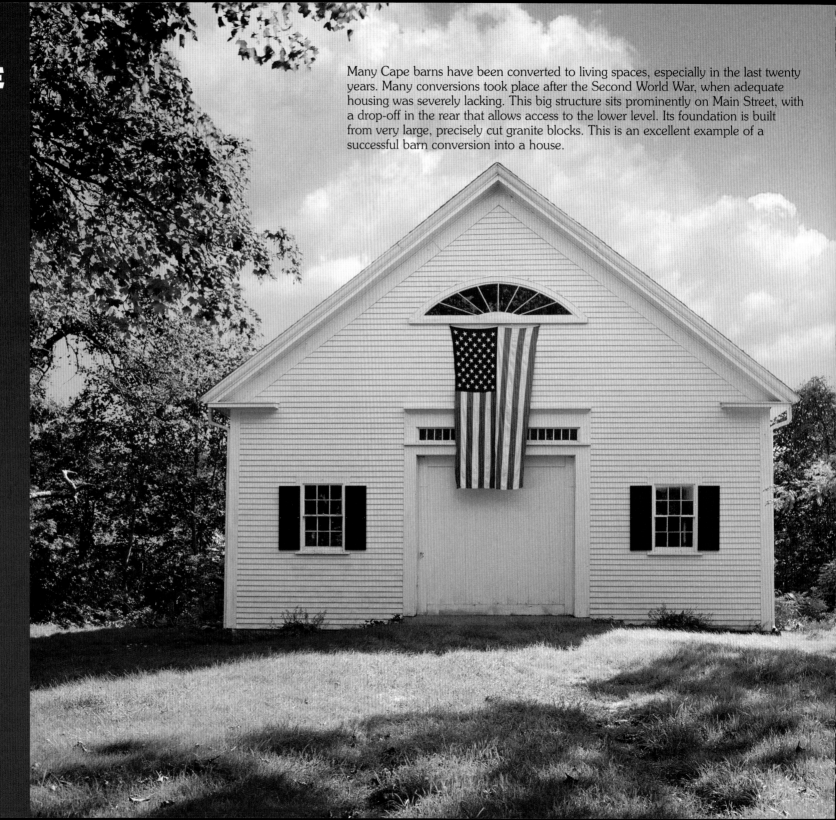

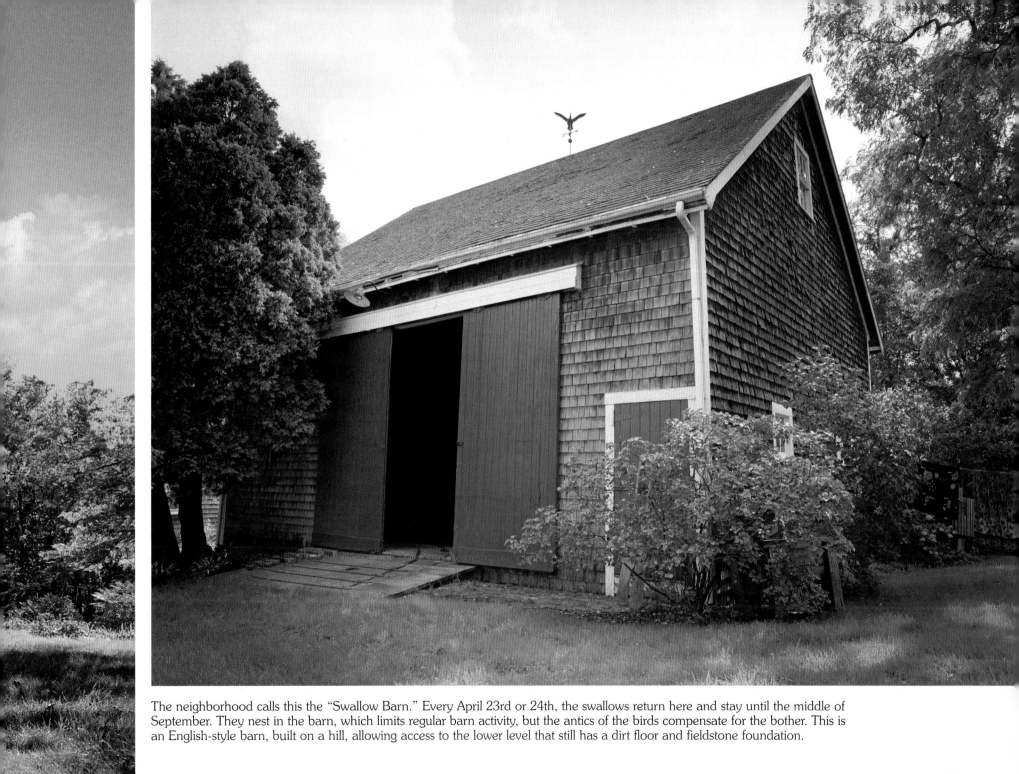

The neighborhood calls this the "Swallow Barn." Every April 23rd or 24th, the swallows return here and stay until the middle of September. They nest in the barn, which limits regular barn activity, but the antics of the birds compensate for the bother. This is an English-style barn, built on a hill, allowing access to the lower level that still has a dirt floor and fieldstone foundation.

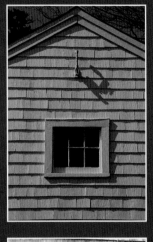

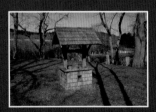

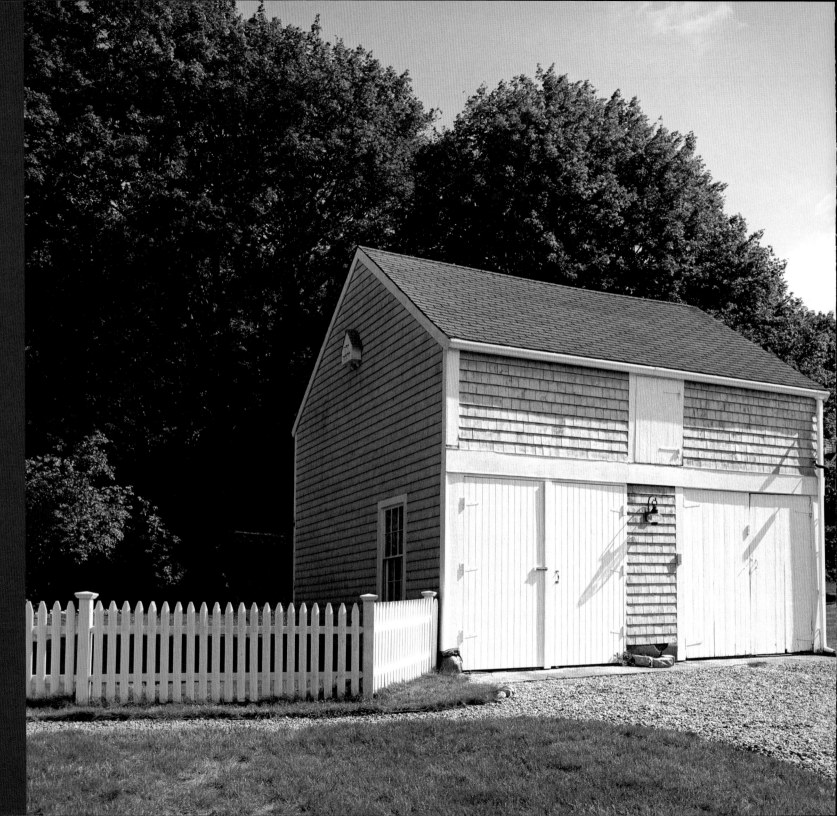

Two double doors make this English-style barn unique. The hay door in the second level is located above the doors in the middle of the long side instead of tucked above on the gable end. Built around 1800, this little barn was built to the owner's needs.

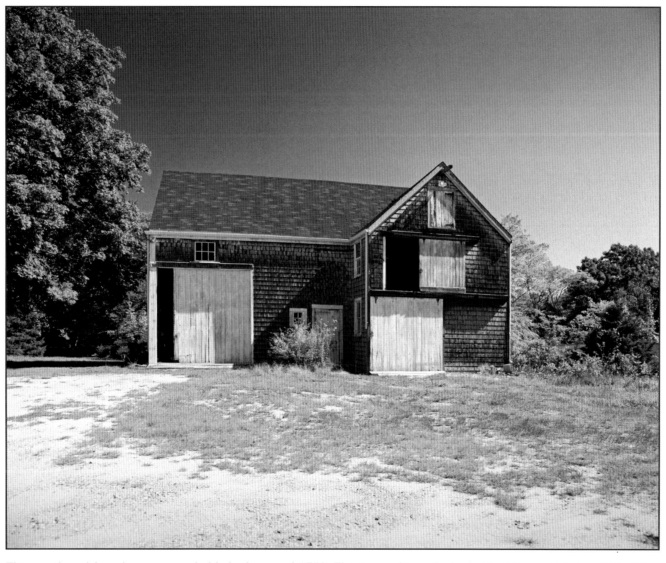

This weathered farm barn was probably built around 1750. This is a multi-use L-shaped building, which is half English-style and half New England-style. The two second-story hay doors indicate its past use for horses and cows. The barn is used today to store modern farm equipment.

BARNSTABLE

The history of this barn reflects many of the industries prevalent at one time on Cape Cod. Since the late 1700s, this barn and farm have been a pig farm, a chicken and egg farm, a Christmas tree farm, a cranberry farm, and today the barn is an antique shop.

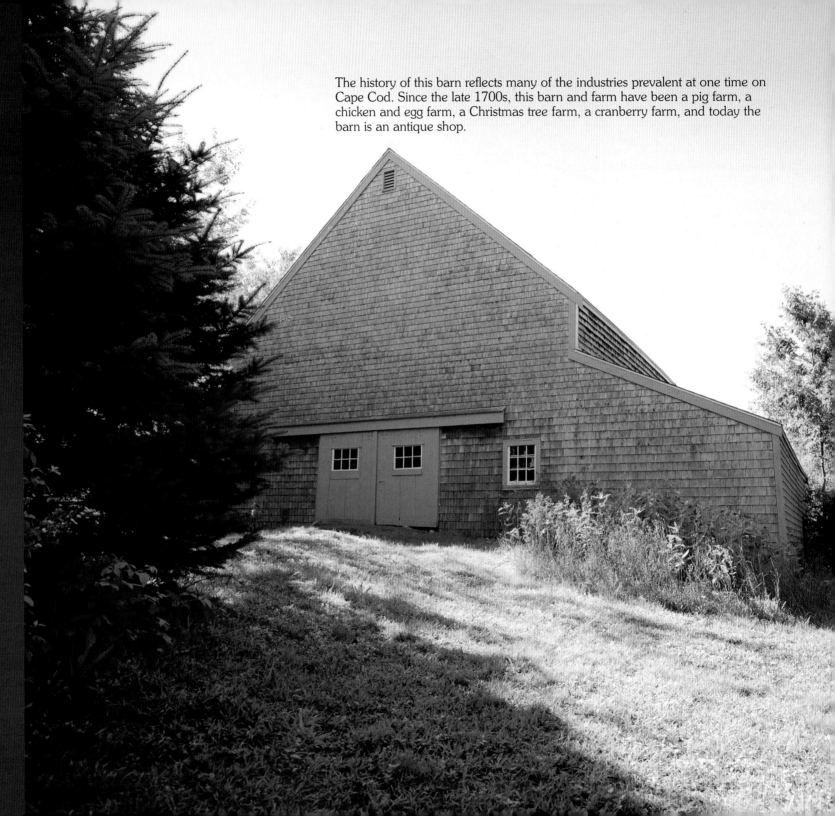

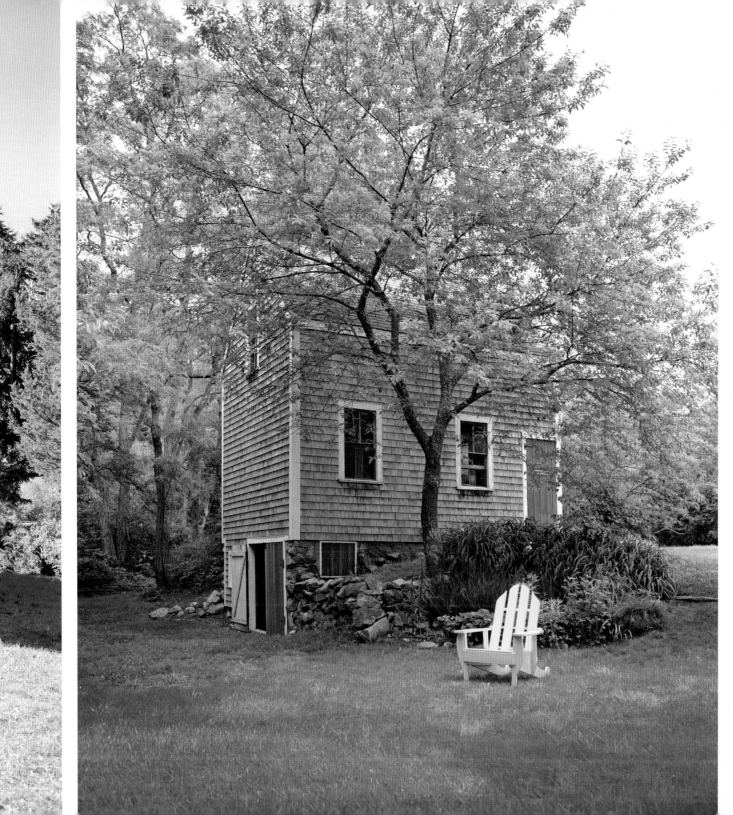

This typical small Cape Cod barn was originally built as an onion farm around 1886. The water tower, built of fieldstones, remains an attractive ruin nearby. The entry door to the barn is placed directly on the corner to allow more storage room inside. The barn is built on a small hill, allowing access to the onion storage on the lower level, which has a low five-foot ceiling.

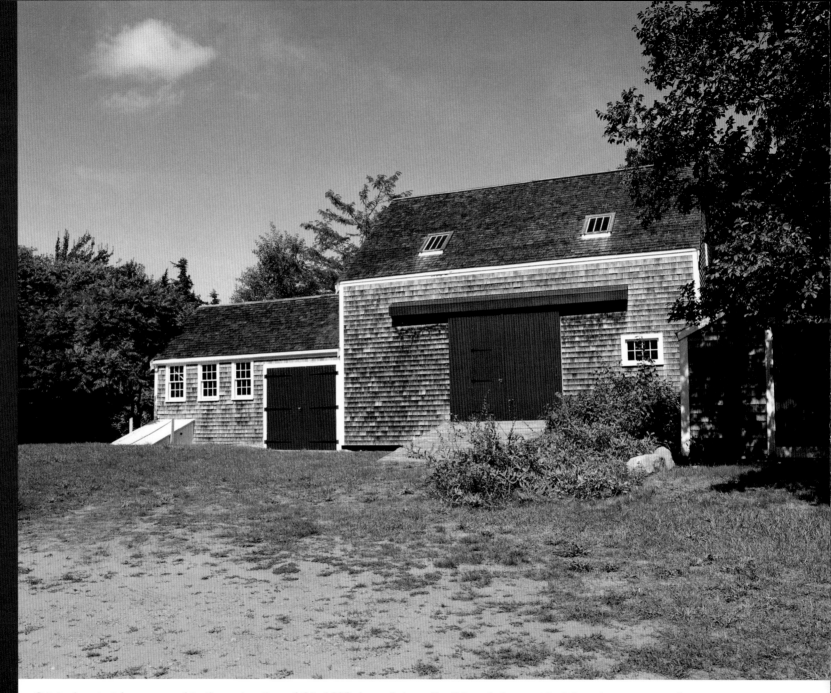

Original materials were used in the restoration of this 1830s barn. It is an English-style barn with sliding doors, centered on a four-bay space inside. A later attached addition is off to the side with swinging barn doors and reproduction hardware.

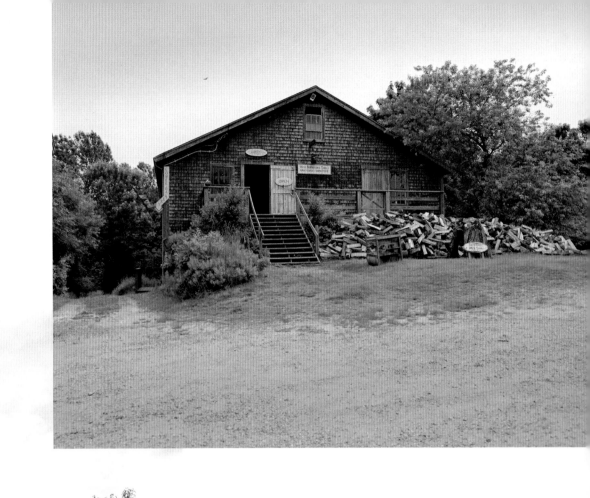

Located in a complex originally known as the Makepeace Cranberry Company, this barn was used for assembling the wooden boxes used in the cranberry business. There are four distinct barns located on this property. A long multi-windowed shed was added to the main 1850s New England-style barn. There is now a retail store in the interior of this barn, which is used as a sales room for antique furniture.

BARNSTABLE

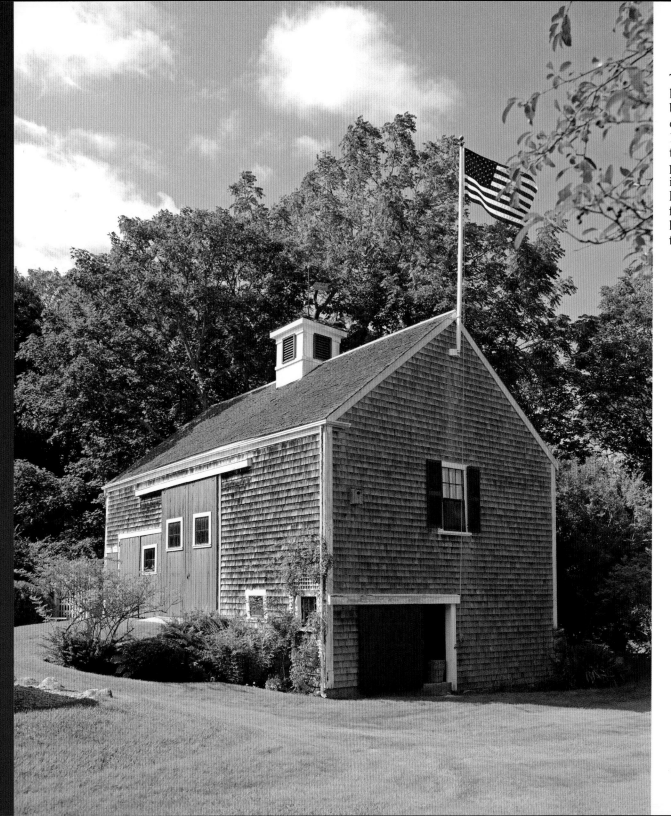

The same family has owned this barn since its construction in the 1820s. In addition to the series of painted doors on its long wall, an English-style barn feature, it also housed goats on the lower level.

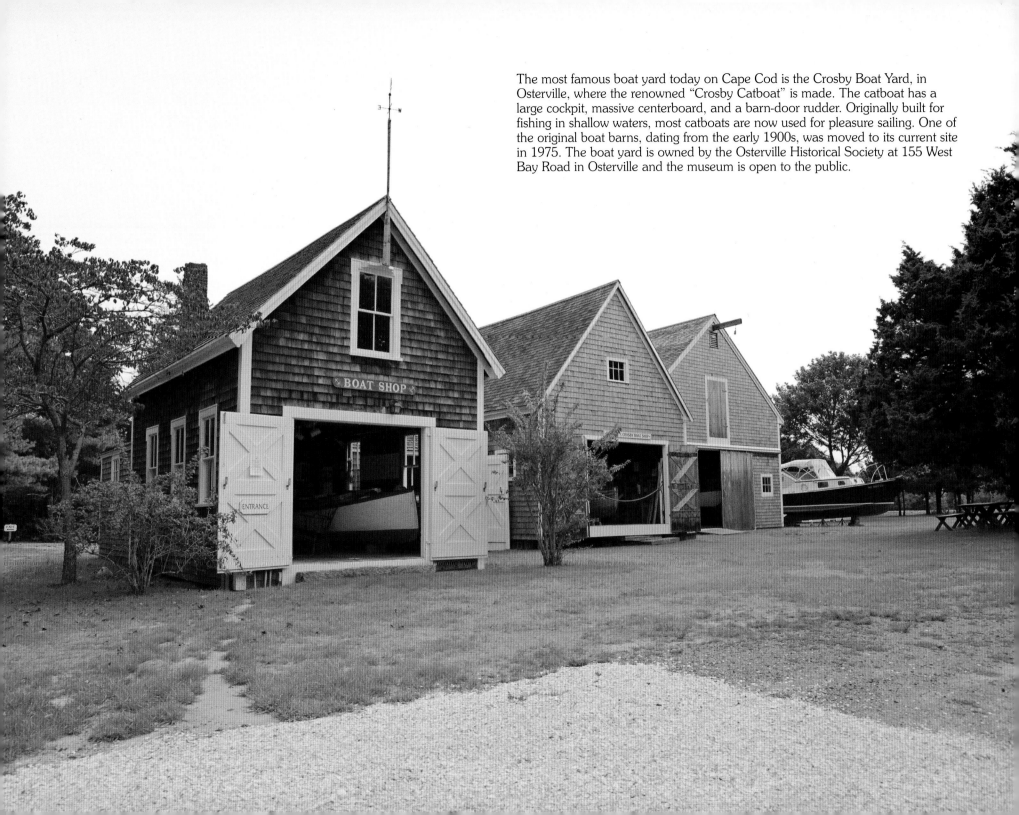

The most famous boat yard today on Cape Cod is the Crosby Boat Yard, in Osterville, where the renowned "Crosby Catboat" is made. The catboat has a large cockpit, massive centerboard, and a barn-door rudder. Originally built for fishing in shallow waters, most catboats are now used for pleasure sailing. One of the original boat barns, dating from the early 1900s, was moved to its current site in 1975. The boat yard is owned by the Osterville Historical Society at 155 West Bay Road in Osterville and the museum is open to the public.

BARNSTABLE

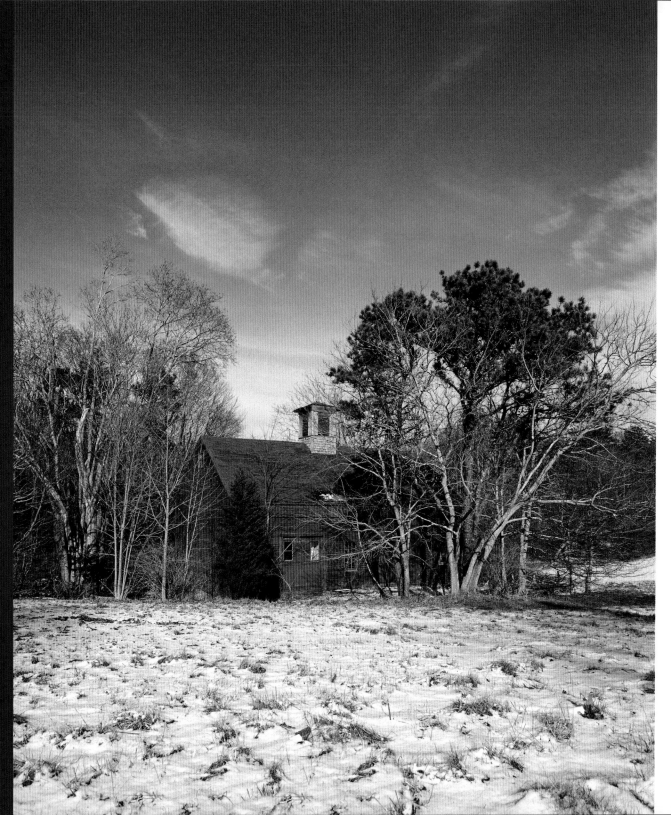

This barn, thought to have been built in 1794, is reputed to be the building where the author Henry Adams wooed his wife, Clover Hooper. The barn is situated on a slope, allowing access to additional storage on the lower level. This is an English-style barn with a hand-hewn frame and several doors on the south facade.

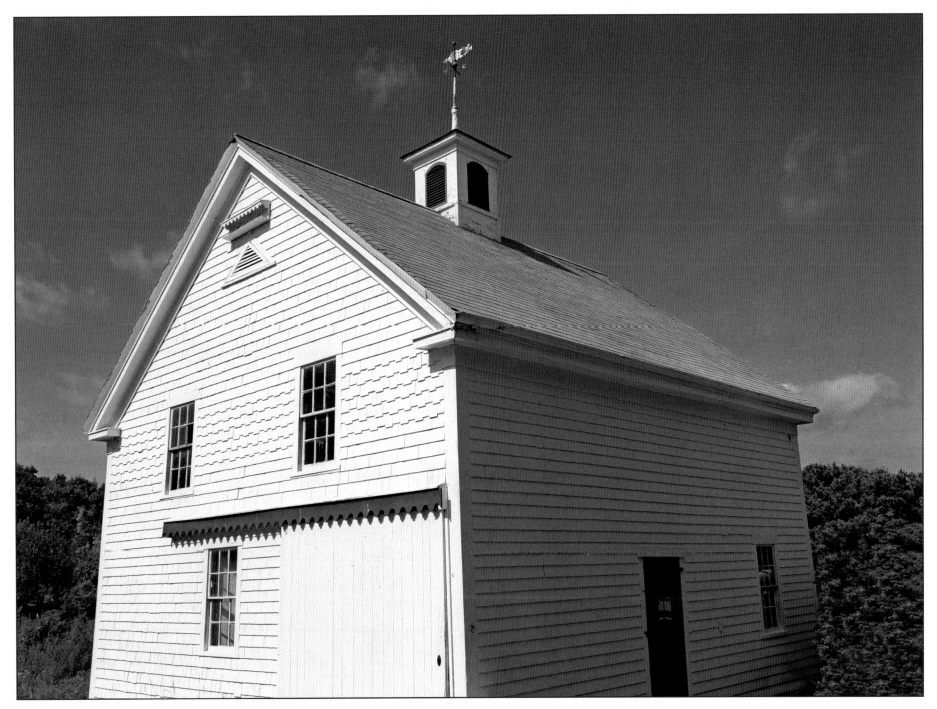

The Victorian love of patterned shingles is evident on this white barn. The simple New England-style barn was originally used as a sail storehouse and was moved from the Barnstable harbor to its present location.

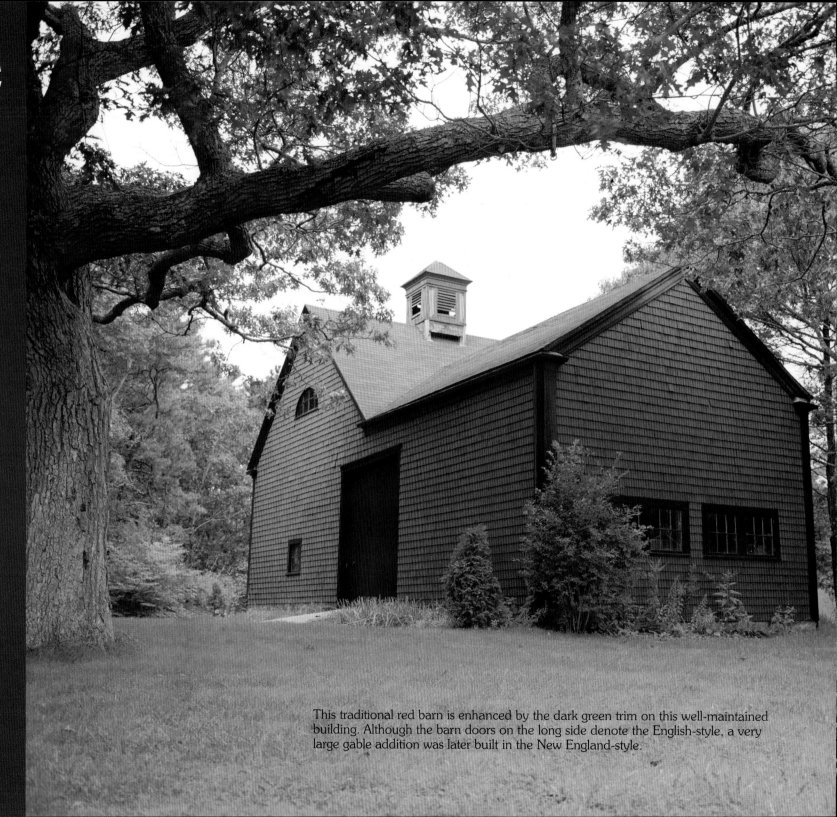

This traditional red barn is enhanced by the dark green trim on this well-maintained building. Although the barn doors on the long side denote the English-style, a very large gable addition was later built in the New England-style.

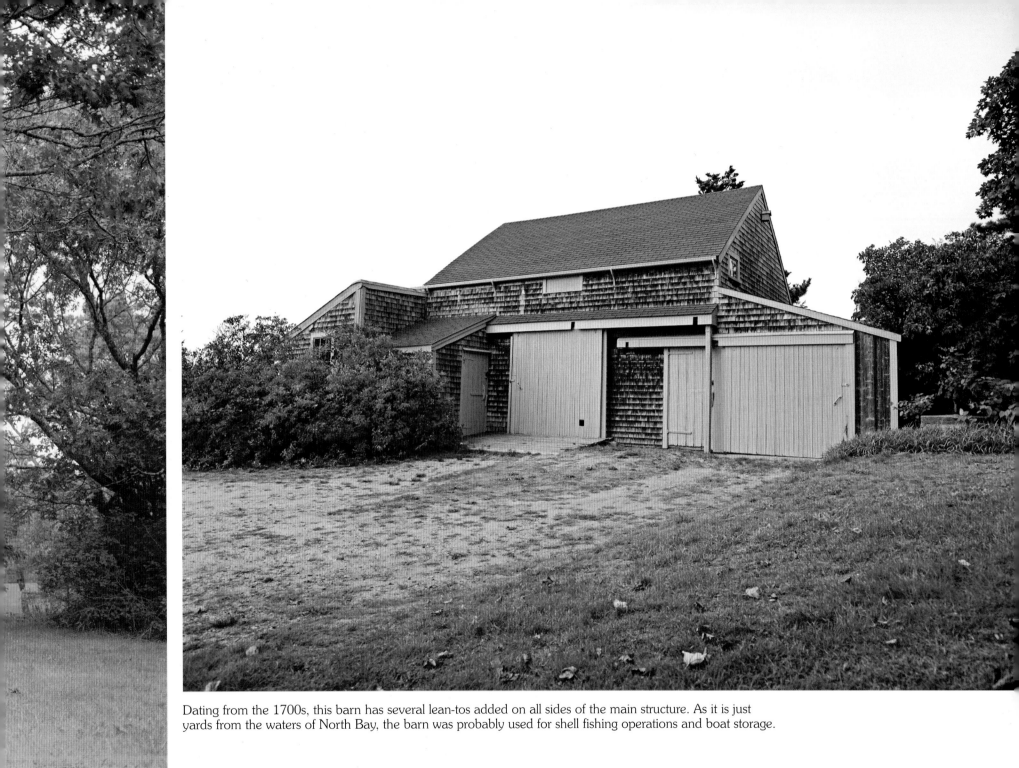

Dating from the 1700s, this barn has several lean-tos added on all sides of the main structure. As it is just
yards from the waters of North Bay, the barn was probably used for shell fishing operations and boat storage.

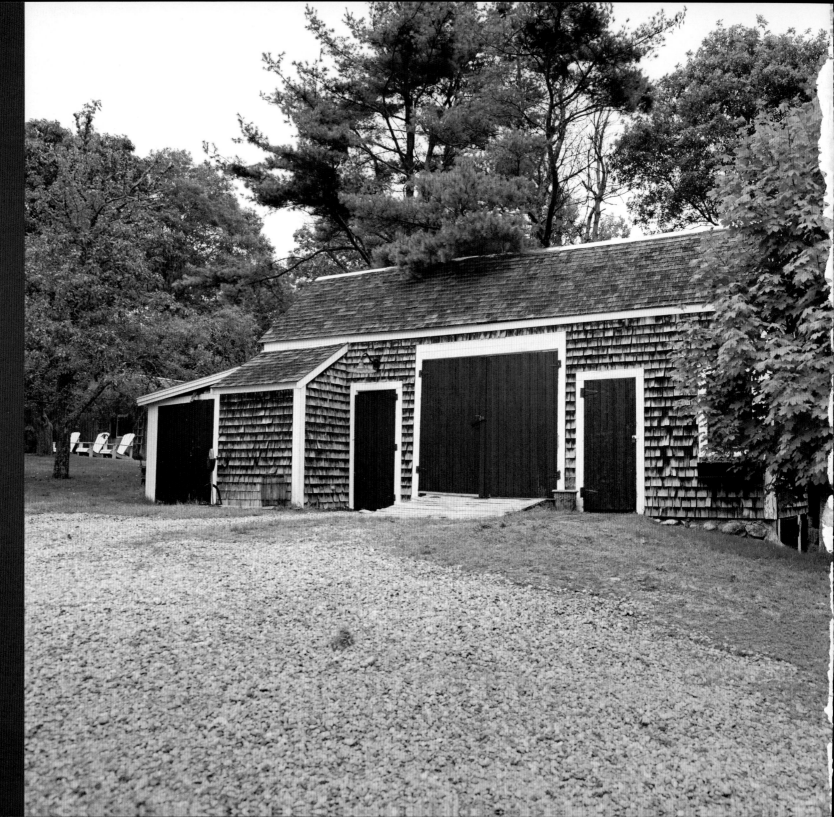

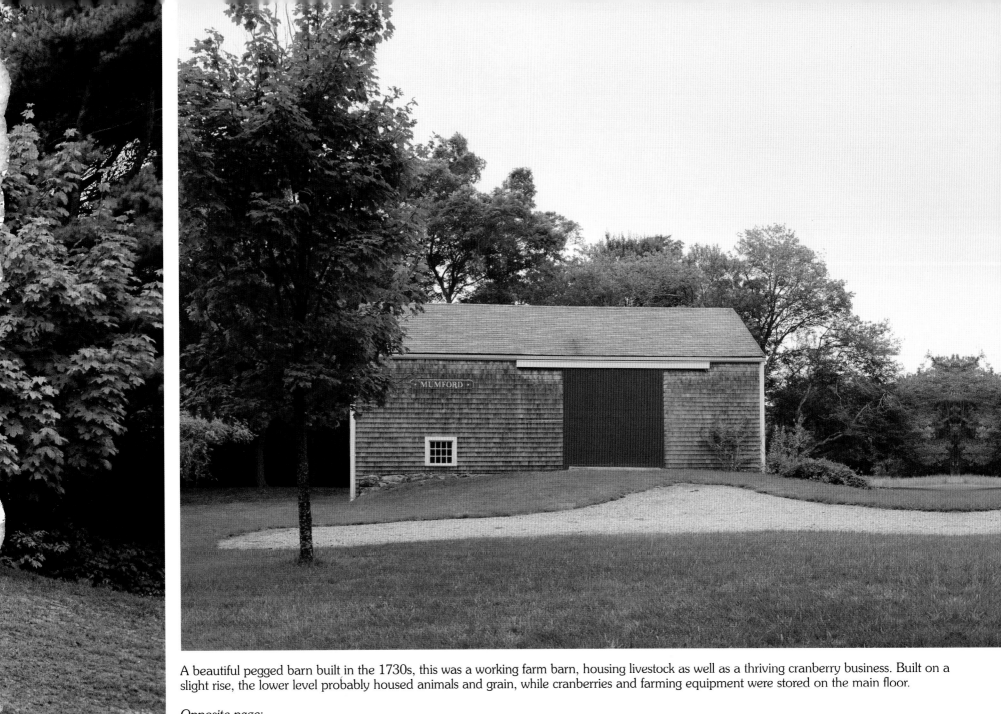

A beautiful pegged barn built in the 1730s, this was a working farm barn, housing livestock as well as a thriving cranberry business. Built on a slight rise, the lower level probably housed animals and grain, while cranberries and farming equipment were stored on the main floor.

Opposite page:
Sitting on a hill, this small barn has a lower level, open on the back side of the barn, as well as an attached shed. The barn door and entryway are nicely balanced on the long side of this English-style barn. It is thought the barn was built around 1900 by Finnish people who came to Cape Cod to harvest cranberries.

BARNSTABLE

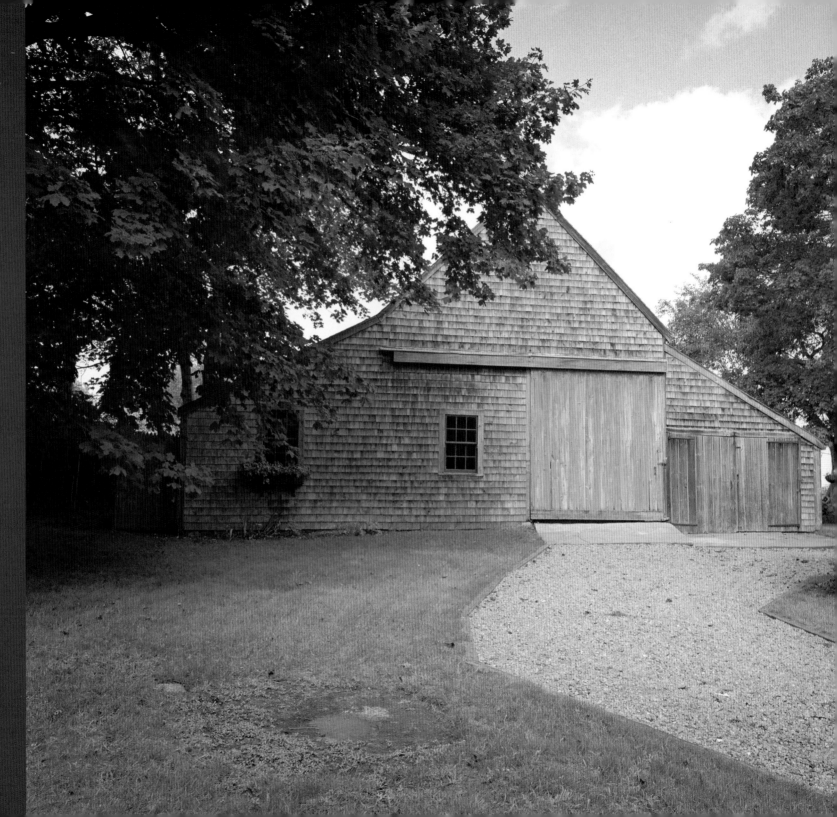

Opposite page:
This New England-style barn has attached sheds on both sides of the main structure. It is one of the oldest barns in Barnstable, as both the barn and the house were built in 1740. At one time, when it was reputed to be the oldest house, the town purchased it. When research disputed its origin, the town sold the property to the present owner.

Left:
Situated on the banks of a millpond, this 1800s barn creates a picturesque setting. This English-style barn has its doors on the long side. A fieldstone foundation anchors the building into the side of a hill above the water.

BARNSTABLE

Surrounded by a hay field, this small horse barn has a view of the lighthouse on Beach Point in Barnstable Harbor. The barn houses two horses in the summer. It has a lean-to on the back of the barn and wide doors on the front. Hay is stored on the second floor loft.

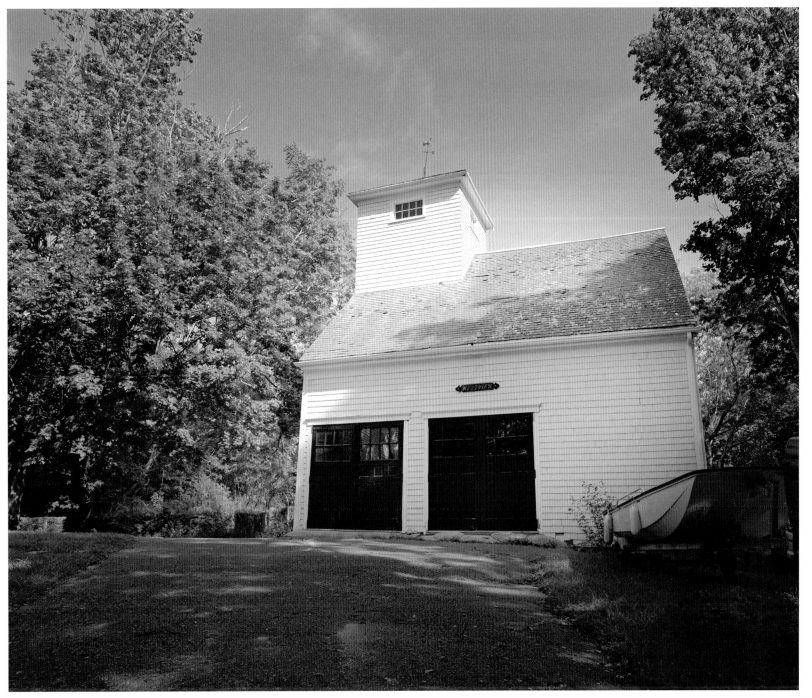

Water tanks were often added to nineteenth century barns. Some are part of a windmill system to raise the water up into the tank, while others stored water without the added windmill. This tank is housed in a structure that is a replica of the original barn.

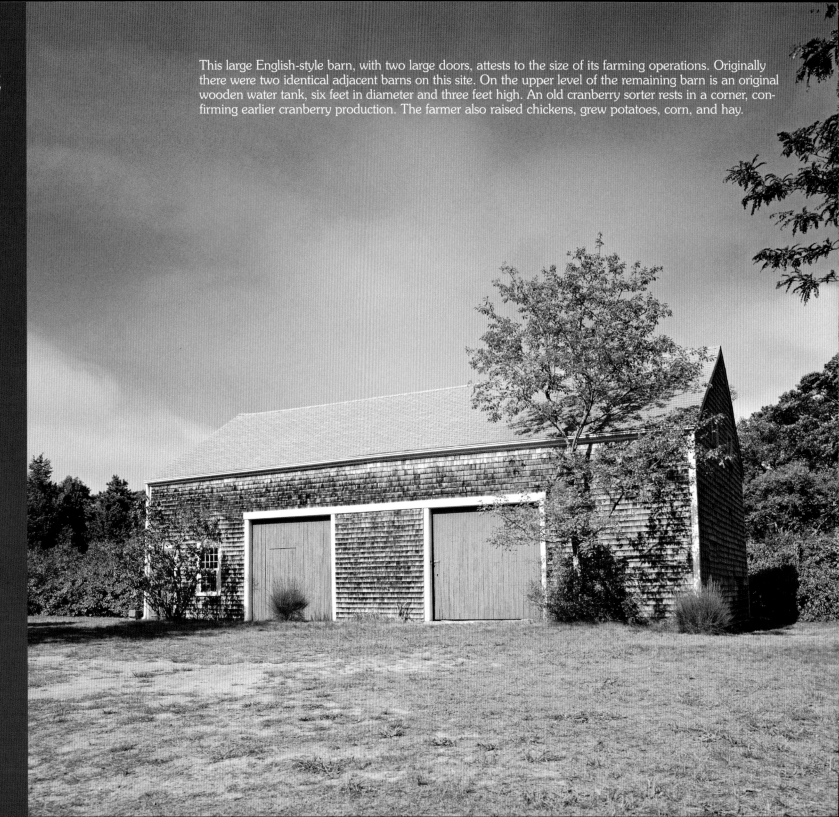

This large English-style barn, with two large doors, attests to the size of its farming operations. Originally there were two identical adjacent barns on this site. On the upper level of the remaining barn is an original wooden water tank, six feet in diameter and three feet high. An old cranberry sorter rests in a corner, confirming earlier cranberry production. The farmer also raised chickens, grew potatoes, corn, and hay.

This original peg barn has weathered the ravages of time since the early 1800s. It is an excellent example of the purest form of a New England-style peg barn: not a single nail was used in its construction. Cotuit had many of these small farmsteads, but today they are more commonly used as vacation homes.

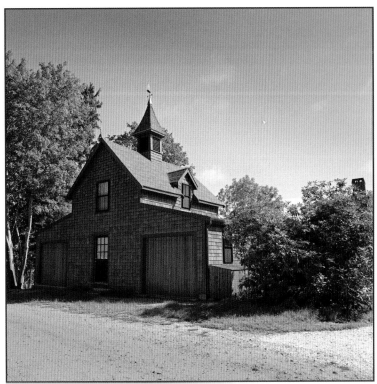

Built in 1851 as an icehouse, this small barn had double walls to insulate the cut blocks of ice. A second floor was added around 1900. When the building became a writer's study, additional windows were added and two side sheds were built into the structure to house cars. An attractive cupola crowns the roof.

71

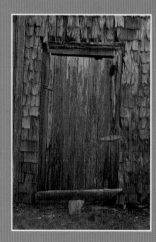

Yarmouth

Yarmouth township consists of the towns of Cummaquid, South Yarmouth, West Yarmouth, Yarmouth, and Yarmouth Port. Originally Yarmouth included land from five other towns. As each town grew, it broke off from Yarmouth, seeking to control its own destiny.

Yarmouth is one of only three Cape townships which spans the entire width of Cape Cod, with seashores on both Cape Cod Bay and Nantucket Sound. It has two historic districts: one north in Yarmouth Port and one south on Old Main Street, which is called the Yarmouth Historic District. Some of the finest remaining large barns on the Cape are in Yarmouth.

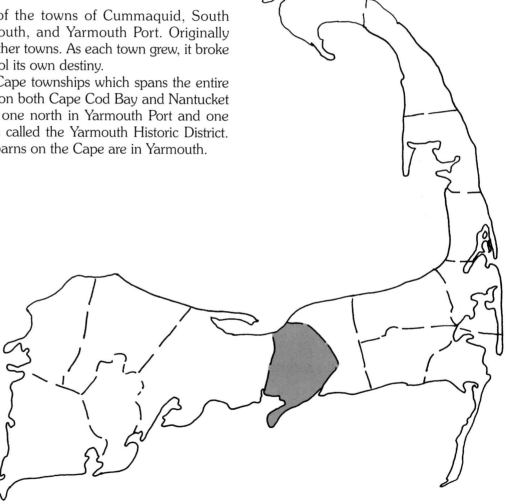

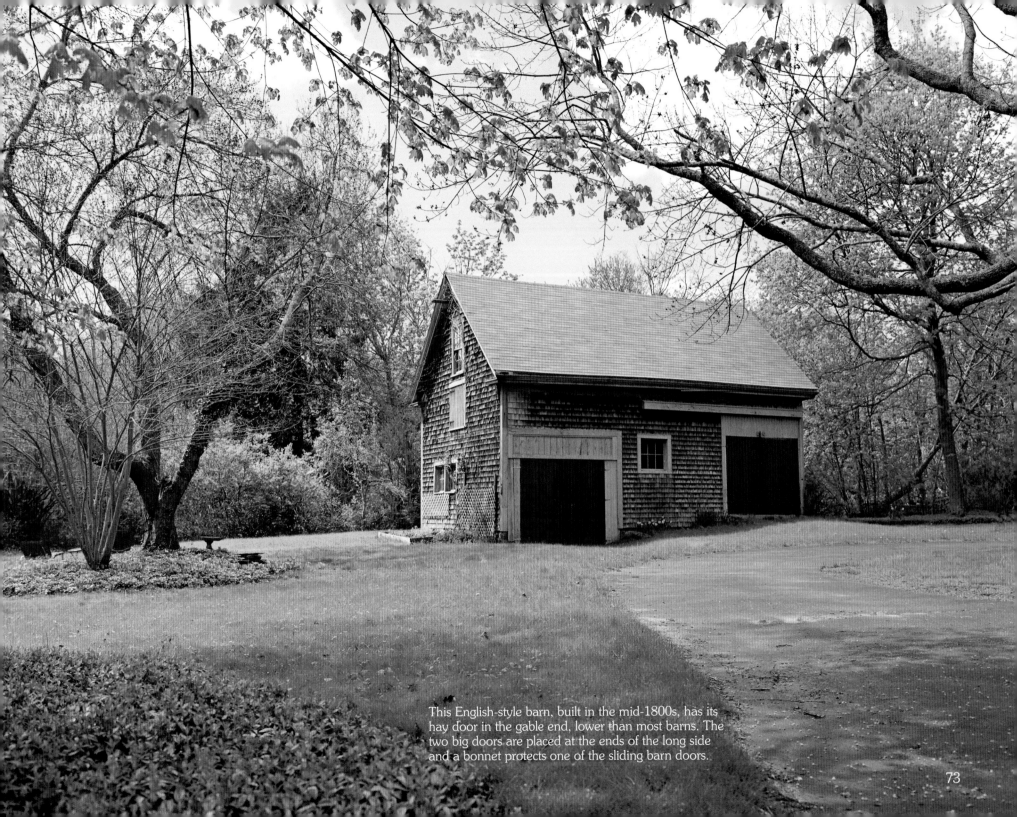

This English-style barn, built in the mid-1800s, has its hay door in the gable end, lower than most barns. The two big doors are placed at the ends of the long side and a bonnet protects one of the sliding barn doors.

YARMOUTH

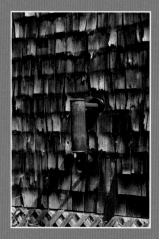

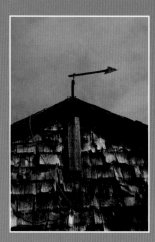

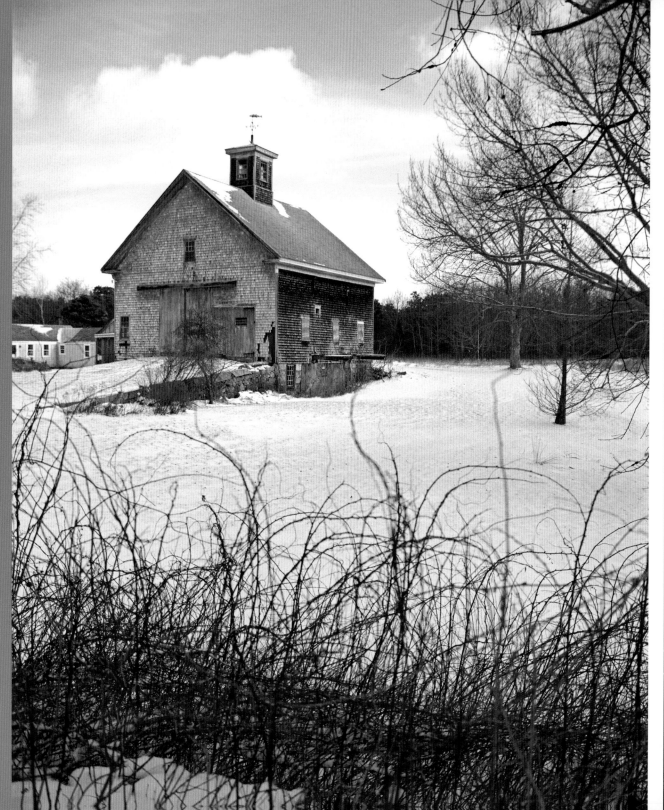

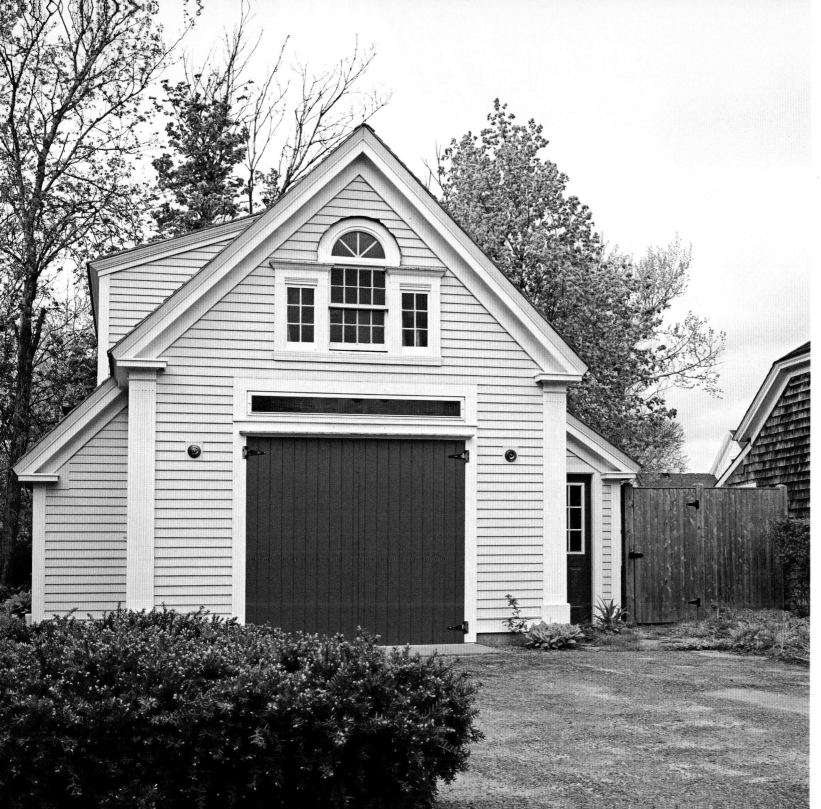

Opposite page:
This fine homestead has been in the same family since a 1639 land grant, which included several hundred Yarmouthport acres. The barn, much in need of repair, and two acres remain in the family. A large portion of the original acreage has been donated to a conservancy. The history and size of this New England-style barn raise important preservation issues. A community effort is needed to restore this historic barn.

Left:
This new barn, built in 1986, was constructed to fit in with the surrounding Victorian neighborhood barns and houses. It is a crisp New England-style barn, with decorative windows and two small lean-to sheds incorporated into both sides of the barn.

YARMOUTH

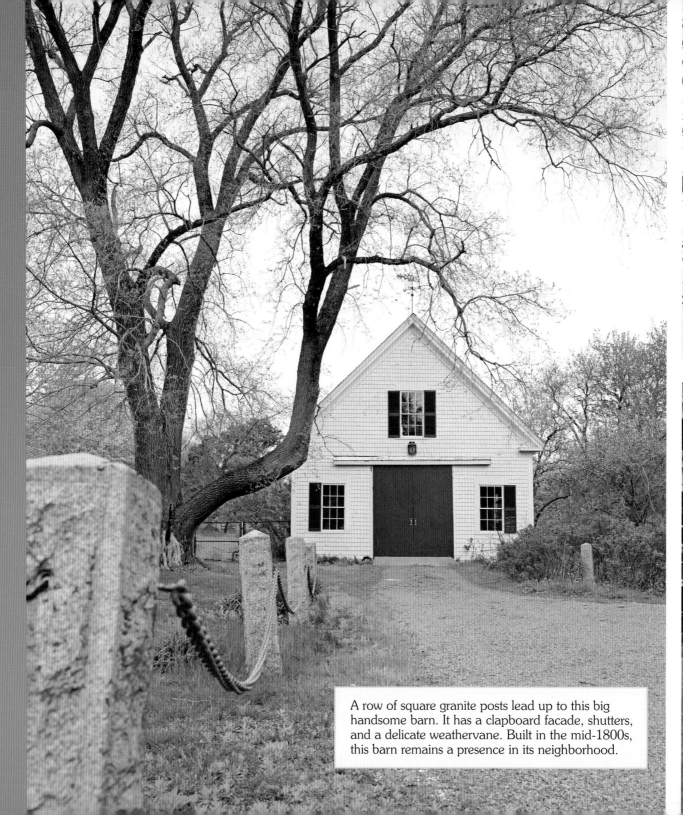

A row of square granite posts lead up to this big handsome barn. It has a clapboard facade, shutters, and a delicate weathervane. Built in the mid-1800s, this barn remains a presence in its neighborhood.

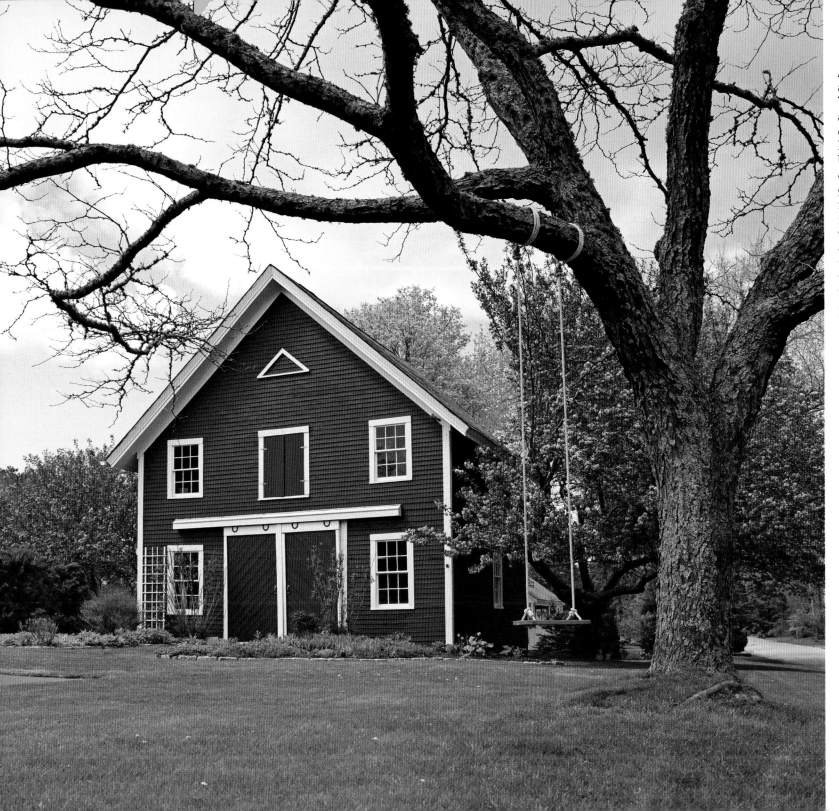

A beautiful red barn always stands out. This one, located on a busy street, is no exception. This is a New England-style barn, with the sliding doors situated on the gable end. This barn features four matching gable-end windows and a hay door centered on the upper level. Built in the mid-1800s, it remains a fine example of a village barn.

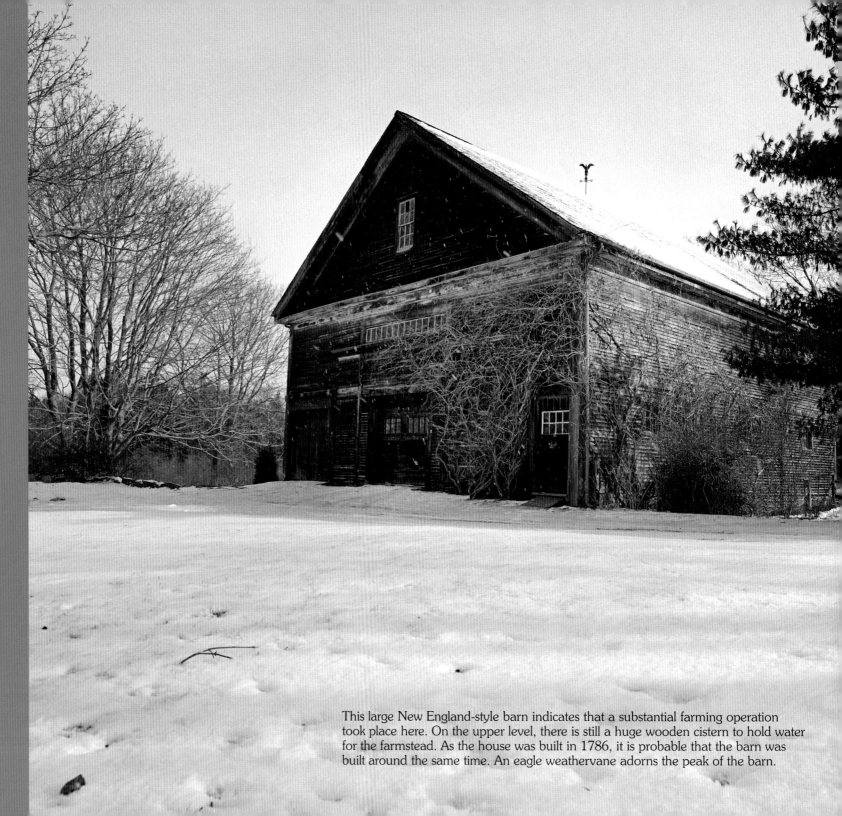

This large New England-style barn indicates that a substantial farming operation took place here. On the upper level, there is still a huge wooden cistern to hold water for the farmstead. As the house was built in 1786, it is probable that the barn was built around the same time. An eagle weathervane adorns the peak of the barn.

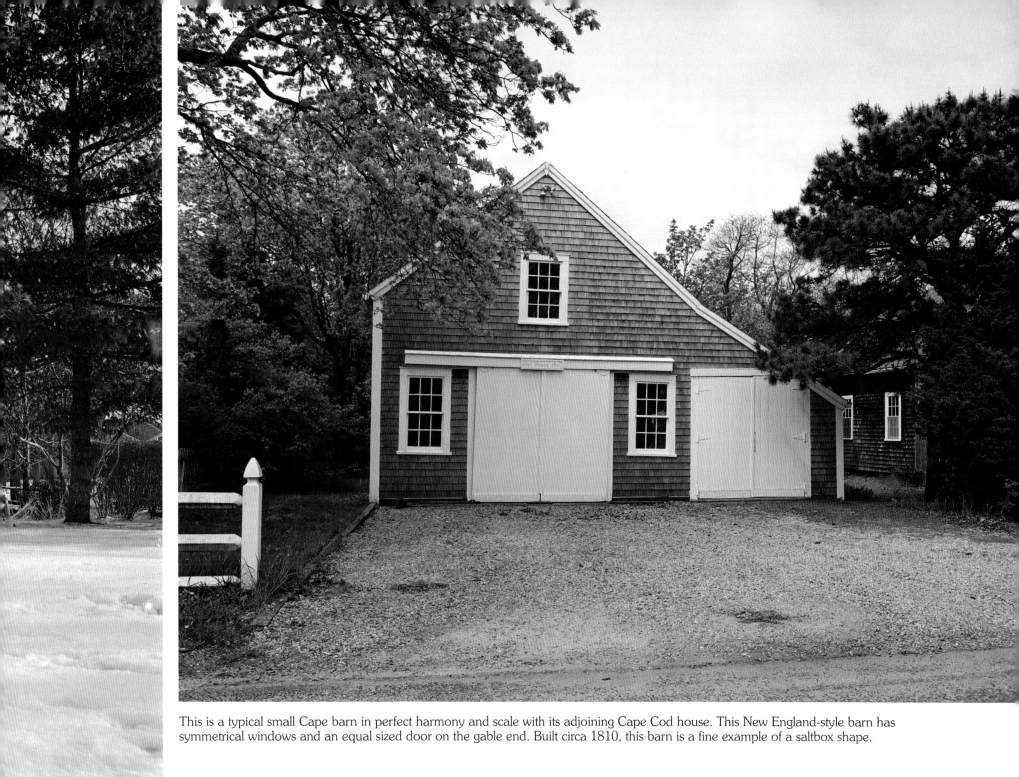

This is a typical small Cape barn in perfect harmony and scale with its adjoining Cape Cod house. This New England-style barn has symmetrical windows and an equal sized door on the gable end. Built circa 1810, this barn is a fine example of a saltbox shape.

YARMOUTH

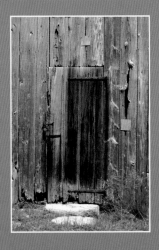

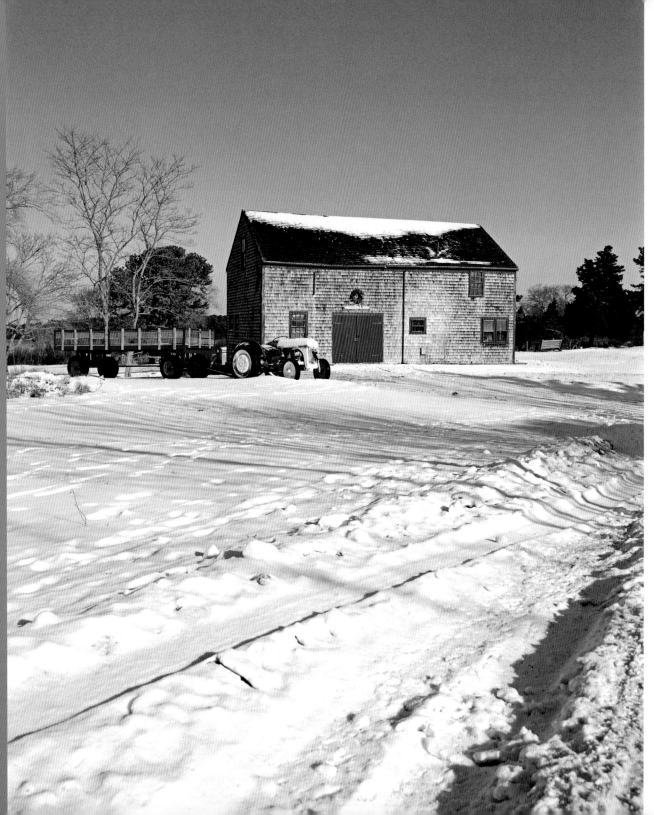

Richard Taylor settled the Taylor-Bray Farm in the 1600s but it is now under town ownership. It has always been a working farm and today hosts a growing sheep herd. The farm and its buildings, including the fine English-style barn, are today used to demonstrate the history of early farm life in Yarmouth to school children and adult groups.

Originally built as a tavern in 1721, this hip-roofed barn has witnessed much Cape Cod history. After the Second World War, it was used as an antique shop. It is now back in use as a barn. The front of the structure is white clapboard, with shingles on the side and rear of the barn.

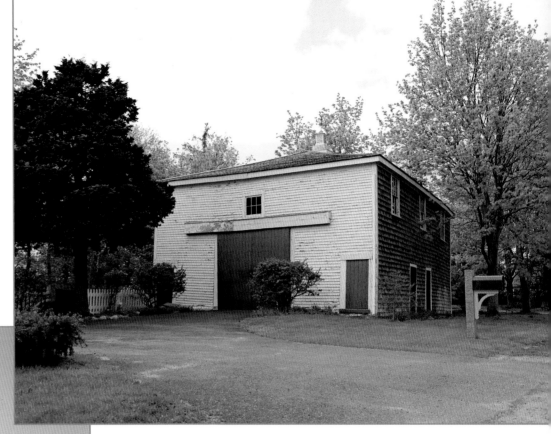

This New England-style barn was originally built around 1795. The lean-to shed was added in 1892. This small barn still has the horse stalls on the main level. The back side of the barn has two doors and several small windows.

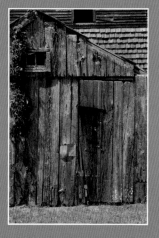

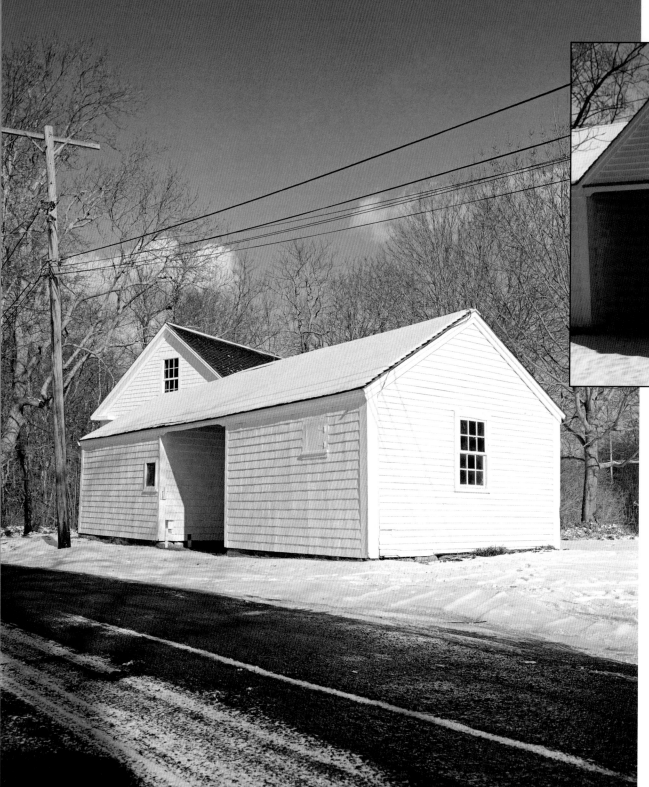

The Colonel John Thatcher House was built in 1664 and is currently owned by the Society for Preservation of New England Antiquities. The farmstead is an unusual one for Cape Cod: set at a right angle to the larger barn is a long one-story carriage house, with an open breeze-way and storage rooms on both sides. This traditional English-style barn has sliding doors at the rear of the building.

Known as Kelly's Barn, this large barn was the meeting place for neighborhood children for years. It is an unusually long building, with many rooms and a hayloft. The barn was built sometime between 1842 and 1864 and still has a three-hole outhouse nearby.

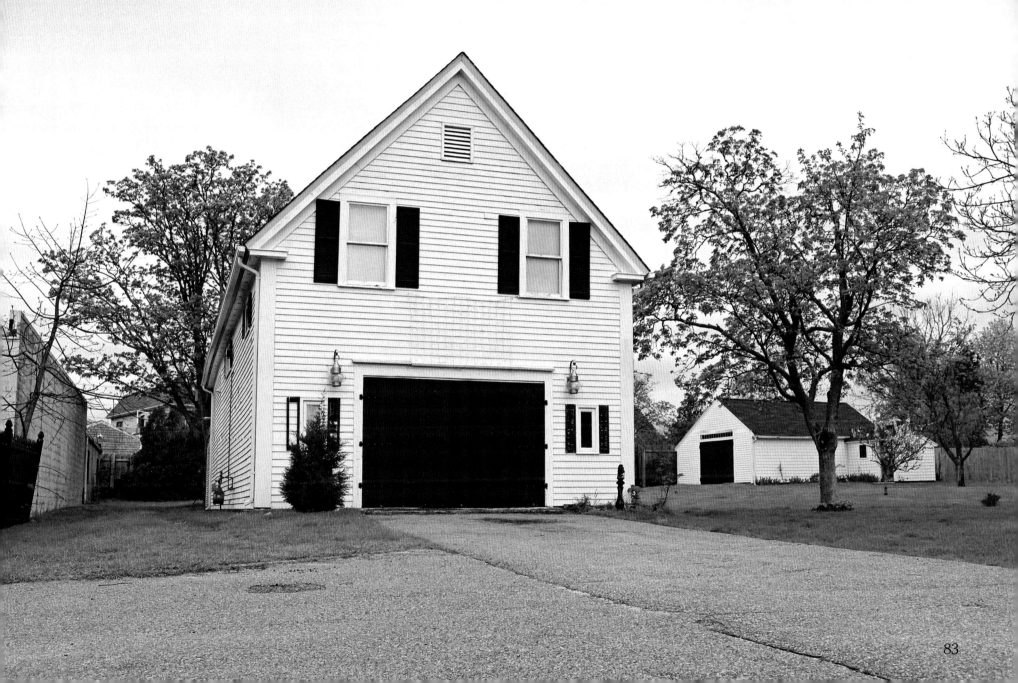

Dennis

There are five towns in Dennis: Dennisport, East Dennis, South Dennis, West Dennis, and Dennis. Dennis is one of the important cultural centers on Cape Cod, including the well-known Cape Playhouse, which has entertained audiences since 1927. It is also the site of the Cape Cod Museum of Art, which features local Cape Cod artists. The Shiverick Shipyard, located in East Dennis, built Clipper ships in the mid-1800s. Many of the handsome houses and barns in Dennis were originally built by ship captains.

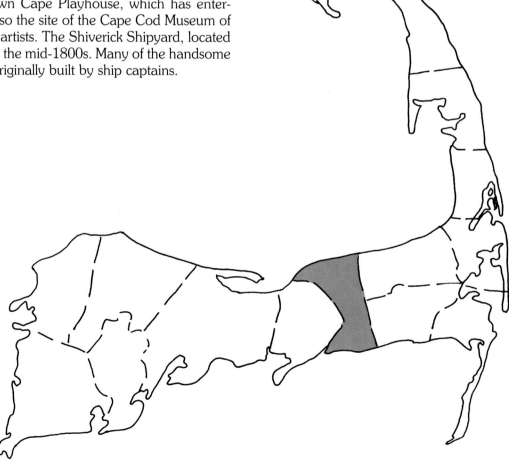

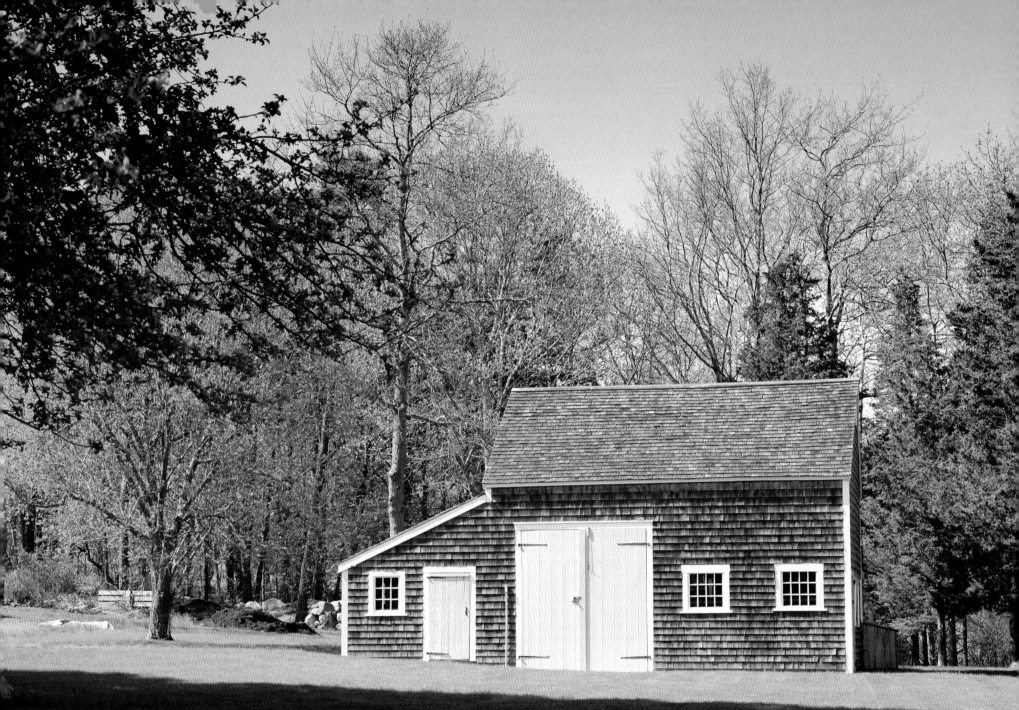

This small barn is thought to be the oldest remaining barn in Dennis. Records state that it was built in 1720, when the house was constructed. It is an English-style barn with a shed attached on one gable end. It sits beside a large marsh, adding to its appeal.

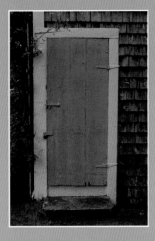

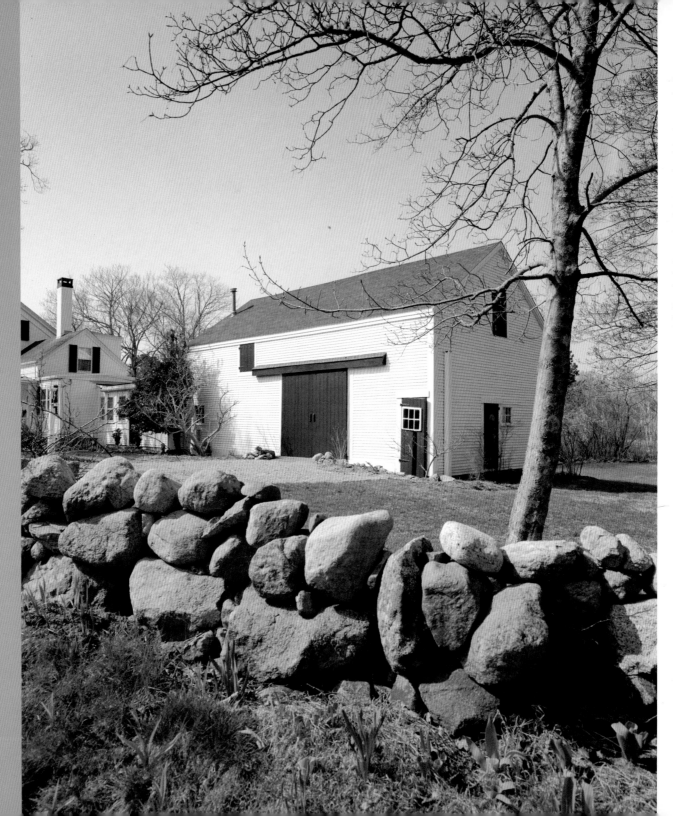

This English-style barn, built in 1880, is an excellent example of an attached house and barn. The passageway connecting the house to the barn is located behind the tree on the left side of the photo. Randomly placed doors add interest to this white clapboard barn. A stone wall surrounds the property.

This typical New England-style barn has an attached lean-to at the back of the barn and stands tall in the field. The yard around the barn has been cut clean, emphasizing its stark architectural outline.

DENNIS

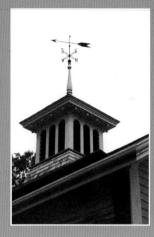

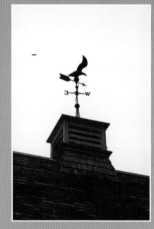

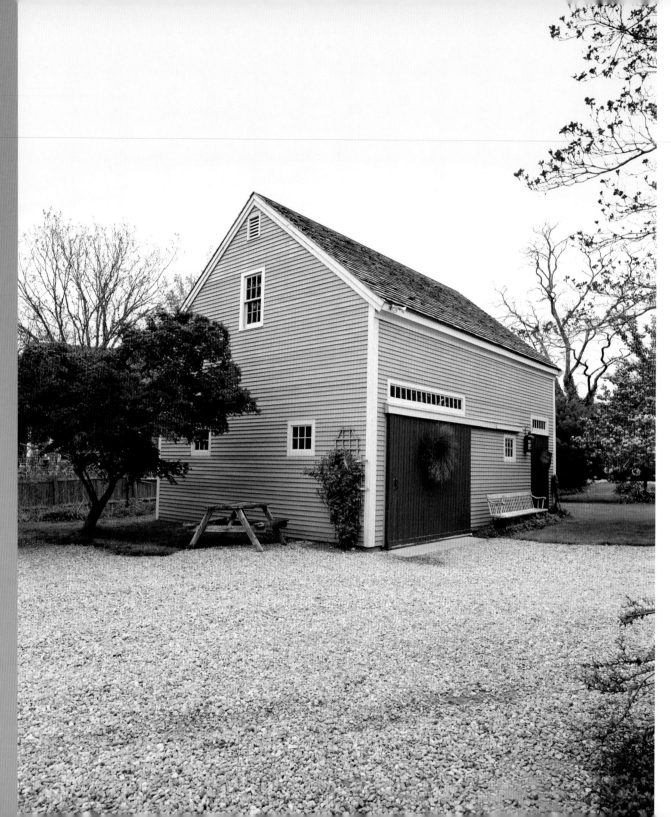

This new English-style barn replaced an earlier barn built on the same site. Constructed in the 1990s, it is situated to take advantage of flowering trees that frame the handsome facade. The sliding barn door opens to reveals a home office.

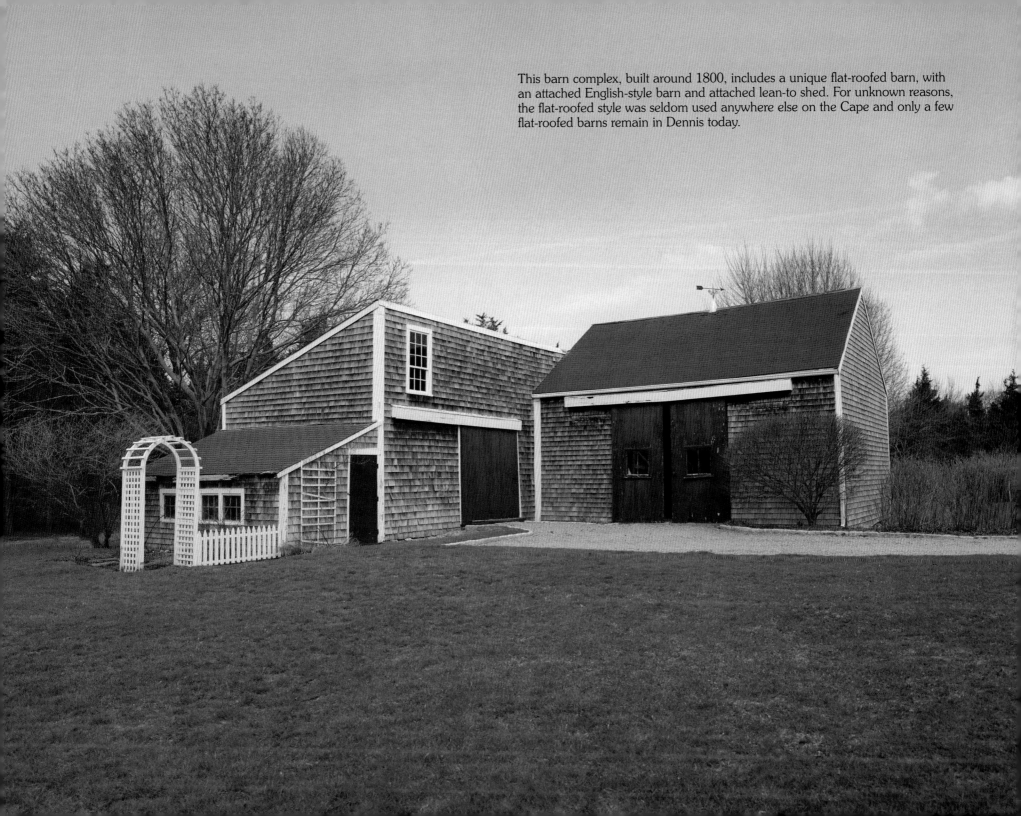

This barn complex, built around 1800, includes a unique flat-roofed barn, with an attached English-style barn and attached lean-to shed. For unknown reasons, the flat-roofed style was seldom used anywhere else on the Cape and only a few flat-roofed barns remain in Dennis today.

DENNIS

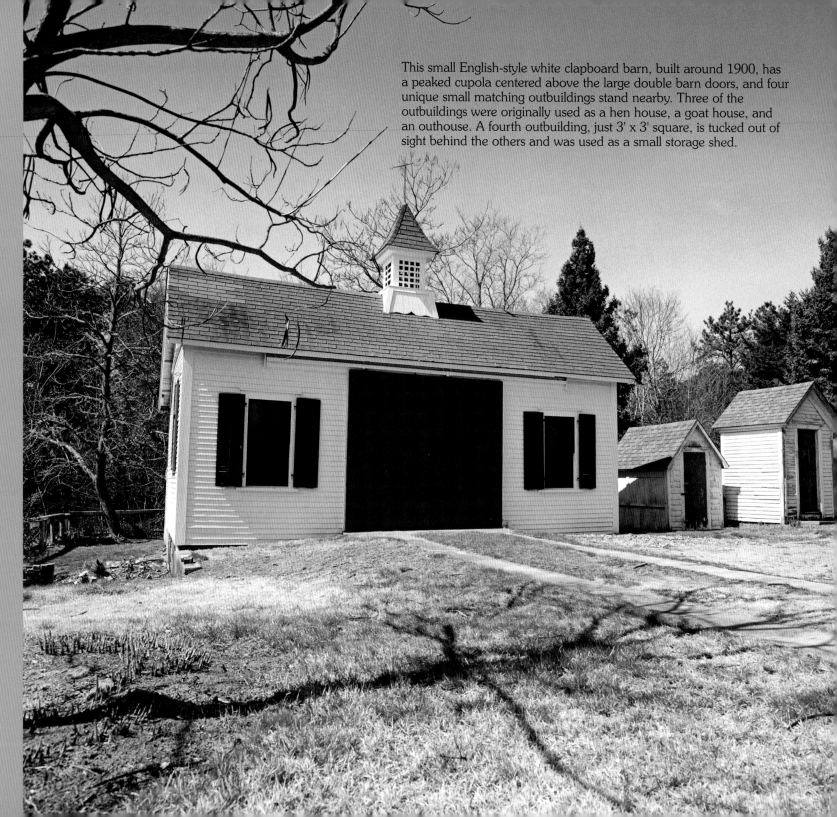

This small English-style white clapboard barn, built around 1900, has a peaked cupola centered above the large double barn doors, and four unique small matching outbuildings stand nearby. Three of the outbuildings were originally used as a hen house, a goat house, and an outhouse. A fourth outbuilding, just 3' x 3' square, is tucked out of sight behind the others and was used as a small storage shed.

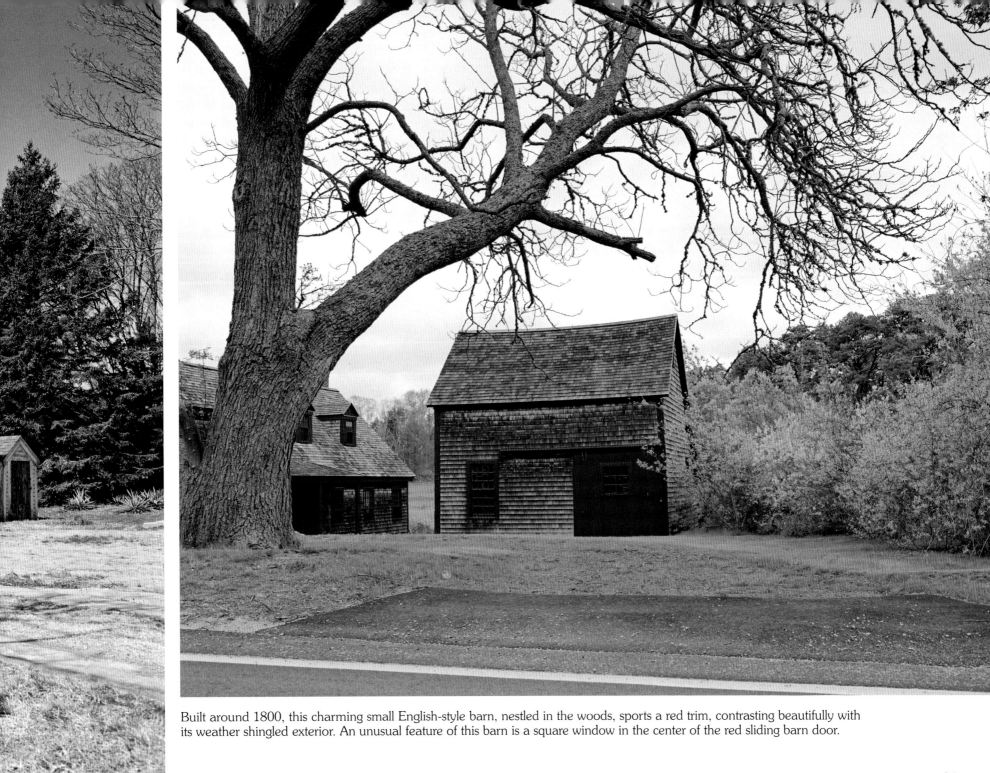

Built around 1800, this charming small English-style barn, nestled in the woods, sports a red trim, contrasting beautifully with its weather shingled exterior. An unusual feature of this barn is a square window in the center of the red sliding barn door.

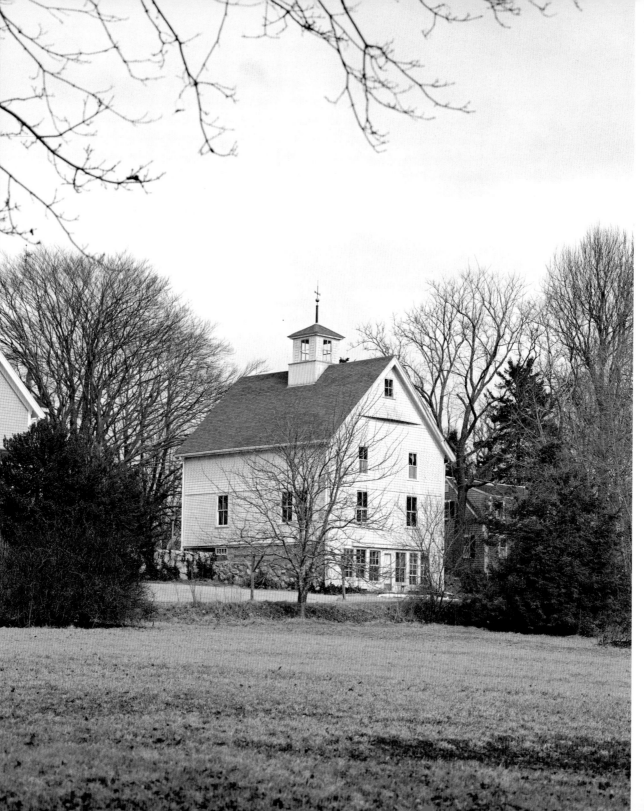

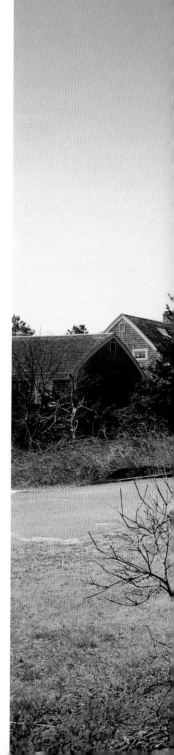

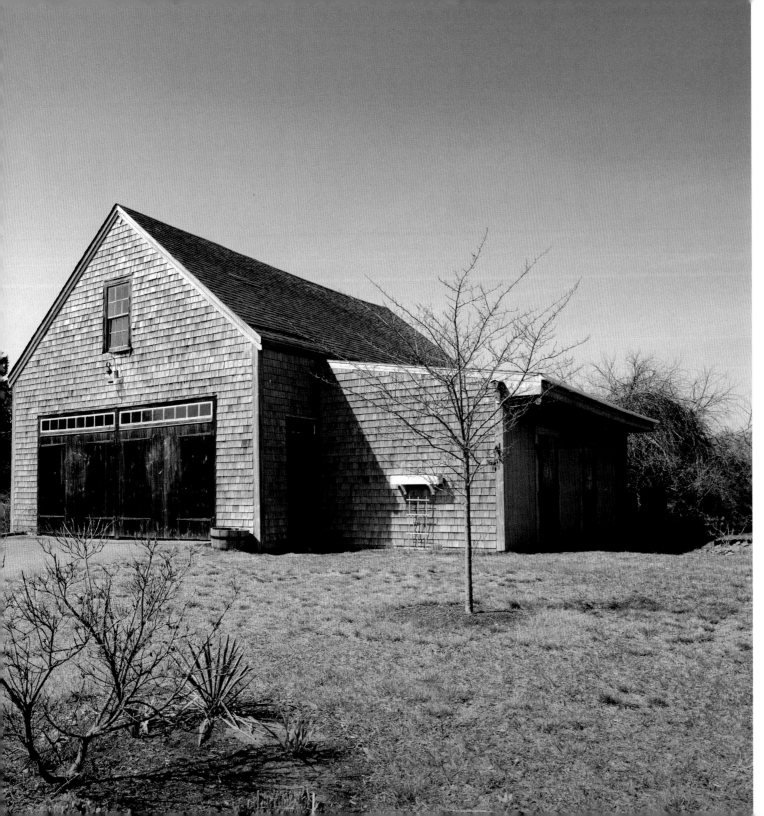

Opposite page:
This imposing Victorian barn belonged to Captain Hedge, who was master of the "Webfoot", a ship of 1,100 tons, built at the Shiverick Shipyards nearby. In 1860, the "Webfoot" made a record sea voyage from Calcutta to New York in just eighty-five days. This is a four-story barn with a cupola and gable-end entrance. The foundation is cut-stone.

Left:
This barn and house were built in the late 1700s. At one time this property was an asparagus farm and the barn was later used as a post office. Still an active farm, this attractive New England style barn boasts a large lean-to potting shed.

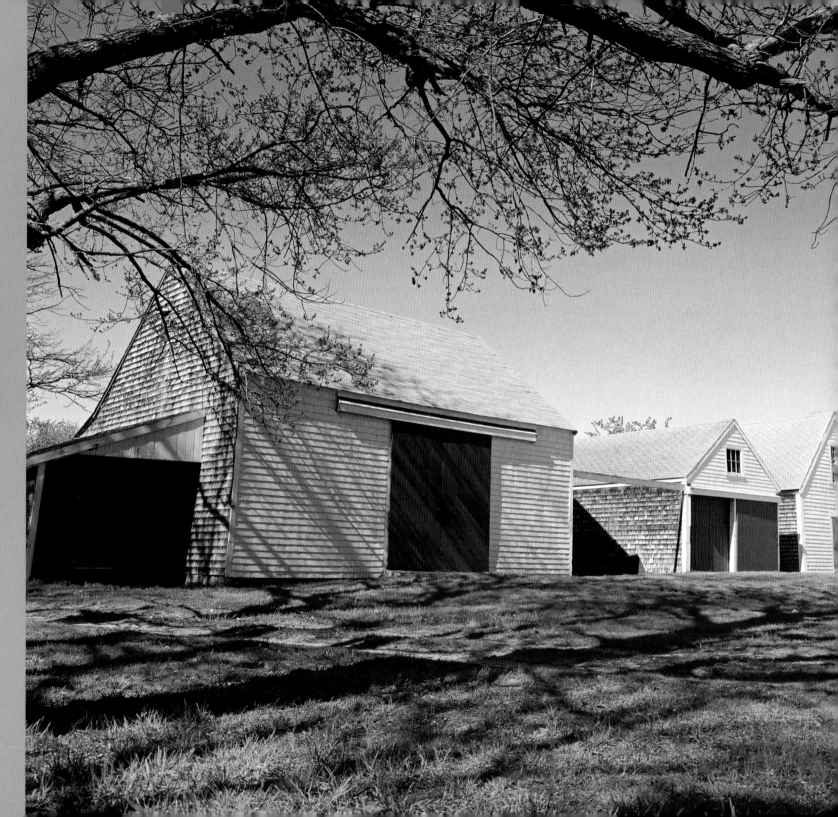

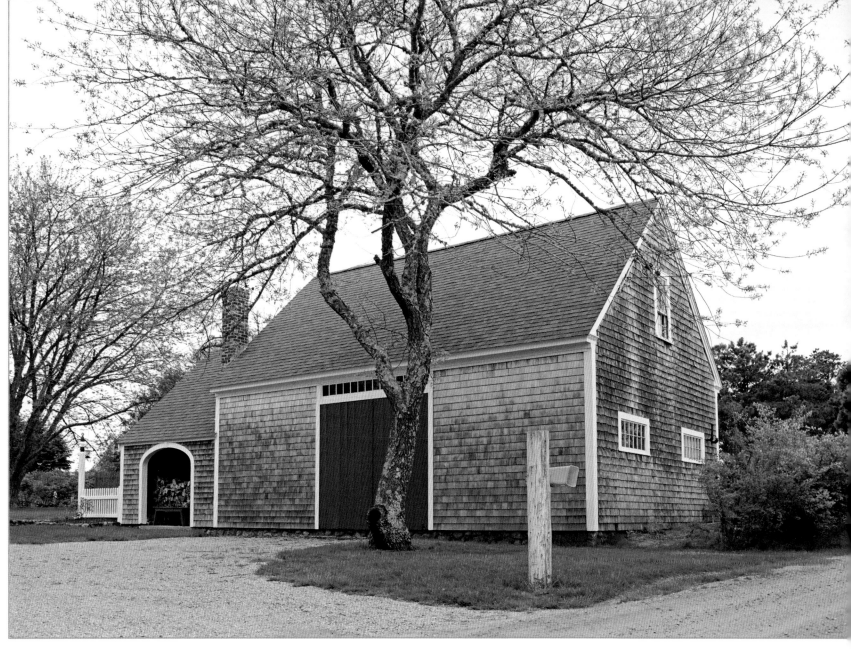

Built around 1801, this small English-style barn features an attached open-style woodshed, framed by a wooden arch. A transom is located over the main barn door and other windows are set in the gable end. The barn was part of an active farm in the 1800s.

Opposite page:
These four barns and house were built around 1812. This property is unique because it has four barns instead of just one. The largest barn has a long-side sliding door, indicating a typical English-style barn, while the three smaller New England-style barns have gable-end entries: one with large doors and the other two with pedestrian entry doors. The four barns have painted clapboard on the side facing the street, while the other three sides are unpainted shingles.

95

DENNIS

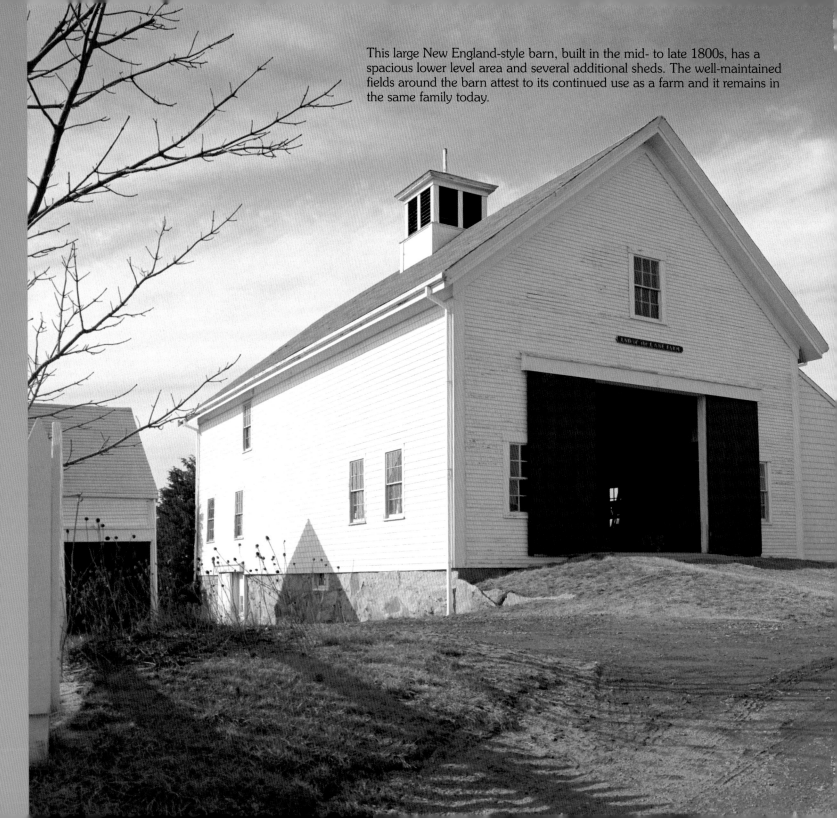

This large New England-style barn, built in the mid- to late 1800s, has a spacious lower level area and several additional sheds. The well-maintained fields around the barn attest to its continued use as a farm and it remains in the same family today.

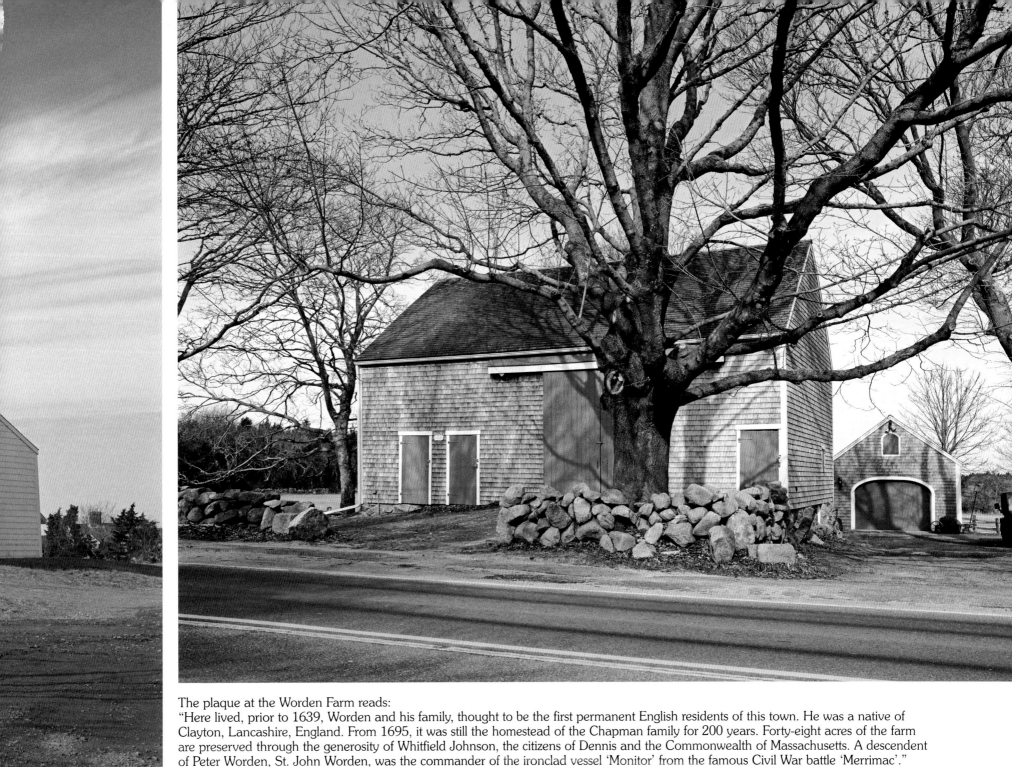

The plaque at the Worden Farm reads:
"Here lived, prior to 1639, Worden and his family, thought to be the first permanent English residents of this town. He was a native of Clayton, Lancashire, England. From 1695, it was still the homestead of the Chapman family for 200 years. Forty-eight acres of the farm are preserved through the generosity of Whitfield Johnson, the citizens of Dennis and the Commonwealth of Massachusetts. A descendent of Peter Worden, St. John Worden, was the commander of the ironclad vessel 'Monitor' from the famous Civil War battle 'Merrimac'."

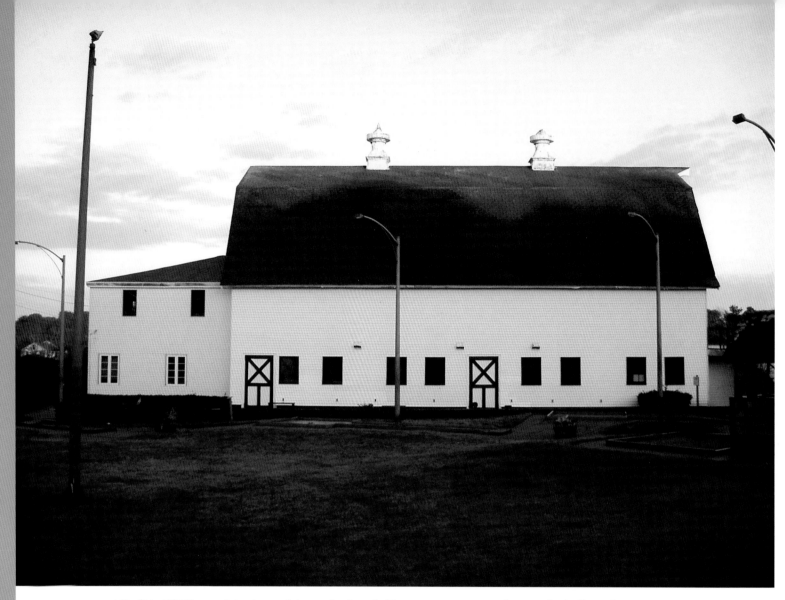

Built in 1917 as a dairy barn, this gambrel-roofed barn was constructed using the balloon frame construction method, rather than the post and beam method. After its usefulness as a dairy barn ended, it became a for-profit recreation center called the "Barn of Fun." Although there were efforts to save the barn and convert it for some practical use, this Cape Cod landmark was razed in 2005.

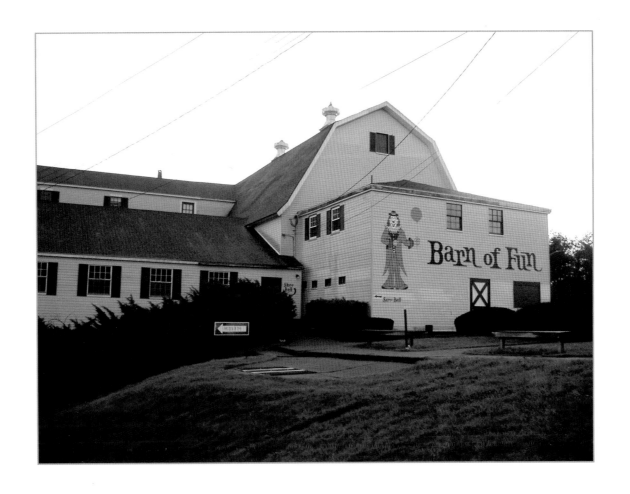

Harwich

Harwich is comprised of Harwich Center, East Harwich, West Harwich, South Harwich, Harwich Port, and Pleasant Lake. It borders the shores of Nantucket Sound and has many sand beaches as well as inland ponds.

The first cranberry cultivation began in Harwich in 1846 and continues today. Harwich Center has a Cranberry Festival every fall. There are many equestrian barns and trails in both Harwich and Brewster, making the area a large horseback-riding center on the Cape.

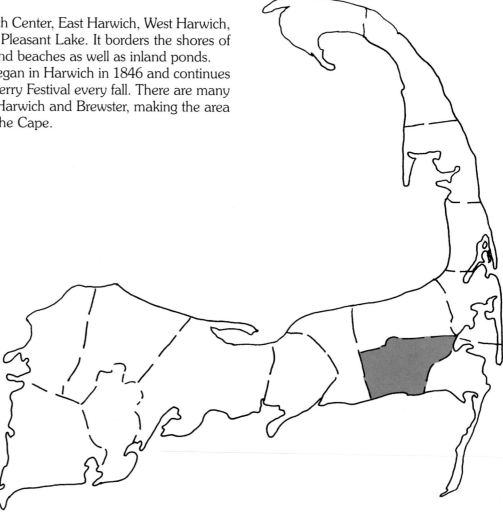

This is one of three remaining turn-of-the-century Harwich barns painted with distinctive striped barn doors. This barn also has striped shutters on the gable end. No one seems to know the name of the original painter, although it is assumed that he was a Harwich native.

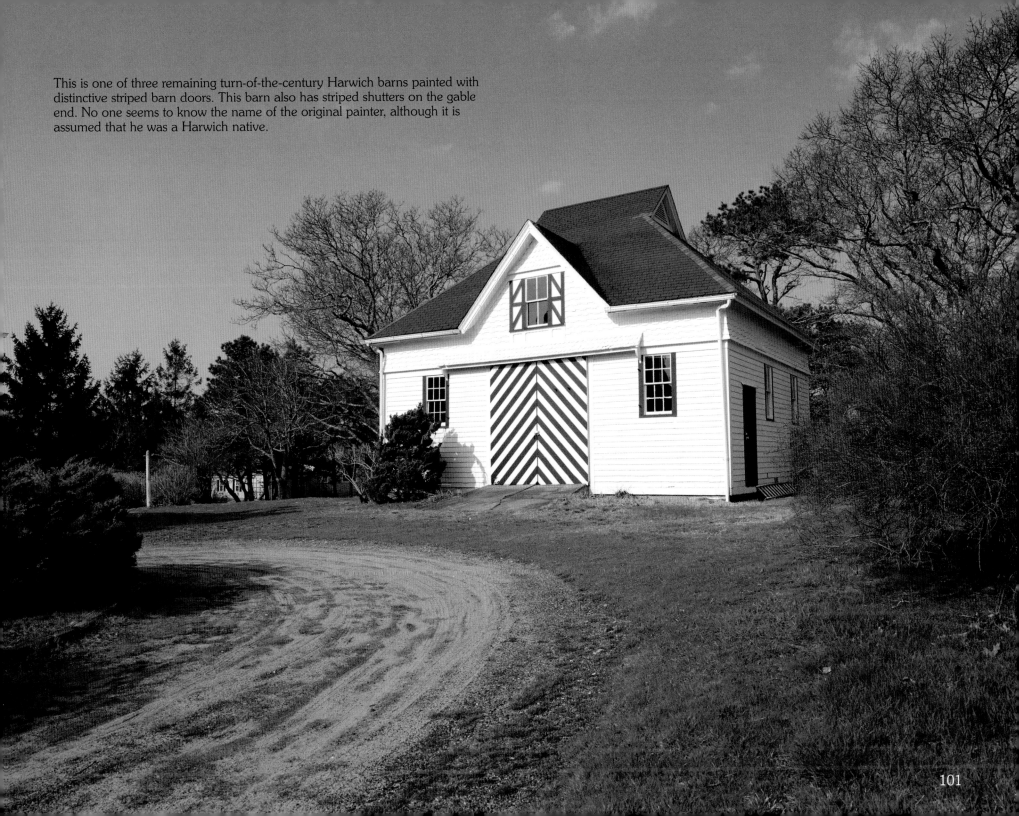

HARWICH

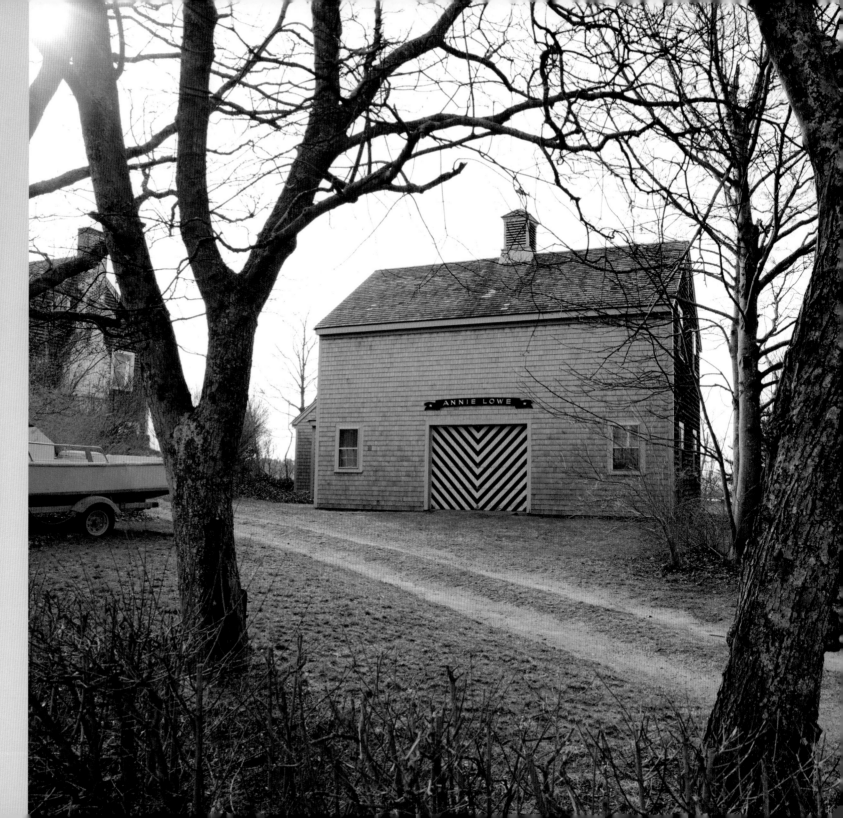

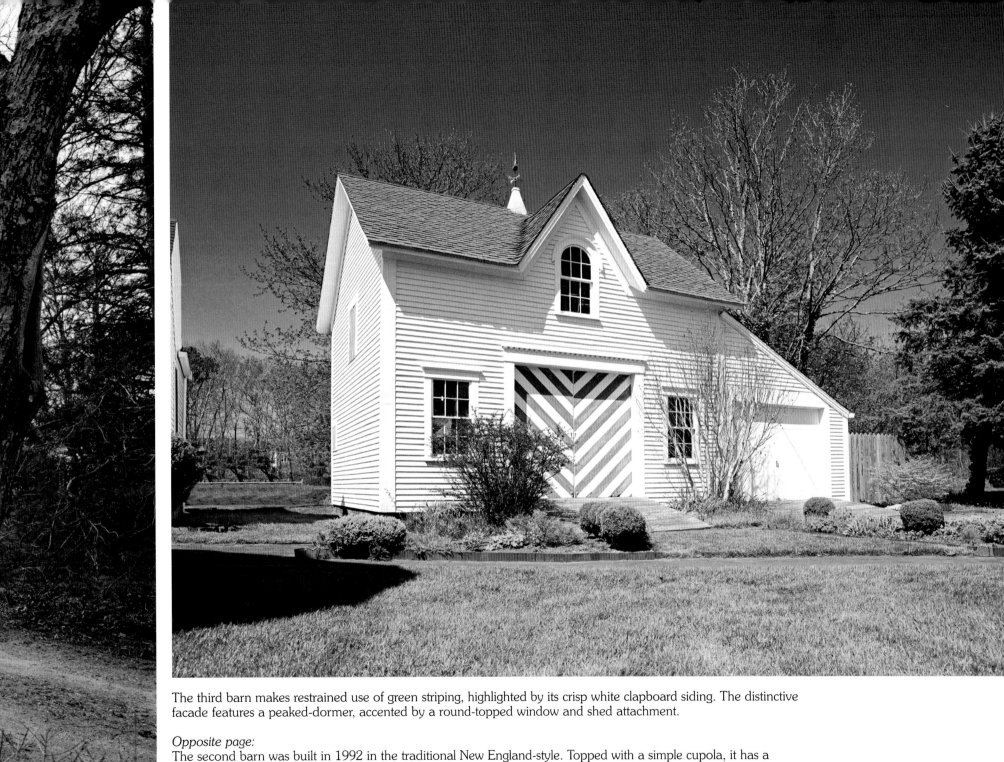

The third barn makes restrained use of green striping, highlighted by its crisp white clapboard siding. The distinctive facade features a peaked-dormer, accented by a round-topped window and shed attachment.

Opposite page:
The second barn was built in 1992 in the traditional New England-style. Topped with a simple cupola, it has a quarterboard over the striped barn doors and two small symmetrical windows on its long side.

HARWICH

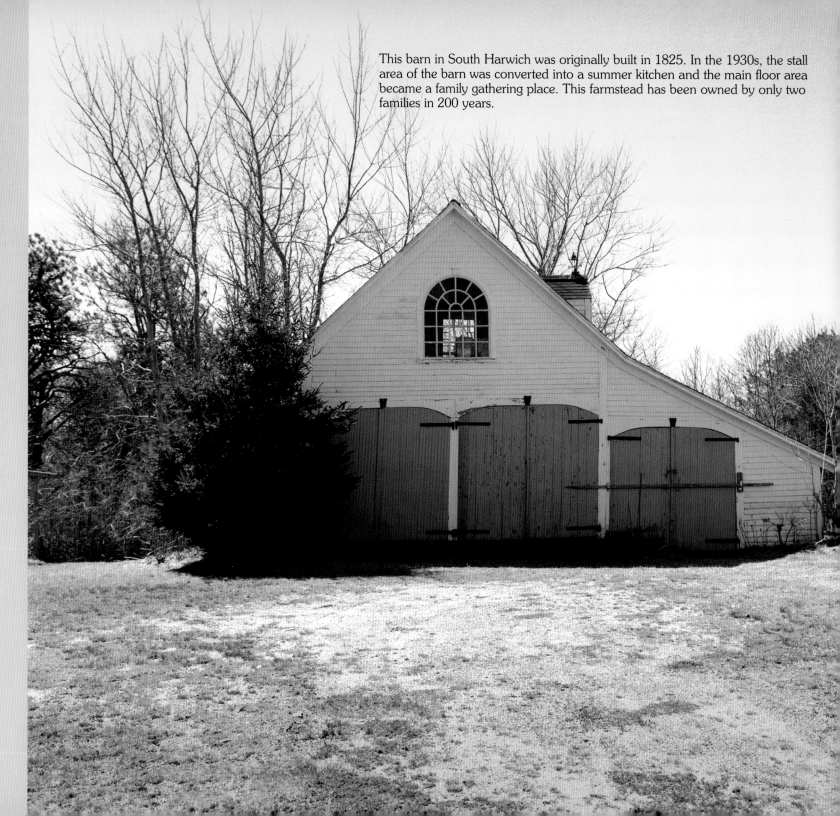

This barn in South Harwich was originally built in 1825. In the 1930s, the stall area of the barn was converted into a summer kitchen and the main floor area became a family gathering place. This farmstead has been owned by only two families in 200 years.

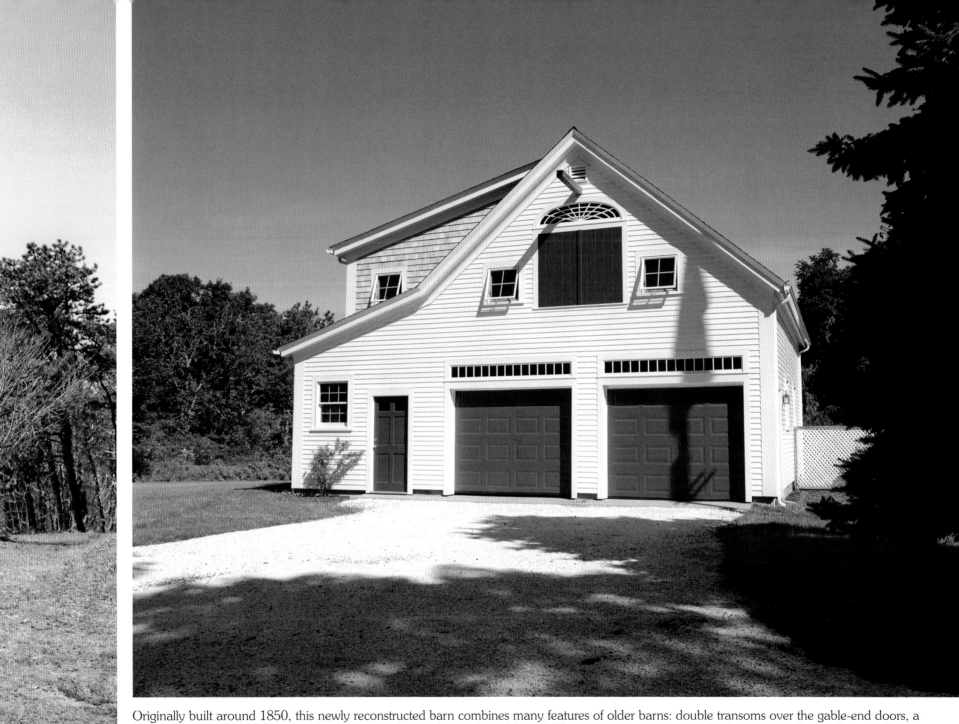

Originally built around 1850, this newly reconstructed barn combines many features of older barns: double transoms over the gable-end doors, a hay door on the second level, and a decorative fan window in the gable end. The interior is very spacious both upstairs and over the main level.

HARWICH

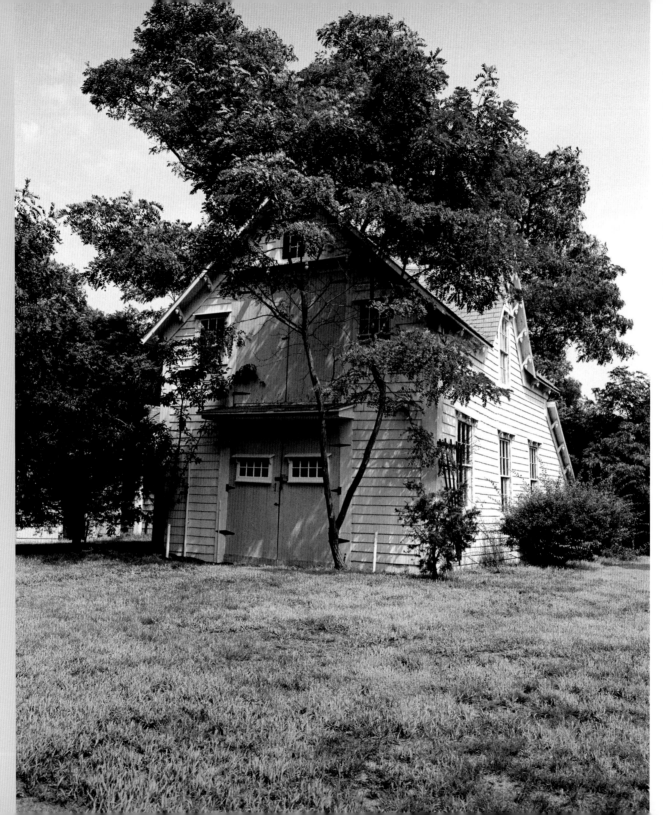

Built around 1854, this barn housed a wagon business with a painting and assembly shop on the second level. Wagon parts were hauled up through the oversized barn doors on the second level, where the parts were painted and assembled, not unlike a Detroit assembly line.

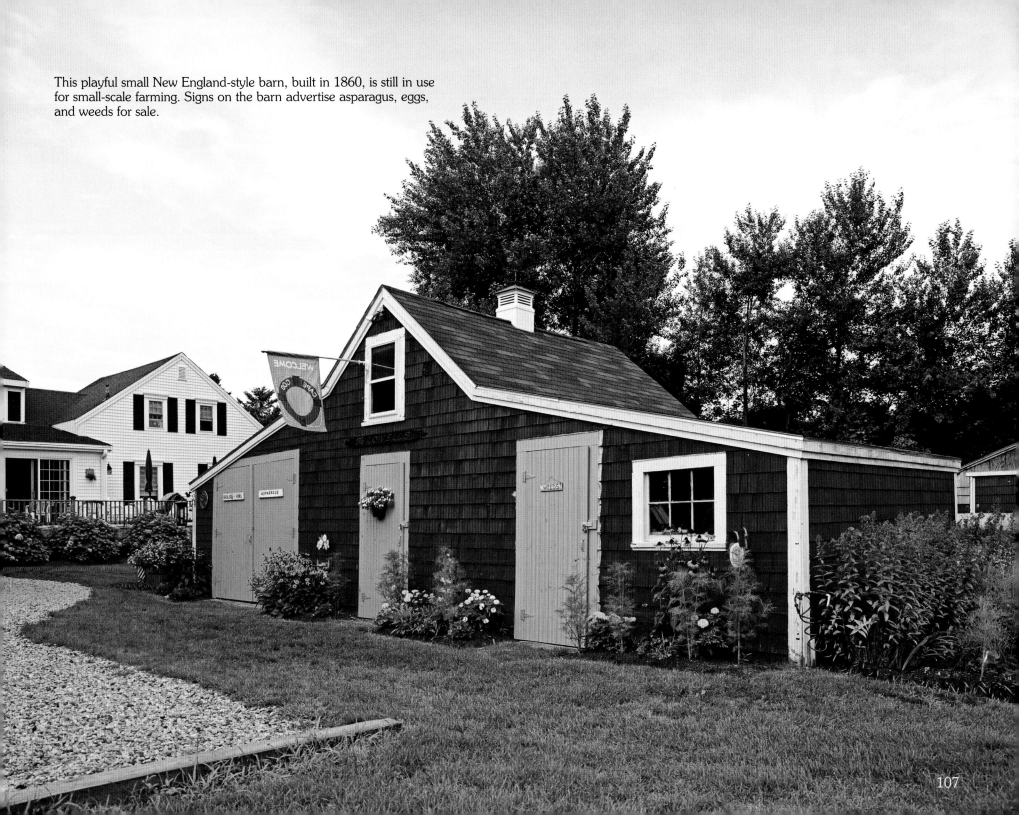

This playful small New England-style barn, built in 1860, is still in use for small-scale farming. Signs on the barn advertise asparagus, eggs, and weeds for sale.

BREWSTER

Brewster

Brewster has a coastline on Cape Cod Bay and contains many small ponds and streams. The early settlers took advantages of the streams to start businesses such as the first gristmill on Cape Cod. Because Brewster has no deep-water harbor, shallow-draft packet boats were popular here in the early 1800s, carrying people, produce, and freight up and down the New England coast. Brewster is often called "the Sea Captain's Town" because so many Clipper ship captains resided here. Many of their large homes and barns are used today as inns or bed and breakfast lodgings.

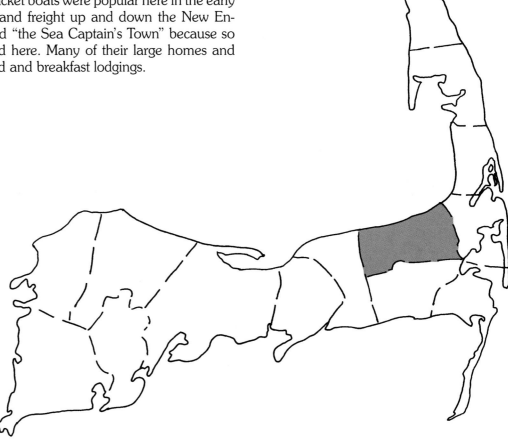

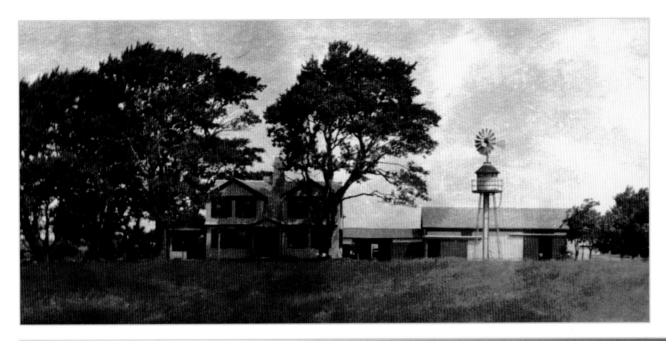

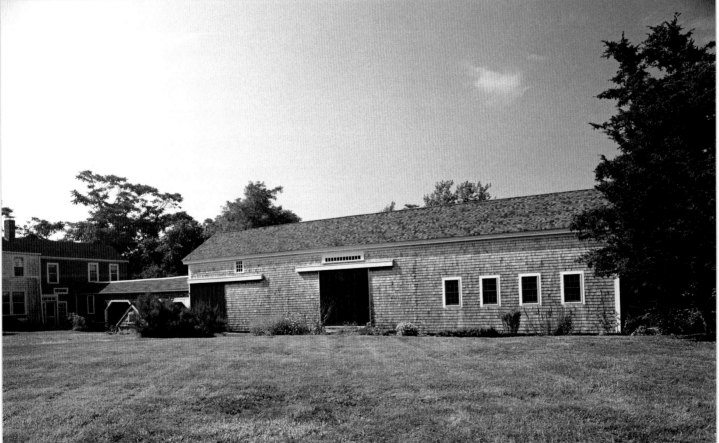

This large 20' by 80' attached barn was originally built as a dairy barn around 1800 and is unusually large for a Cape Cod barn. An attached carriage house on the left is used today to store firewood. The interior of the barn has four horse stalls, a granary, and at one time had a rare inside privy. Although the barn exterior remains the same, the interior has been remodeled as a guesthouse. The old photograph shows the barn around the turn of the twentieth century.

BREWSTER

This trim English-style barn was built around 1870 and was used for storing shell-fishing gear. The property is still owned by a fisherman today.

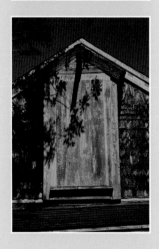

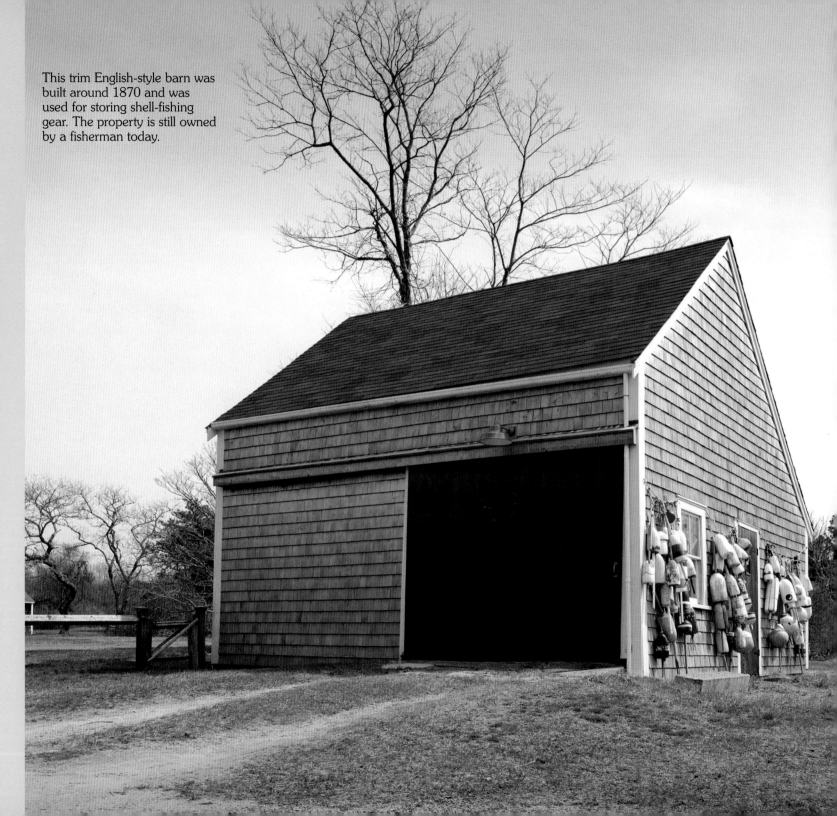

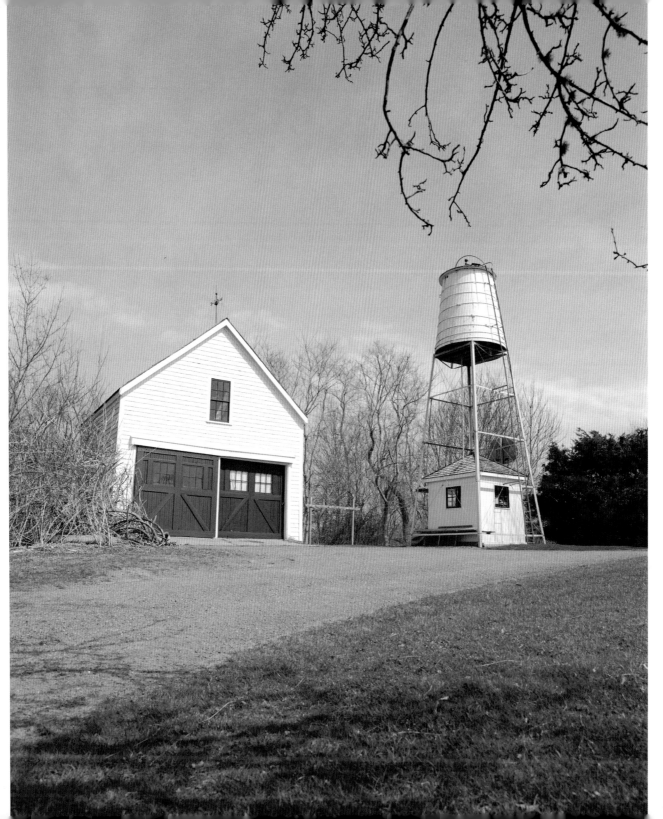

A remarkably intact thirty-five-foot tall water tower stands beside this small New England-style barn. The water tower was the sole source of water for this farm until the 1970s, when town water first became available. The owner says this well water "was the best water in the world." Built in 1799, this barn features two gable-end barn doors with a small loft up above.

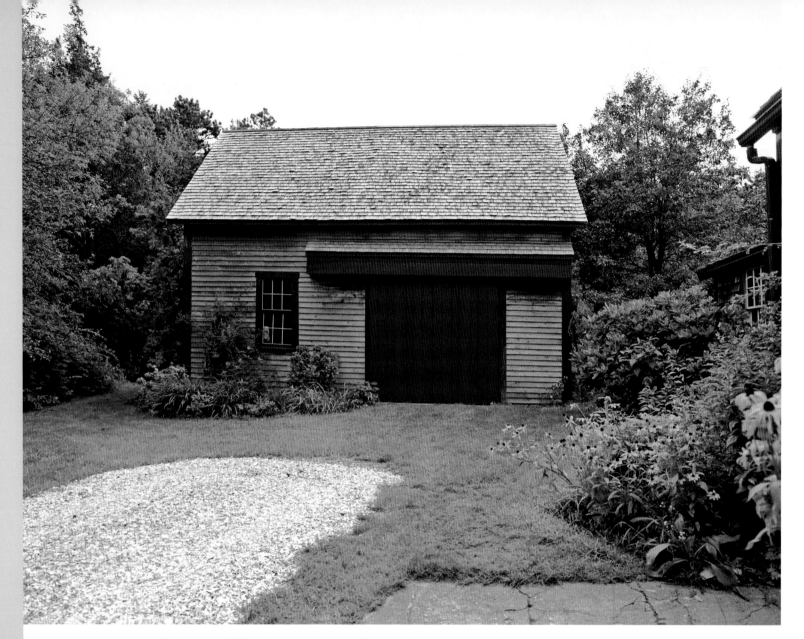

Built in the 1700s, this charming small barn reflects the scale of the house. The pent roof covers the sliding doors. This barn has remained unchanged for the past 100 years.

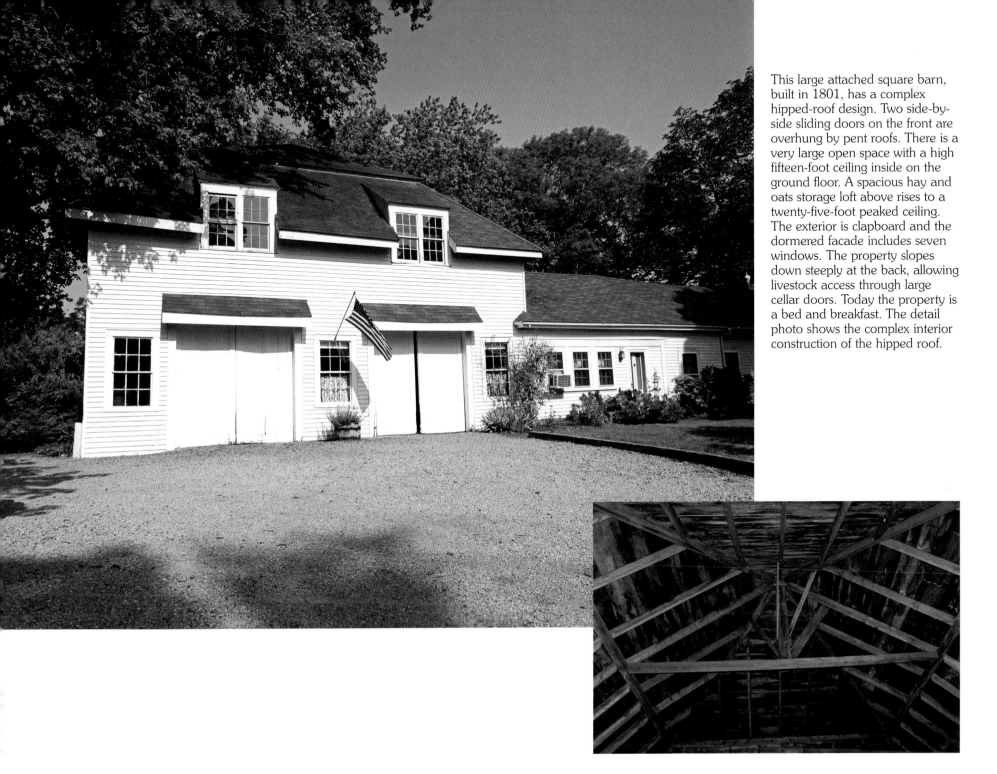

This large attached square barn, built in 1801, has a complex hipped-roof design. Two side-by-side sliding doors on the front are overhung by pent roofs. There is a very large open space with a high fifteen-foot ceiling inside on the ground floor. A spacious hay and oats storage loft above rises to a twenty-five-foot peaked ceiling. The exterior is clapboard and the dormered facade includes seven windows. The property slopes down steeply at the back, allowing livestock access through large cellar doors. Today the property is a bed and breakfast. The detail photo shows the complex interior construction of the hipped roof.

BREWSTER

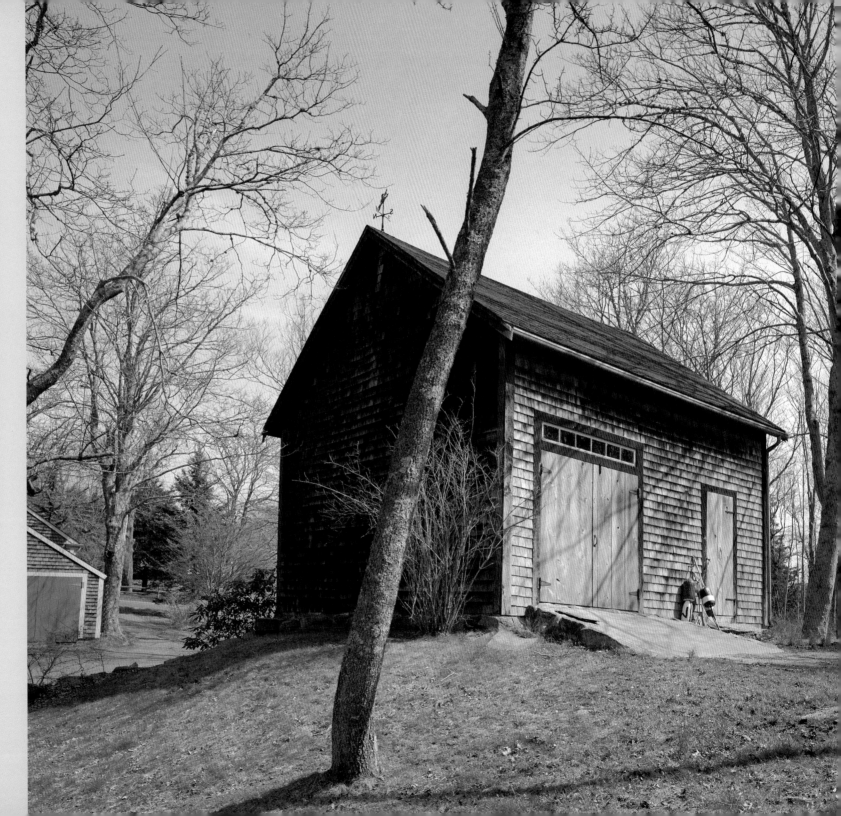

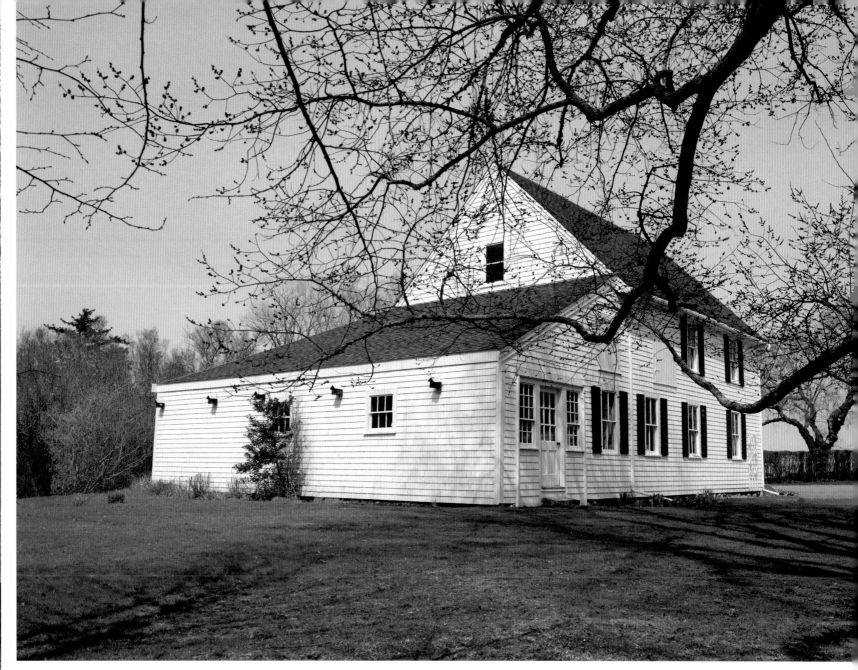

Built in 1830 by wealthy owners, this barn has been scrupulously maintained to this day. This substantial building houses a big addition for horse carriages and livestock. Unlike most other Cape barns, this barn was originally built with living quarters on the second and third floors.

Opposite page:
Brewster is one of the hilliest towns on Cape Cod. This 1820s three-level barn was built on one of these steep hills. It is in perfect proportion to the Cape Cod three-quarter house nearby. A shell fisherman may have originally built the barn and today it is still used by a lobsterman.

BREWSTER

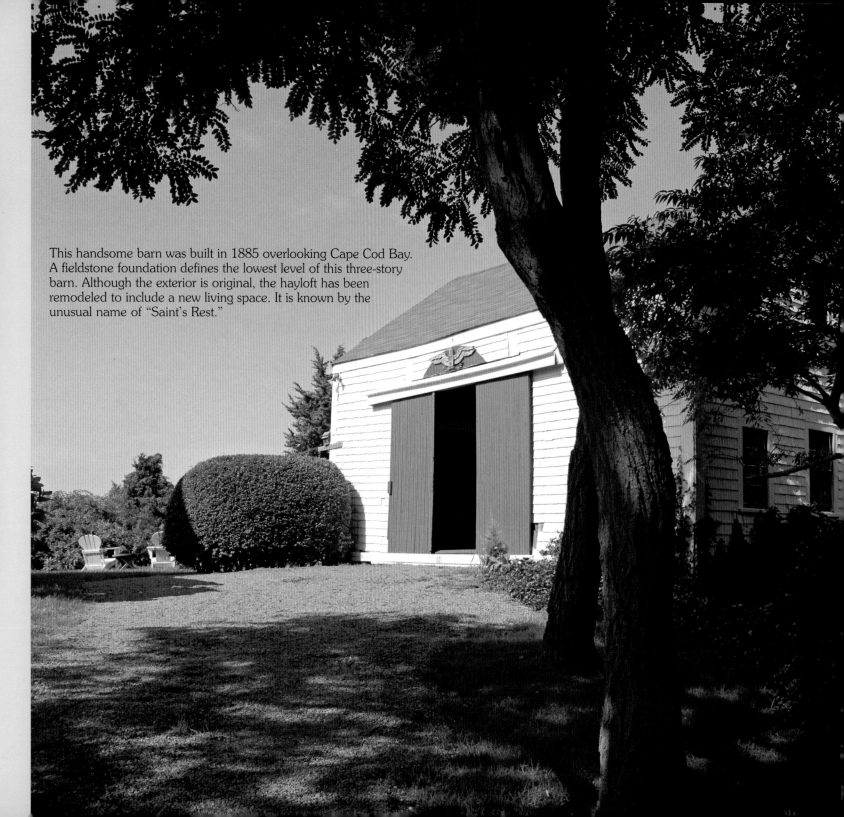

This handsome barn was built in 1885 overlooking Cape Cod Bay. A fieldstone foundation defines the lowest level of this three-story barn. Although the exterior is original, the hayloft has been remodeled to include a new living space. It is known by the unusual name of "Saint's Rest."

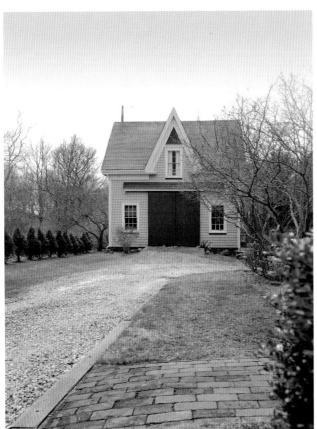

This quaint Victorian barn is an excellent example of the style of small English barns built around 1900. The pent roof over the main door also functions as the hood for the door's roller.

This charming New England-style barn, constructed in 1909, features an unusual rail extension to support the attached shed's sliding door. Built on a fieldstone foundation, this clapboard barn enhances Brewster's historic district.

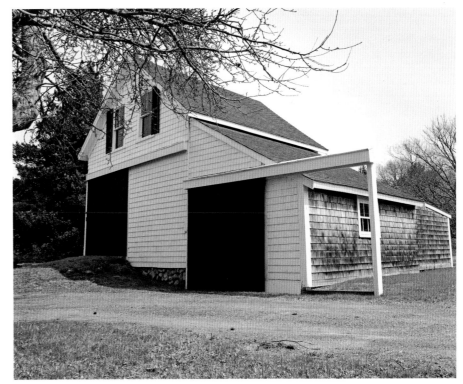

Chatham

Settled in 1656 and incorporated in 1712, Chatham is comprised of Chatham, North Chatham, South Chatham, and West Chatham. With over sixty miles of shorelines on the Nantucket Sound and the Atlantic Ocean, Chatham is a Mecca for sport and commercial fishing. The Friday night band concerts in Chatham are legendary, as well as the "Outlook" overlooking the Outer Beach "Break." Chatham also has a functioning Coast Guard station and working lighthouse with a bright beam that can be seen thirty miles at sea.

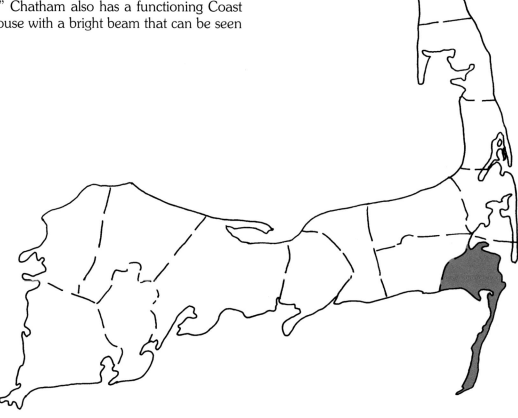

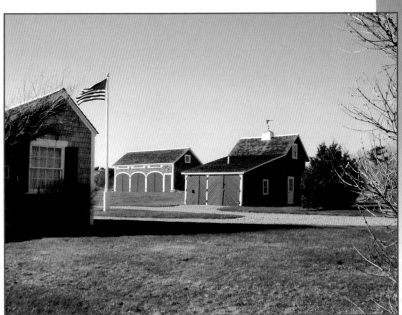

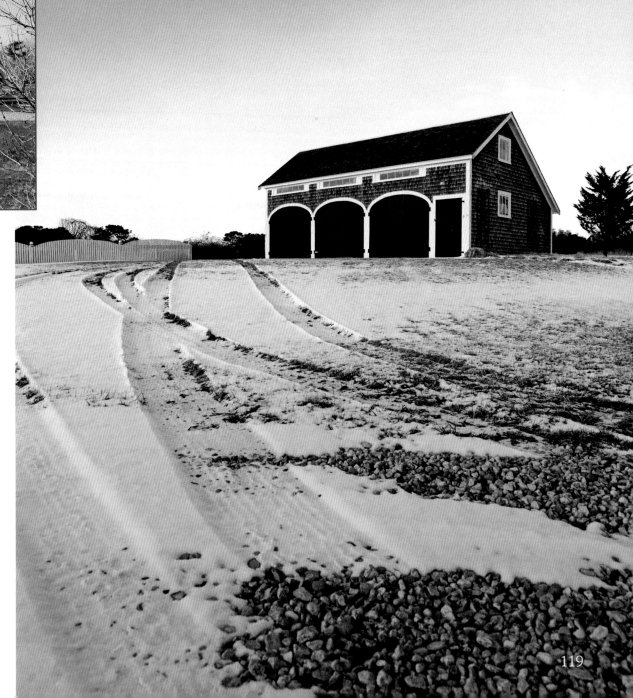

This large three-bay barn near a harbor was originally used to house carriages and now stores boats in the off-season. The carriage house was built ten years after the 1830s smaller structure in the foreground. Its big doors are uniquely located on the end of the lean-to extension. A goose weathervane tops the smaller barn.

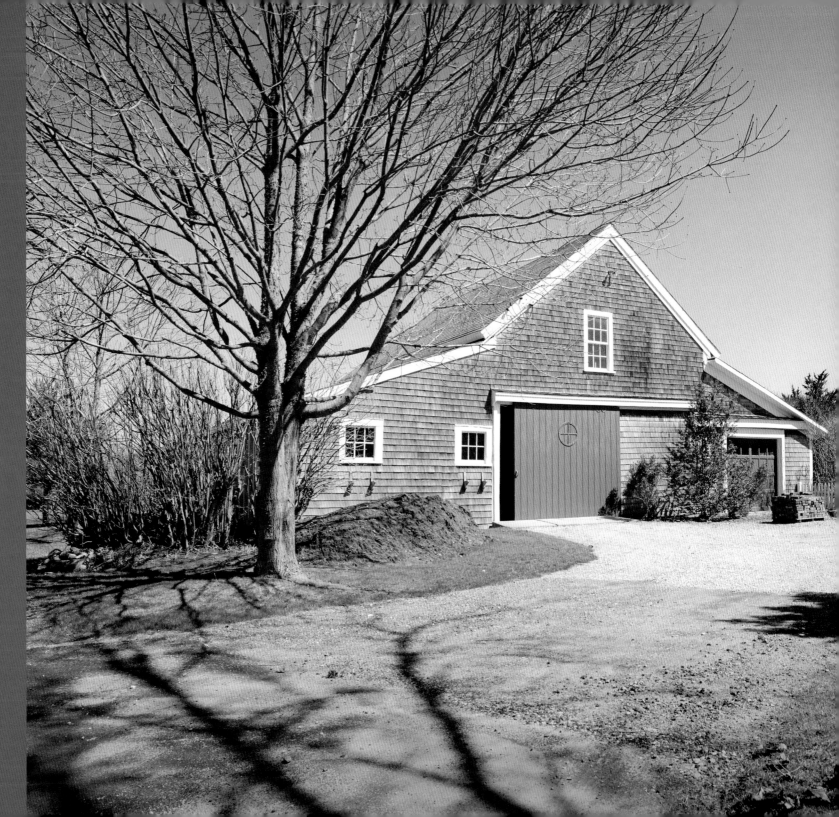

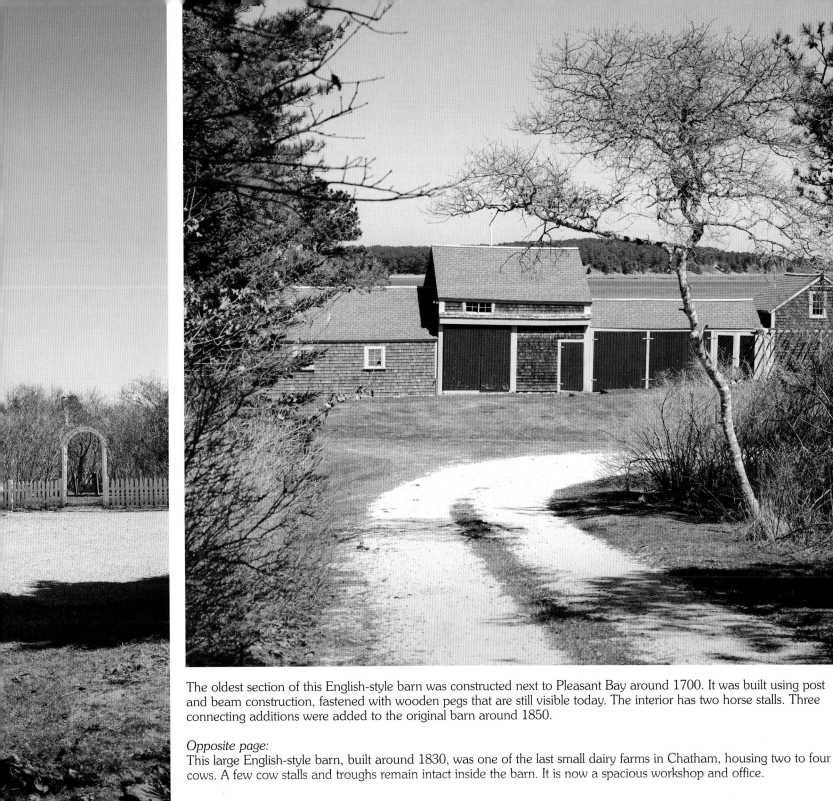

The oldest section of this English-style barn was constructed next to Pleasant Bay around 1700. It was built using post and beam construction, fastened with wooden pegs that are still visible today. The interior has two horse stalls. Three connecting additions were added to the original barn around 1850.

Opposite page:
This large English-style barn, built around 1830, was one of the last small dairy farms in Chatham, housing two to four cows. A few cow stalls and troughs remain intact inside the barn. It is now a spacious workshop and office.

CHATHAM

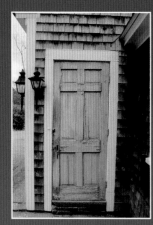

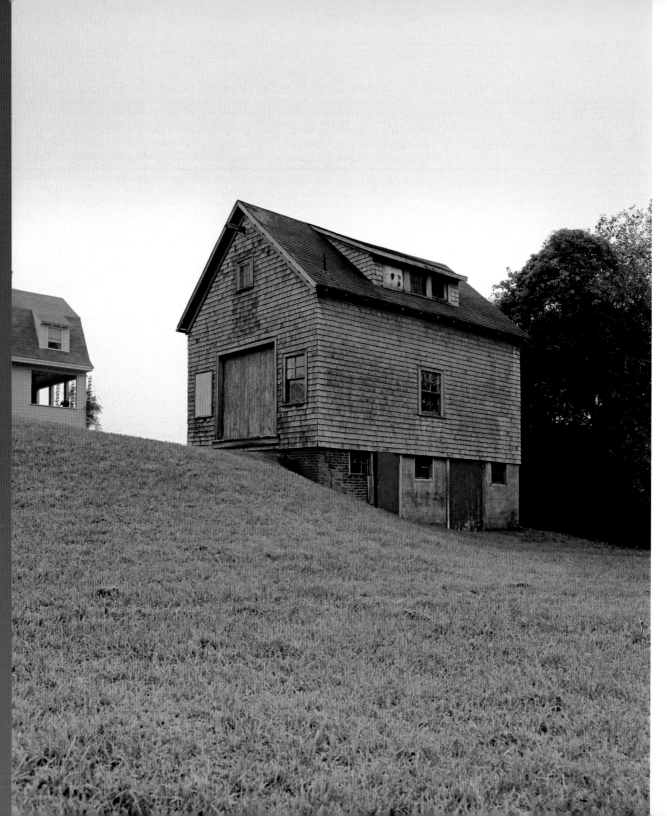

This small New England-style barn, facing the ocean, was built around 1900 and is now used to store boats in the off-season. It has two large barn doors, one on the long side and one on the gable end. Built on a steep slope, the lower level foundation is red brick, typical for a barn of this era.

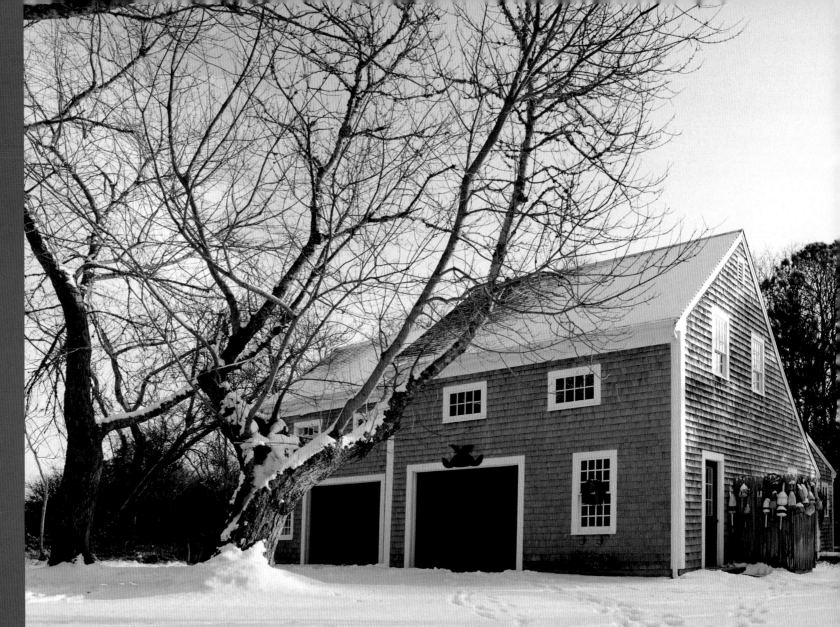

This English-style barn was originally built by Captain Timothy Stearns in 1846. Constructed as two attached buildings, it has six symmetrical windows on the long side and an unusual sliding hay door on the second level of the gable end. Until a few years ago, there was an attached three-hole privy on the back of the barn.

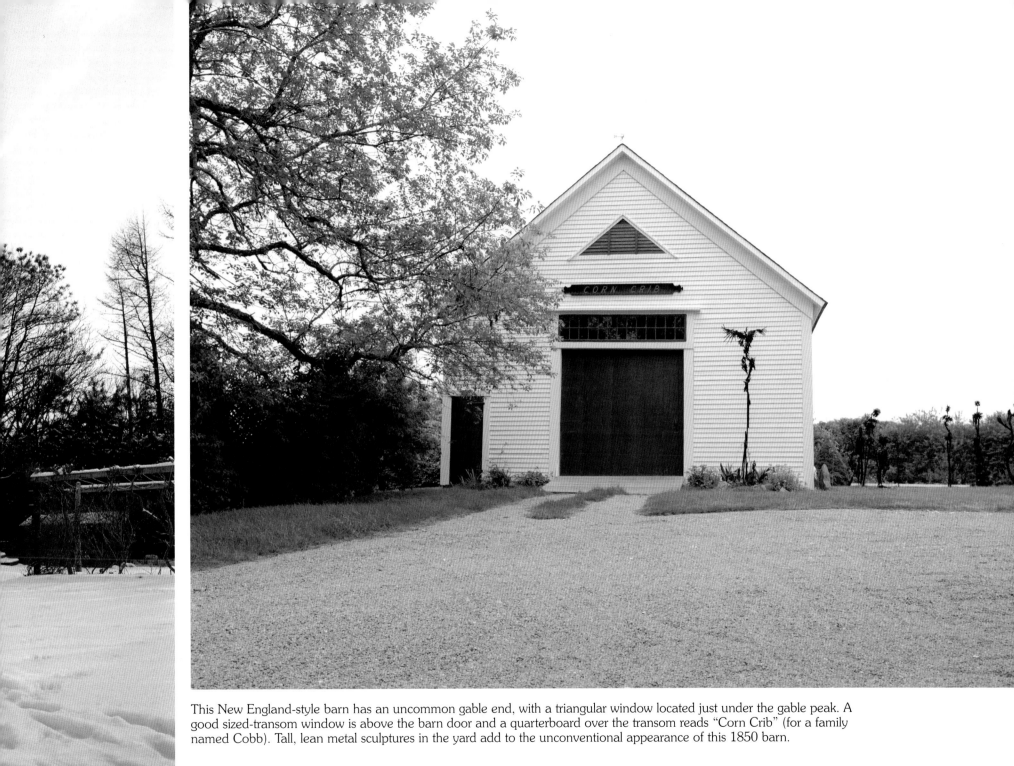

This New England-style barn has an uncommon gable end, with a triangular window located just under the gable peak. A good sized-transom window is above the barn door and a quarterboard over the transom reads "Corn Crib" (for a family named Cobb). Tall, lean metal sculptures in the yard add to the unconventional appearance of this 1850 barn.

This small English-style barn was floated on a barge from Connecticut to Chatham around 1840. It was used for cranberry processing in its second life in Chatham. Three small-paned windows are visible in the gable end.

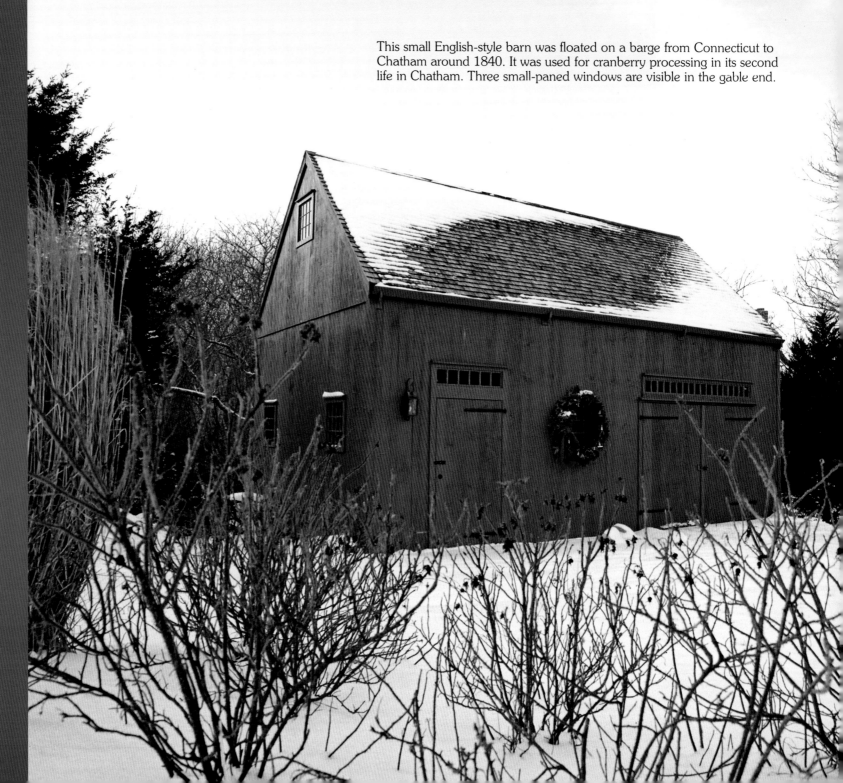

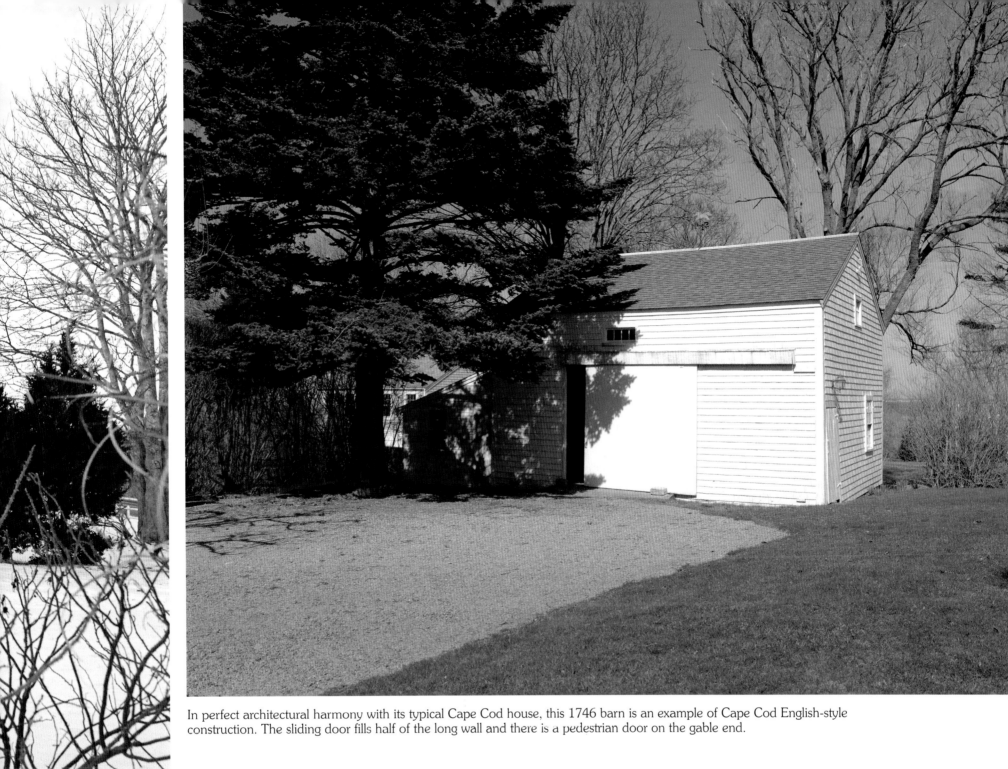

In perfect architectural harmony with its typical Cape Cod house, this 1746 barn is an example of Cape Cod English-style construction. The sliding door fills half of the long wall and there is a pedestrian door on the gable end.

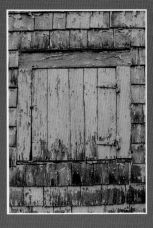

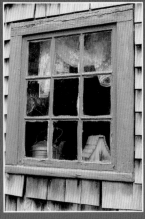

Built in 1810 and situated on a knoll overlooking Stage Harbor, this English-style barn was originally built as the barn for the nearby Elisa Harding House. It has broad sliding doors on the long side and an original cupola adorns the roof. The quarterboard over the barn door reads "Cora F. Cressy," the name of a famous 273-foot five-masted schooner built in 1902 in Bath, Maine.

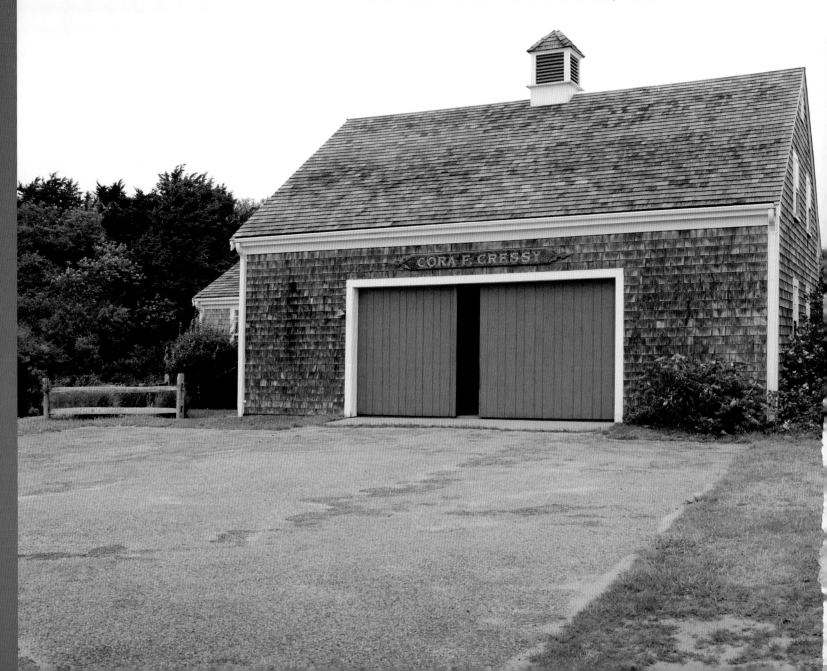

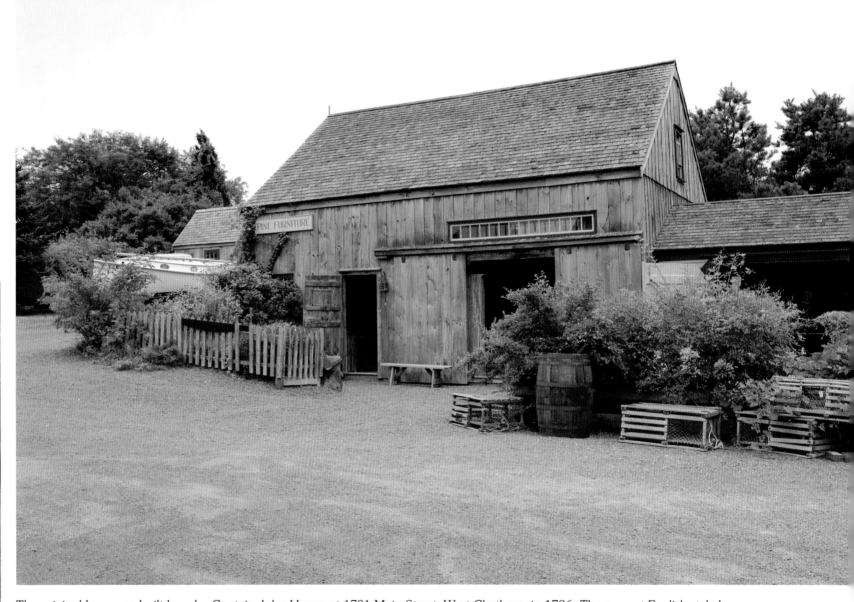

The original barn was built here by Captain John Hawes at 1731 Main Street, West Chatham, in 1736. The present English-style barn was constructed in 1976. The main barn connects with a series of three attached buildings, each with large front-facing barn doors and is used today as a showroom for antique pine furniture.

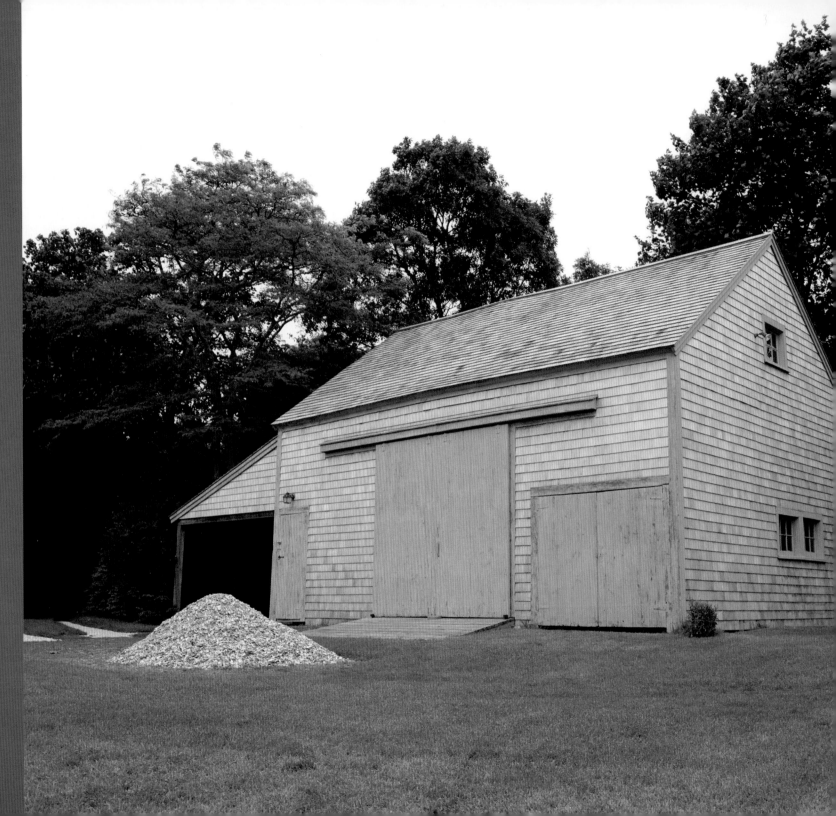

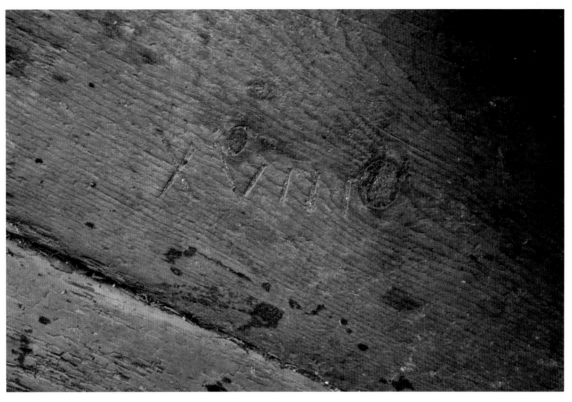

Built in 1789, this New England-style barn was once the office for a croquet headquarters. The barn has a small addition on one gable end. The pile of crushed seashells in front of the barn will fill the driveway leading up to the barn. The detail photo reveals an original hand-carved number "XVIII" on one of the interior barn boards. When the barn was moved, numbering the boards helped facilitate rebuilding.

Orleans

Orleans has three villages: East Orleans and South Orleans with access to the Atlantic Ocean beaches and Orleans Center with access to Cape Cod Bay. Farming was the primary Pilgrim industry in the 1600s and then fishing became the major source of income in the 1700s and 1800s. Fish were shipped in packet boats to the lucrative Boston market. When the Cape Cod National Seashore was created by President John F. Kennedy on August 7, 1961, it encompassed 43,500 acres of land on Cape Cod and tourism grew to become Orlean's mainstay.

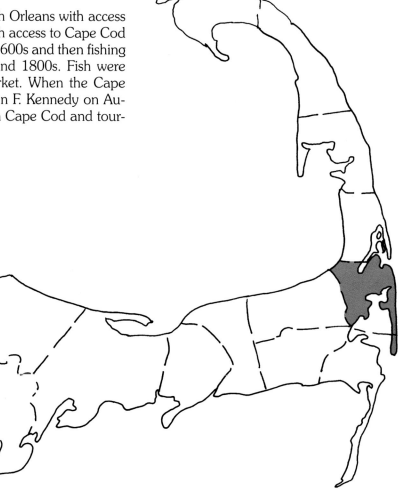

This typical New England-style barn was built in 1845. The barn was originally used to store grain and hay and also housed some animals and farm equipment. A quarterboard over the main barn door and a white picket fence enhance this well-maintained Cape Cod barn.

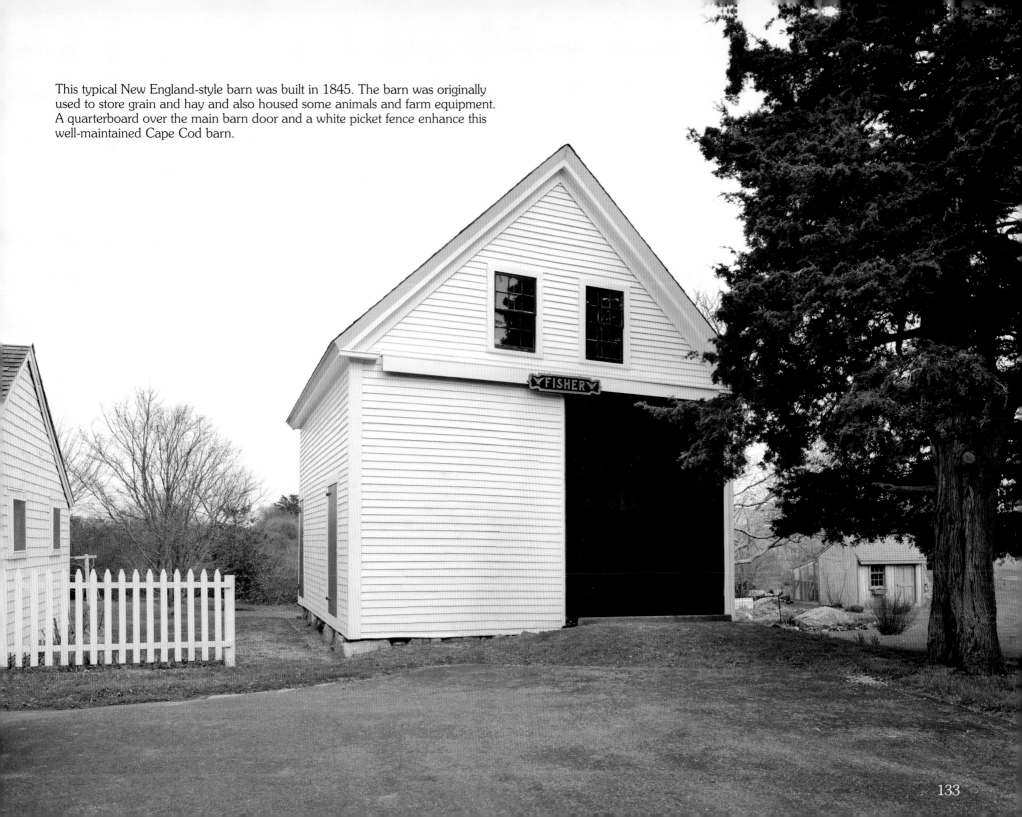

ORLEANS

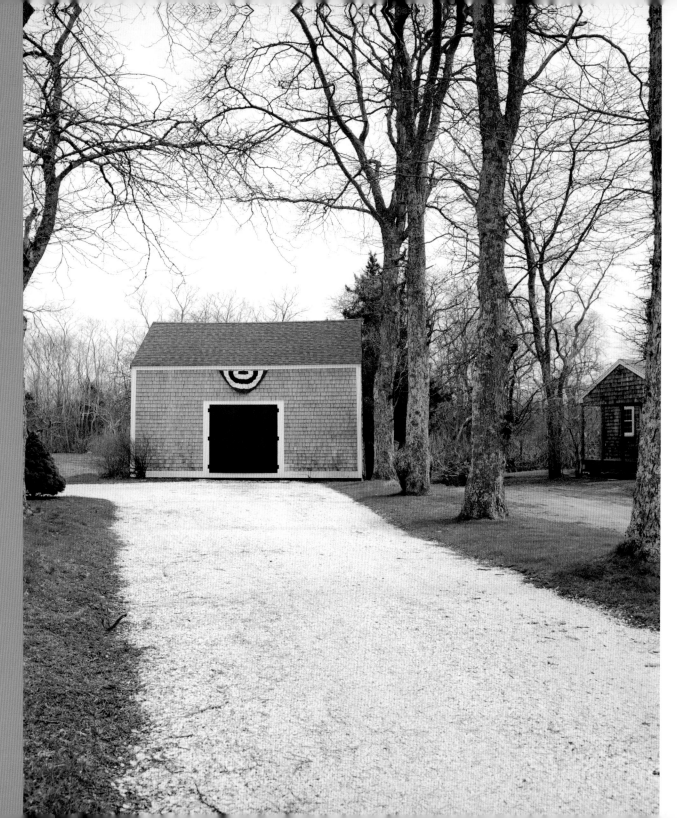

This old Cape barn was originally constructed in 1790. It is a pure English-style with only one main door on the long wall. The driveway leading to the barn is lined with an alley of tall locust trees.

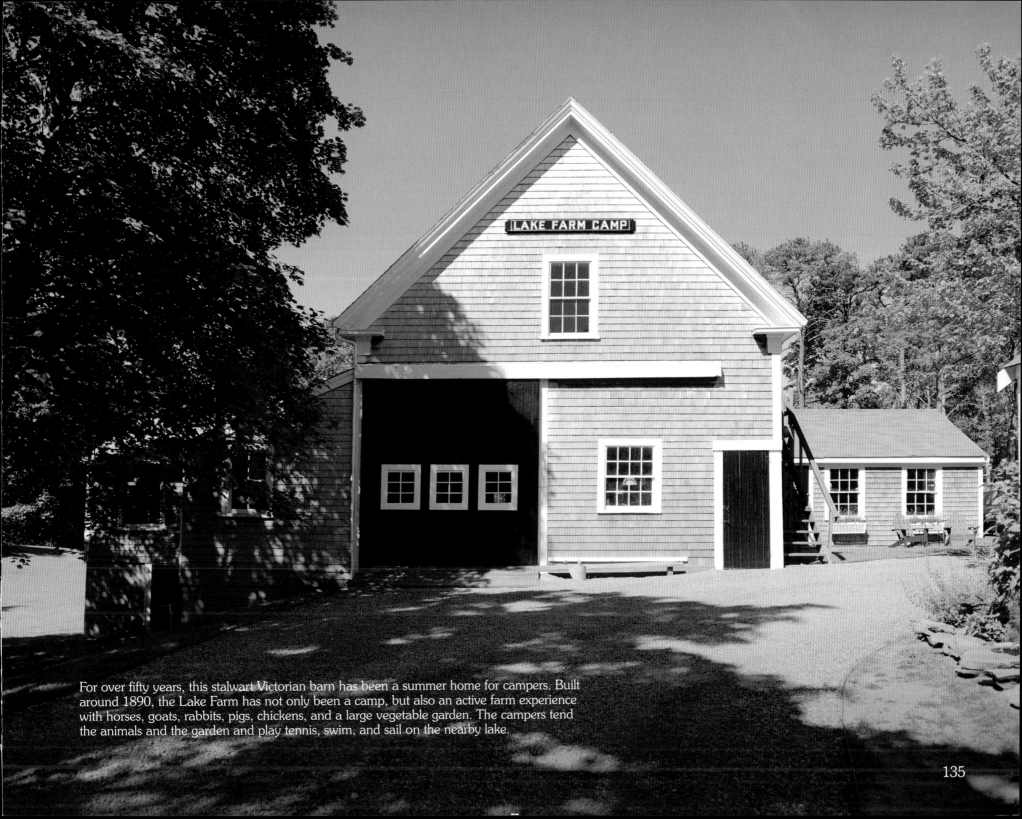

For over fifty years, this stalwart Victorian barn has been a summer home for campers. Built around 1890, the Lake Farm has not only been a camp, but also an active farm experience with horses, goats, rabbits, pigs, chickens, and a large vegetable garden. The campers tend the animals and the garden and play tennis, swim, and sail on the nearby lake.

ORLEANS

Despite its colorful and whimsical appearance, this is still a working farm. The main barn is a gable-ended New England-style barn with an attached chicken coop. A flock of sheep graze the farmyard and pasture. Some of the smaller outbuildings once housed goats.

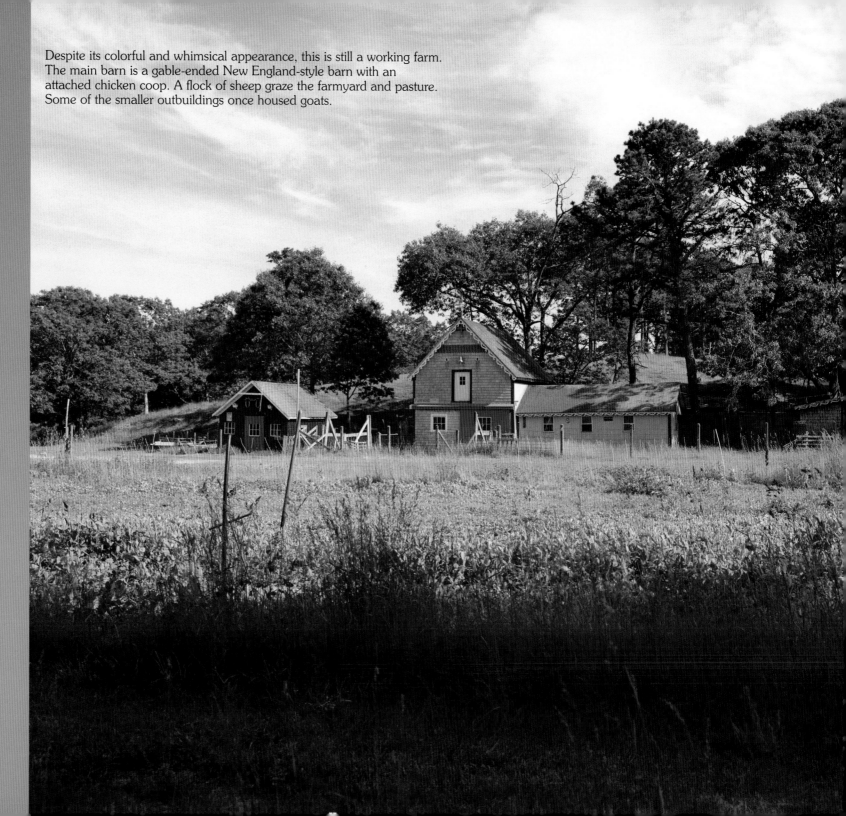

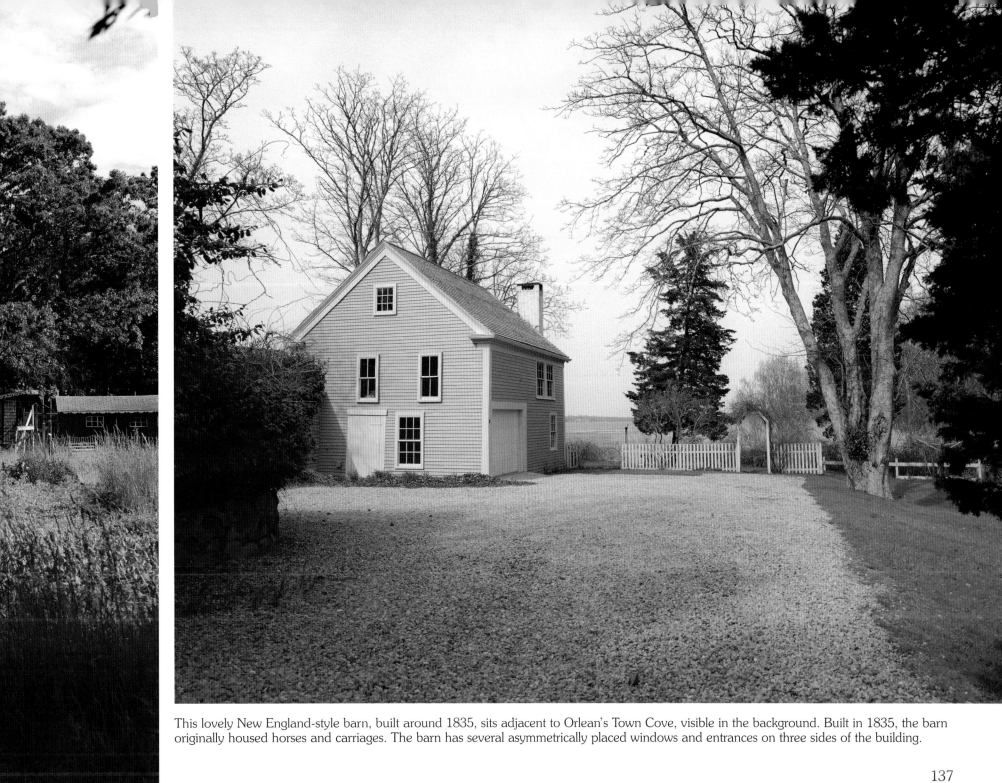

This lovely New England-style barn, built around 1835, sits adjacent to Orlean's Town Cove, visible in the background. Built in 1835, the barn originally housed horses and carriages. The barn has several asymmetrically placed windows and entrances on three sides of the building.

"Corporal Trim" is an imposing English-style barn set in a large field with a small forest behind the barn. The original barn was built around 1850 and was rebuilt on the same foundation in 1910 after a fire destroyed the original barn. Using an innovative barn moving technique, the Orleans volunteer fire department roped the burning barn and pulled it off its foundation into the open field, thus saving the house.

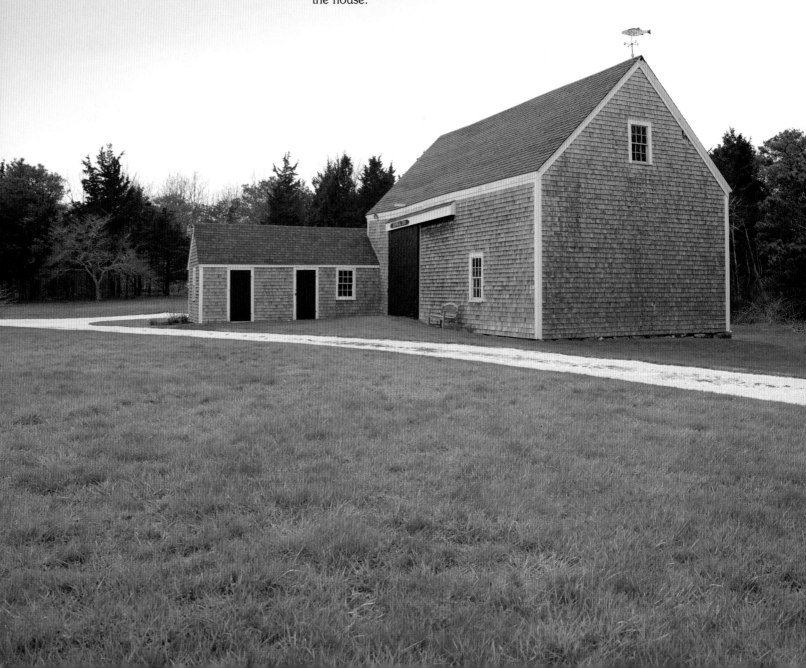

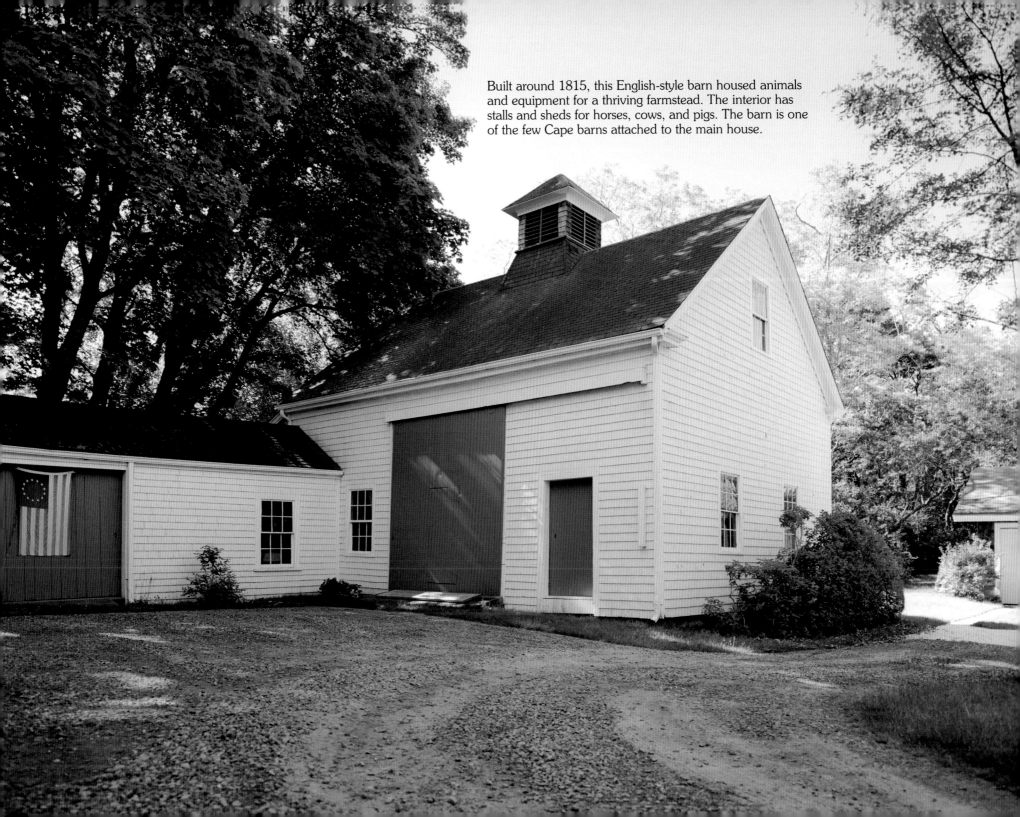

Built around 1815, this English-style barn housed animals and equipment for a thriving farmstead. The interior has stalls and sheds for horses, cows, and pigs. The barn is one of the few Cape barns attached to the main house.

Brick Hill Farm, built around 1850, sits on the top of a small rise with a pictur-esque pond located behind the barn. This English-style clapboard barn has a fieldstone foundation and there is a unique cat door on the long wall adjacent to the pedestrian entrance door. A goose weathervane sits atop the peak of the roof.

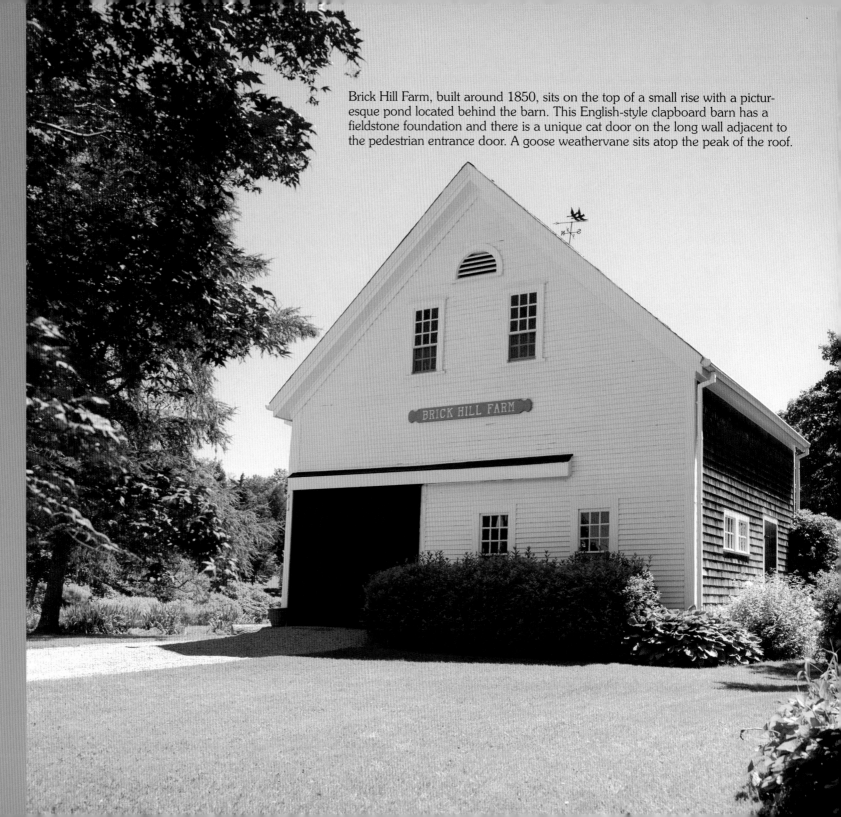

BRICK HILL FARM

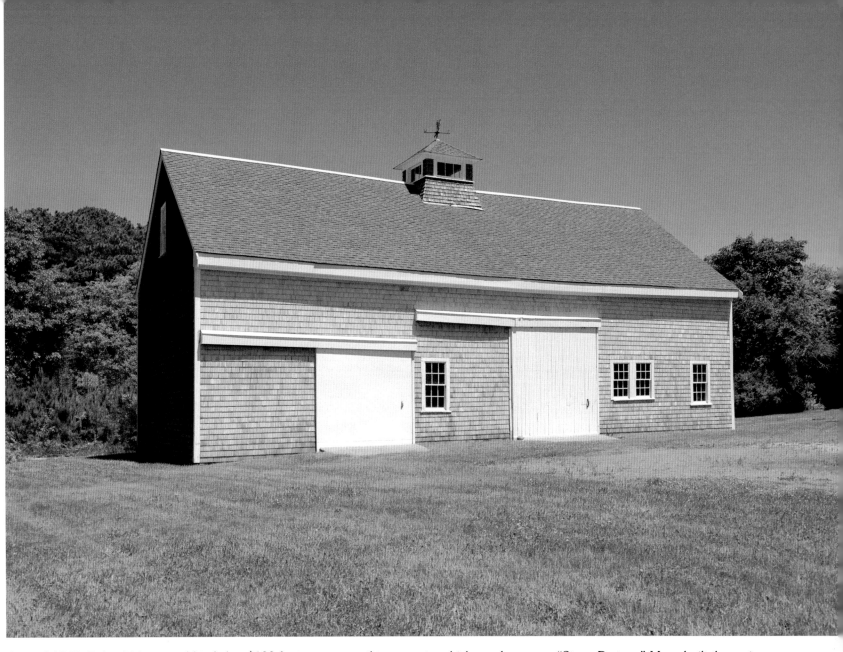

Around 1860, Roland Mayo paid his father $100 for ten acres on this property, which was known as "Stony Pasture." Mayo built the main house here for $4,500. But there was no barn on the property, so he bought a large nearby barn and moved it to his land in 1860. This enormous three-story New England-style barn was originally built in 1700 using the post and beam construction, fastened with only wooden pegs. The barn, measuring thirty feet wide and seventy feet long, has several horse stalls and a tall second-story hay loft, as well as a precarious interior three-story stairway leading up to the 8' x 8' cupola at the barn's peak. A smaller adjacent barn was used to prepare and pack asparagus for off-Cape markets. The two barns became part of Mayo's extensive farmstead.

141

ORLEANS

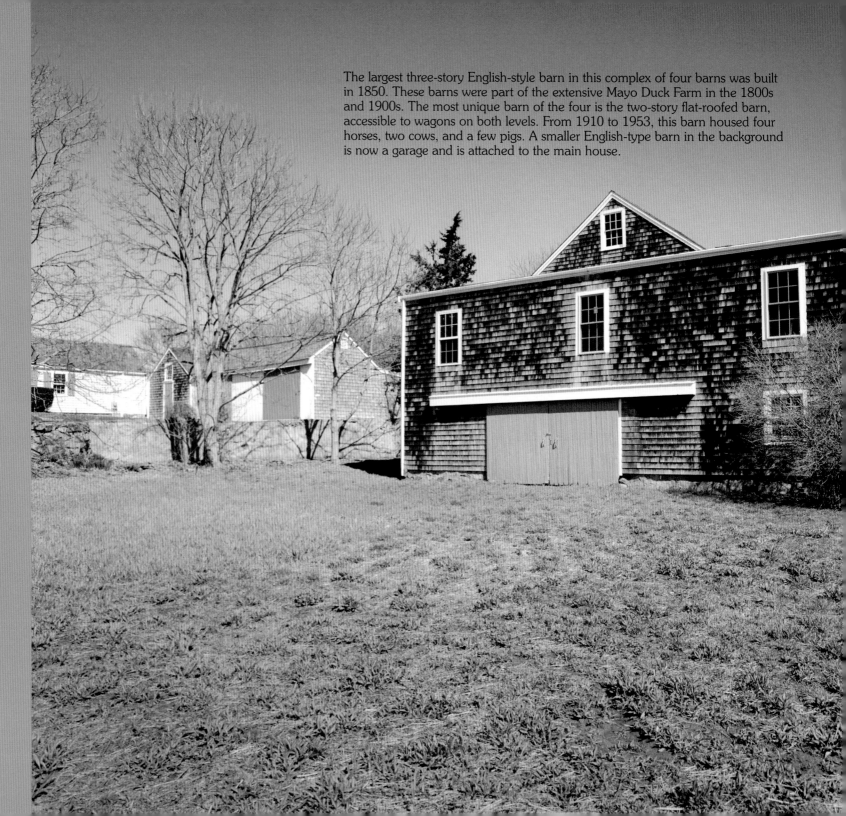

The largest three-story English-style barn in this complex of four barns was built in 1850. These barns were part of the extensive Mayo Duck Farm in the 1800s and 1900s. The most unique barn of the four is the two-story flat-roofed barn, accessible to wagons on both levels. From 1910 to 1953, this barn housed four horses, two cows, and a few pigs. A smaller English-type barn in the background is now a garage and is attached to the main house.

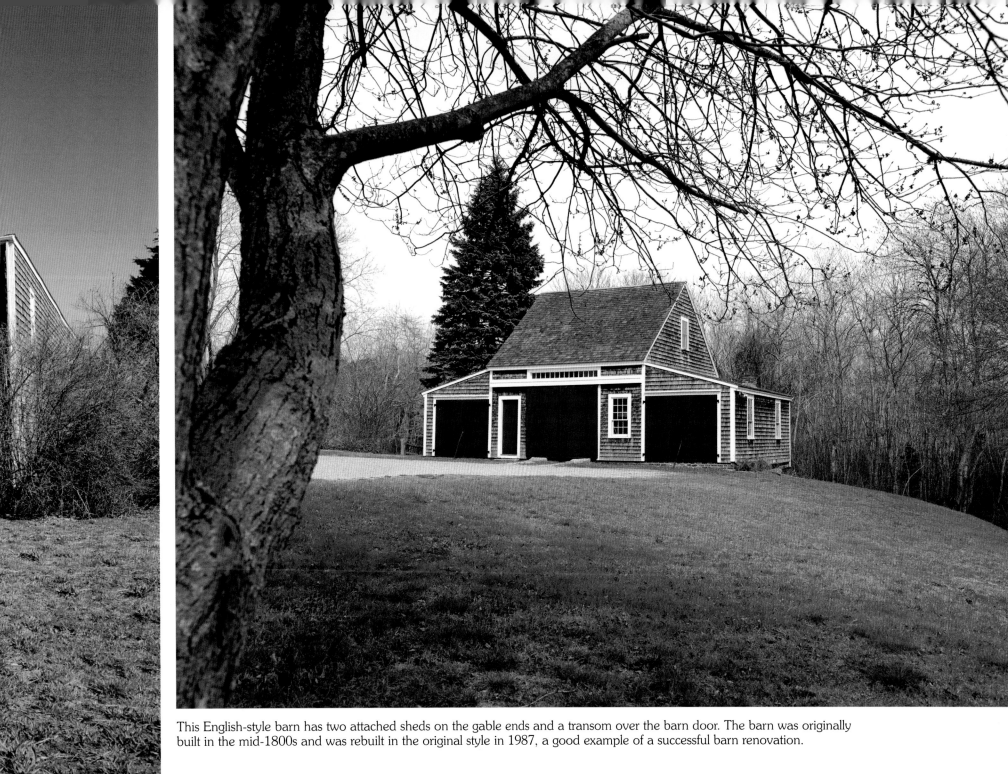

This English-style barn has two attached sheds on the gable ends and a transom over the barn door. The barn was originally built in the mid-1800s and was rebuilt in the original style in 1987, a good example of a successful barn renovation.

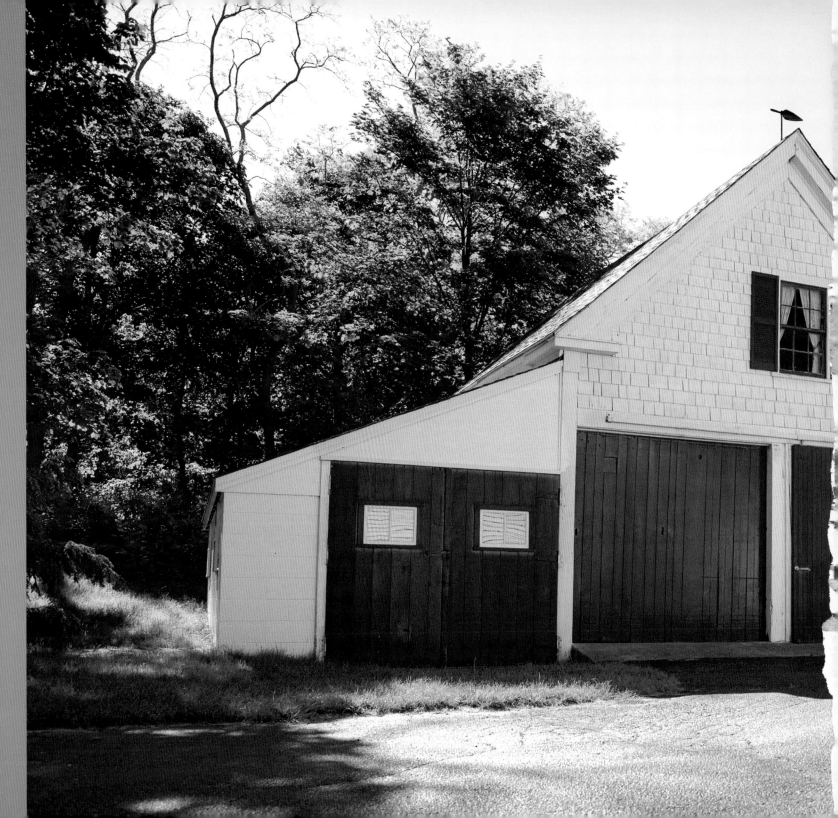

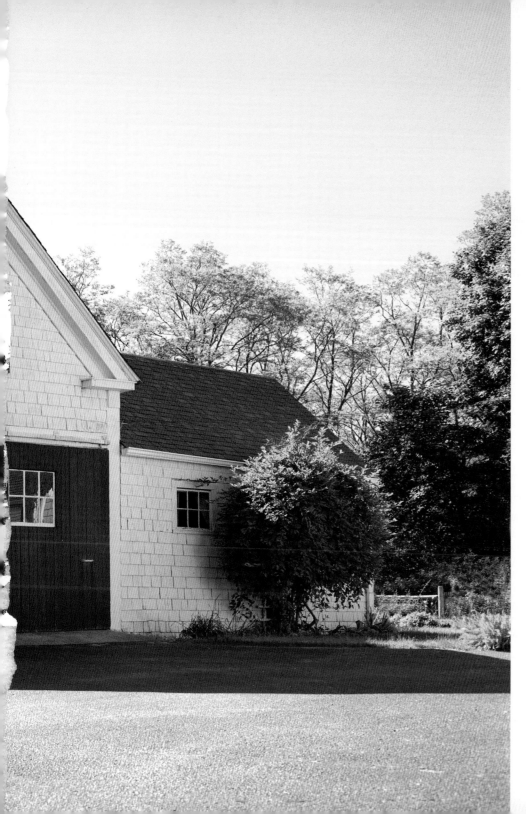

Built around 1850, this handsome New England-style barn was originally built to house a buggy and two horses. During the Great Depression era of the 1930s and on into the turbulent war years of the 1940s, the barn was used as a dairy barn. An attached lean-to on the left side of the barn houses a workshop and the trowel-shaped weathervane suggests that a previous owner may have been a stonemason.

Eastham

Eastham originally incorporated parts of Chatham, Orleans, Wellfleet, and Truro. Now it has only two villages: Eastham and North Eastham. The town was settled in 1644 by Pilgrims who were looking for better farming soil than they had originally been given at Plymouth. Landing on the bay side, Pilgrims first met the Native Americans at Eastham's First Encounter Beach. Eastham's sandy soil was perfectly suited for growing asparagus in the spring and turnips in the fall and became the mid-Cape's garden produce center. The National Seashore encompasses a third of Eastham's land today.

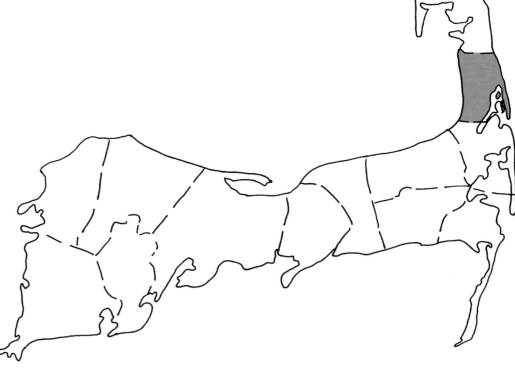

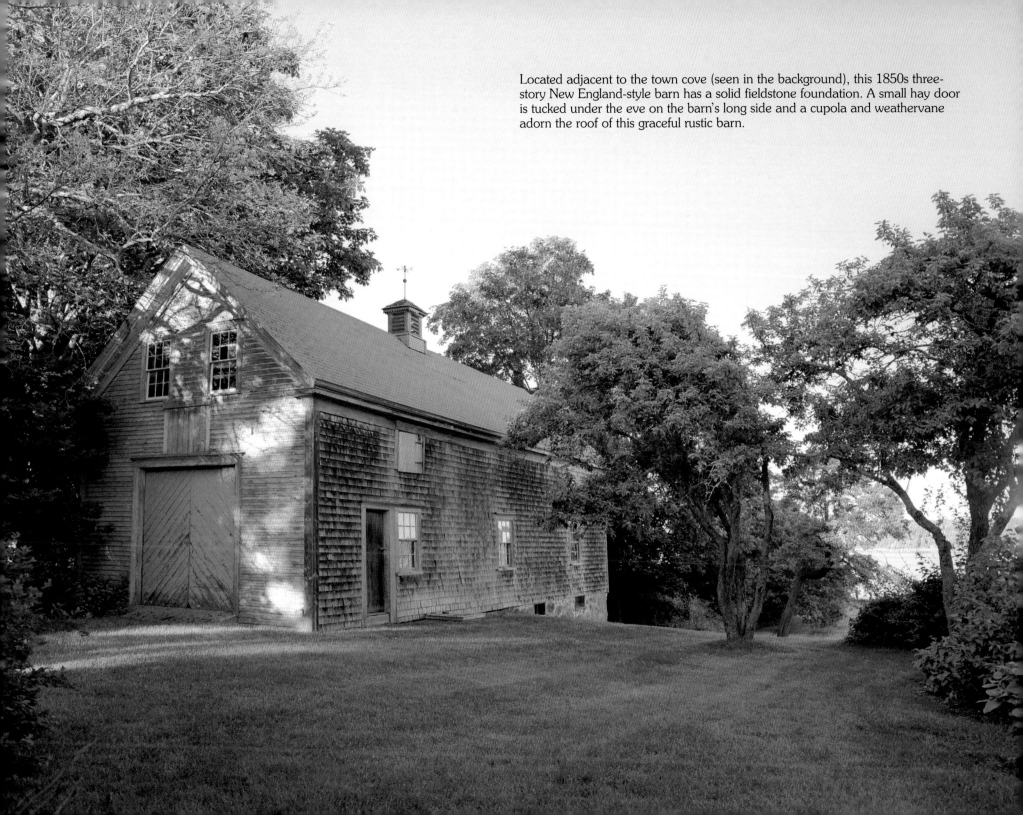

Located adjacent to the town cove (seen in the background), this 1850s three-story New England-style barn has a solid fieldstone foundation. A small hay door is tucked under the eve on the barn's long side and a cupola and weathervane adorn the roof of this graceful rustic barn.

EASTHAM

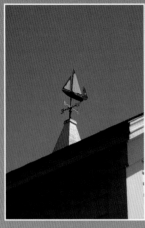

This elegant Mansard-roofed house and barn were built in the late 1800s. The barn is truly a gentleman's barn, and was used mainly for storing carriages. Two giant whale tusks create an arch over the front walkway. The National Park Service at Fort Hill maintains and operates this property, just off Route 6, and it is open to the public.

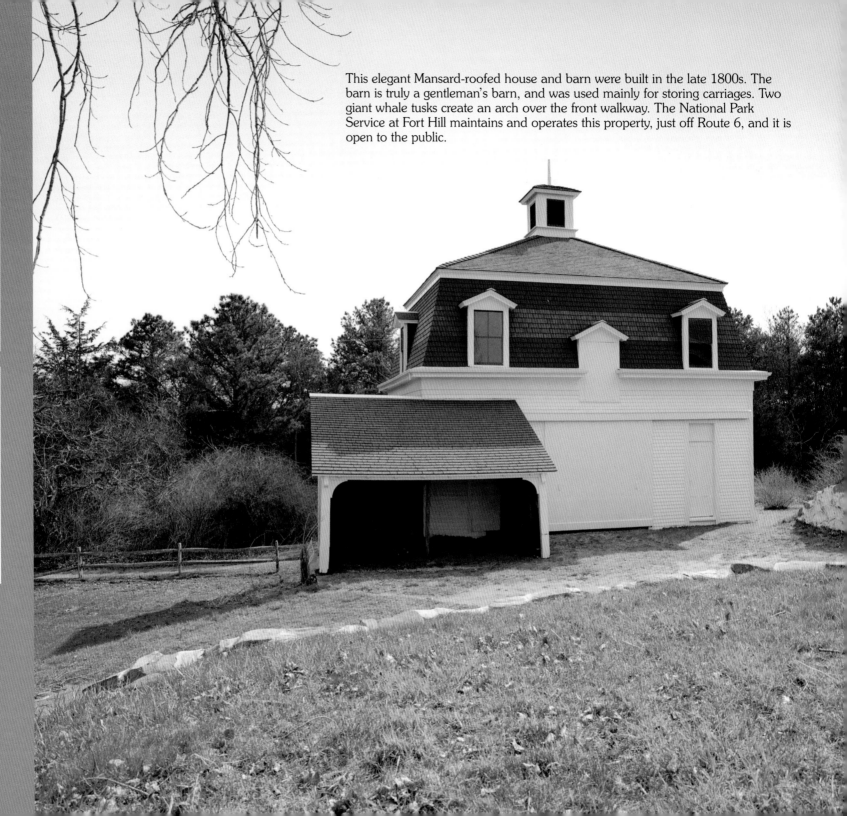

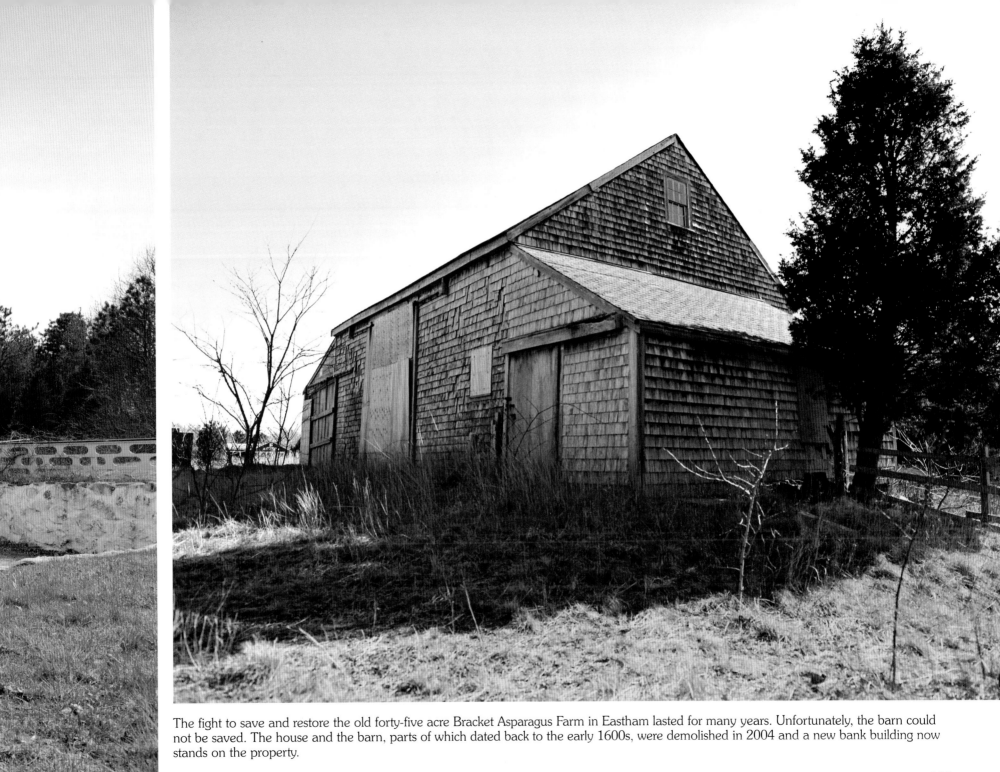

The fight to save and restore the old forty-five acre Bracket Asparagus Farm in Eastham lasted for many years. Unfortunately, the barn could not be saved. The house and the barn, parts of which dated back to the early 1600s, were demolished in 2004 and a new bank building now stands on the property.

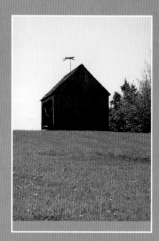

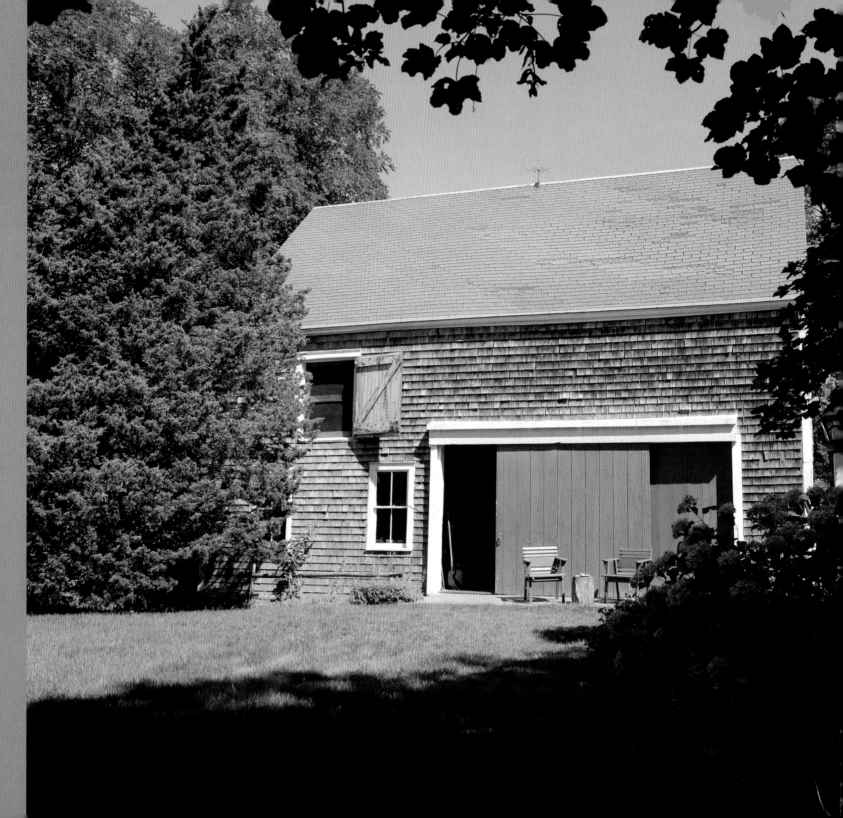

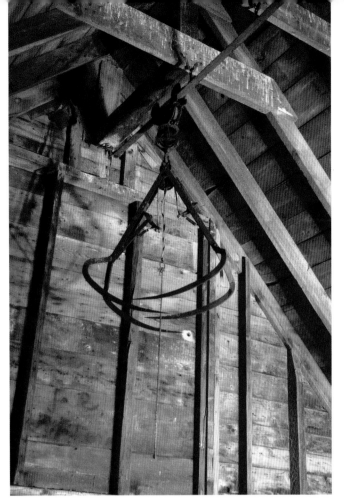

This large, well-maintained barn boasts a second-story hay door on the long side and an extant hayfork on the second level still moves on its original track. The house, known as the Crosby Tavern, was built around 1720. When Cape Codders captured a British warship circa 1776 by steering it aground on Cape Cod Bay, many of the captured soldiers were quartered in this barn.

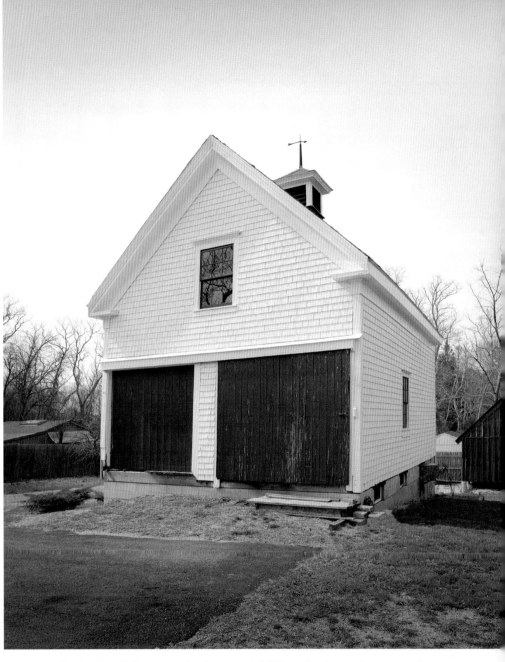

This New England-style barn was built around 1850 and is located next to a large inland marsh. Cape farmers harvested salt hay and seaweed from the marsh to feed their livestock. Hay and seaweed were often piled around house and barn foundations to help insulate the buildings against the harsh New England winters.

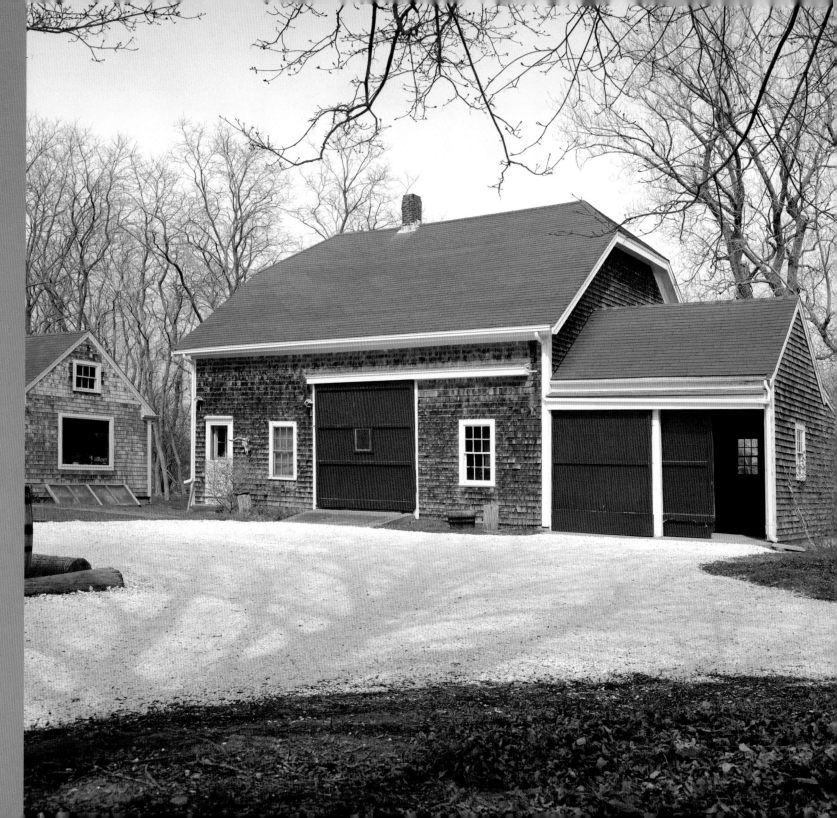

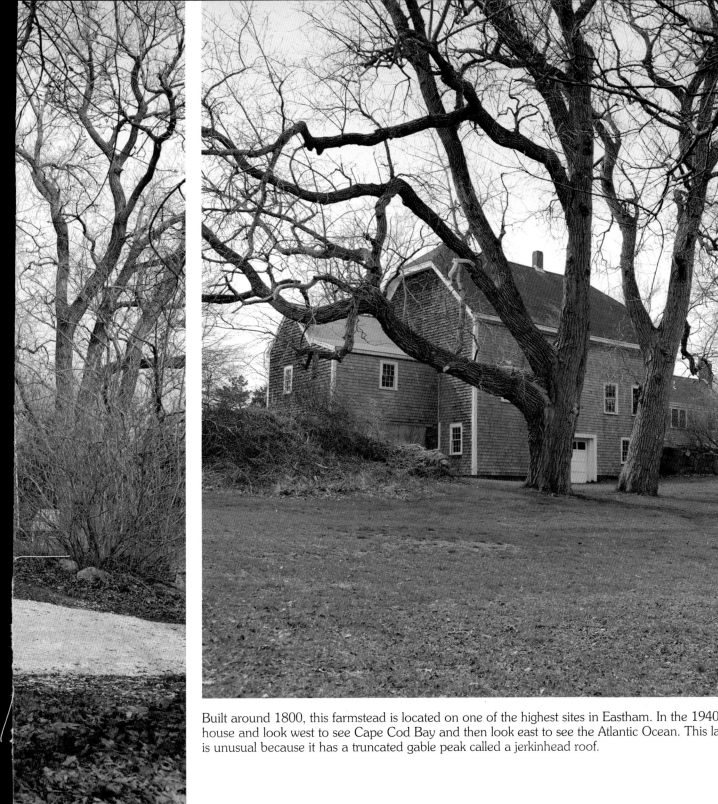

Built around 1800, this farmstead is located on one of the highest sites in Eastham. In the 1940s, one could stand in front of the house and look west to see Cape Cod Bay and then look east to see the Atlantic Ocean. This large three-story English-style barn is unusual because it has a truncated gable peak called a jerkinhead roof.

EASTHAM

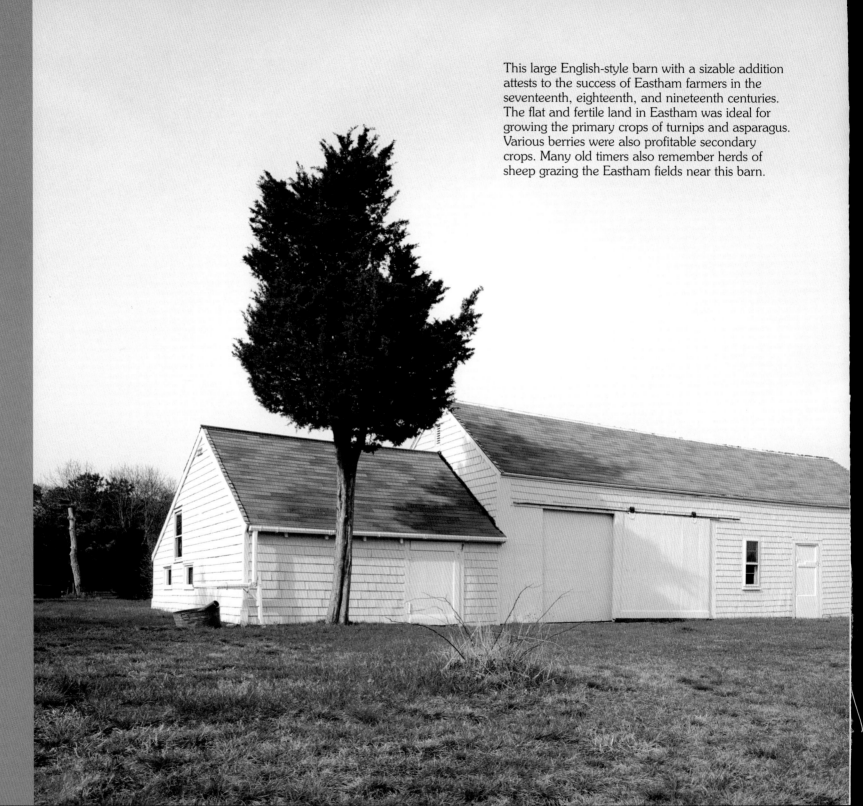

This large English-style barn with a sizable addition attests to the success of Eastham farmers in the seventeenth, eighteenth, and nineteenth centuries. The flat and fertile land in Eastham was ideal for growing the primary crops of turnips and asparagus. Various berries were also profitable secondary crops. Many old timers also remember herds of sheep grazing the Eastham fields near this barn.

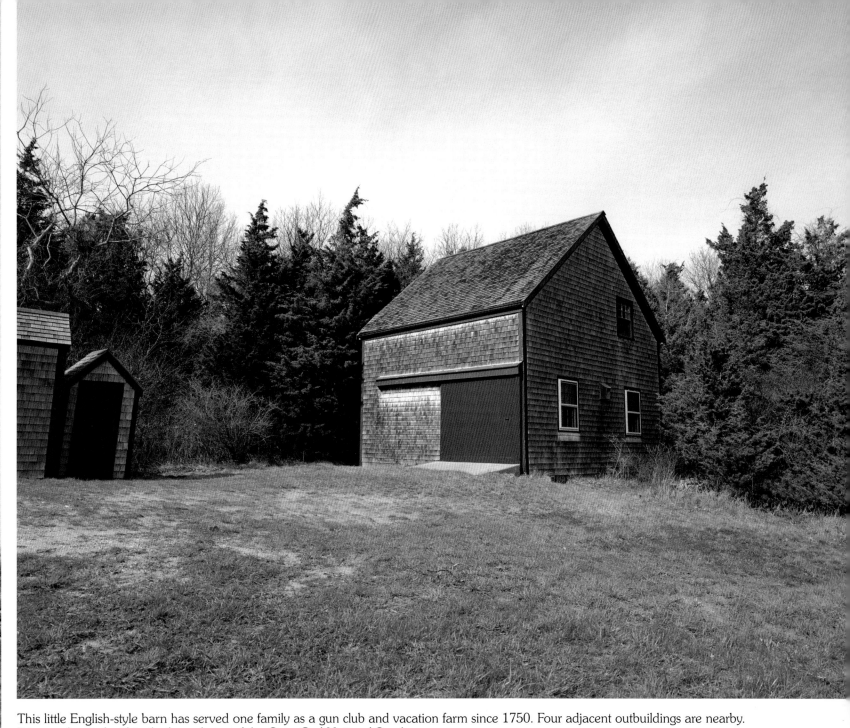

This little English-style barn has served one family as a gun club and vacation farm since 1750. Four adjacent outbuildings are nearby. It is now located within the boundaries of the Cape Cod National Seashore.

EASTHAM

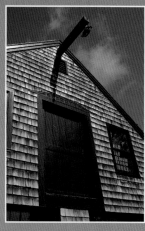

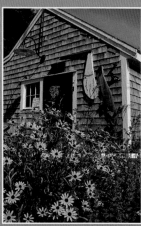

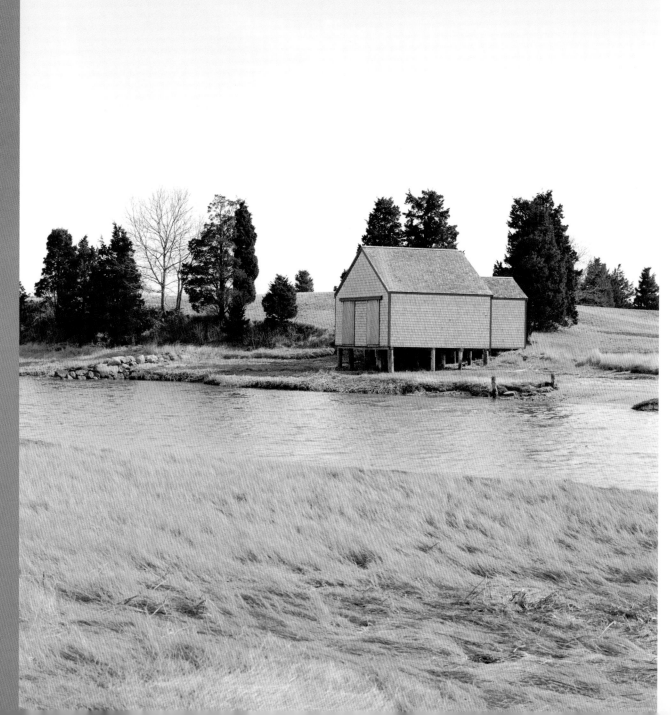

This New England-style boat barn sits on the edge of a saltwater river directly across from the Great Nauset Inlet marsh. This two-room barn was built around 1900 and was later rebuilt after extensive storm damage. The land surrounding the barn was originally barren and resembled the moors of Scotland. Today, the tall cedar trees and green fields make this waterfront barn one of the most picturesque on Cape Cod.

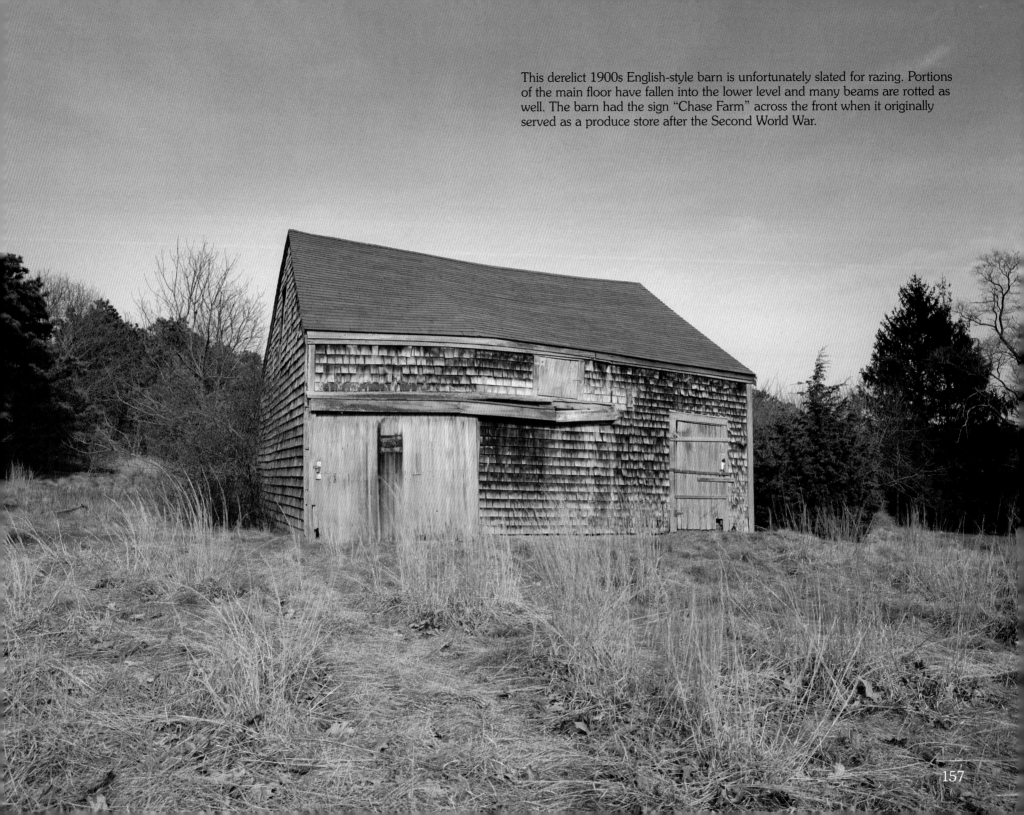

This derelict 1900s English-style barn is unfortunately slated for razing. Portions of the main floor have fallen into the lower level and many beams are rotted as well. The barn had the sign "Chase Farm" across the front when it originally served as a produce store after the Second World War.

WELLFLEET

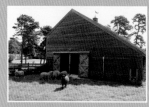

Wellfleet

Over half of Wellfleet's land is under the jurisdiction of the Cape Cod National Seashore, which kept economic development in Wellfleet at the same levels from the 1950s to the 1970s. Wellfleet is rightfully known as a prominent Cape Cod "art gallery" town and it has a charming Main Street and a large and bustling harbor. Wellfleet is also famous for it's succulent oysters, which are shipped worldwide. The 700-acre Audubon Wellfleet Bay Wildlife Sanctuary, with its high dunes, wide beaches, extensive marshes, and nature trails, makes Wellfleet an important center for nature studies. Wellfleet's Congregational Church in the town center has the only clock in the United States which strikes on ship's time: every four hours.

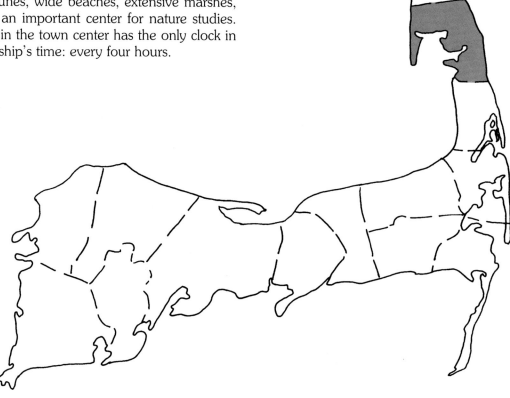

This is one of several barns now located within the boundaries of the Cape Cod National Seashore. Called the Atwood-Higgins House, it was built around 1850. The barn, the house and other outbuildings on the farmstead are small, indicating that the hilly site provided only a meager living for it's farming occupants. The barn is in poor condition today and some local residents hope to form a "Friends of Atwood-Higgins House" to assist the National Seashore in repairing buildings of historical importance like this one.

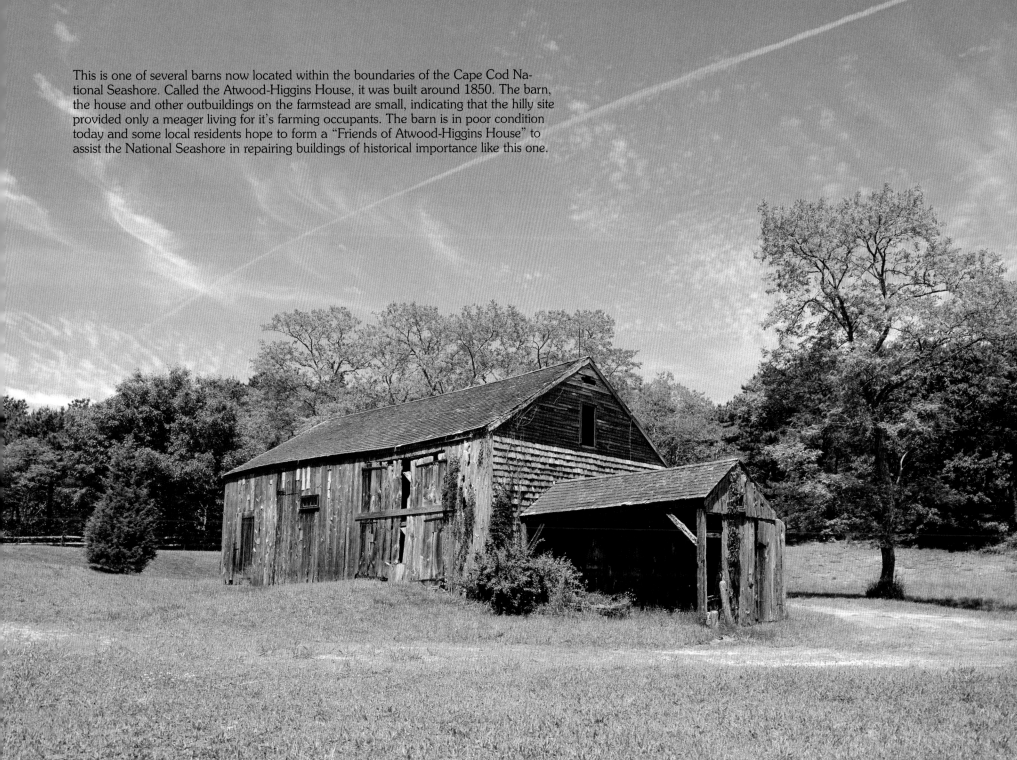

WELLFLEET

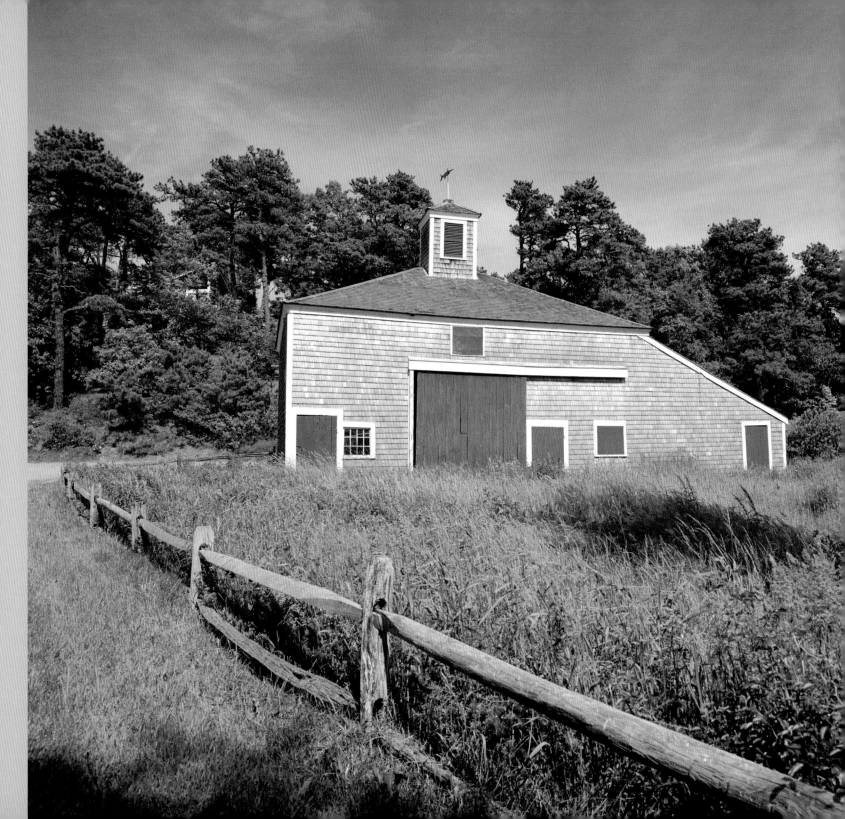

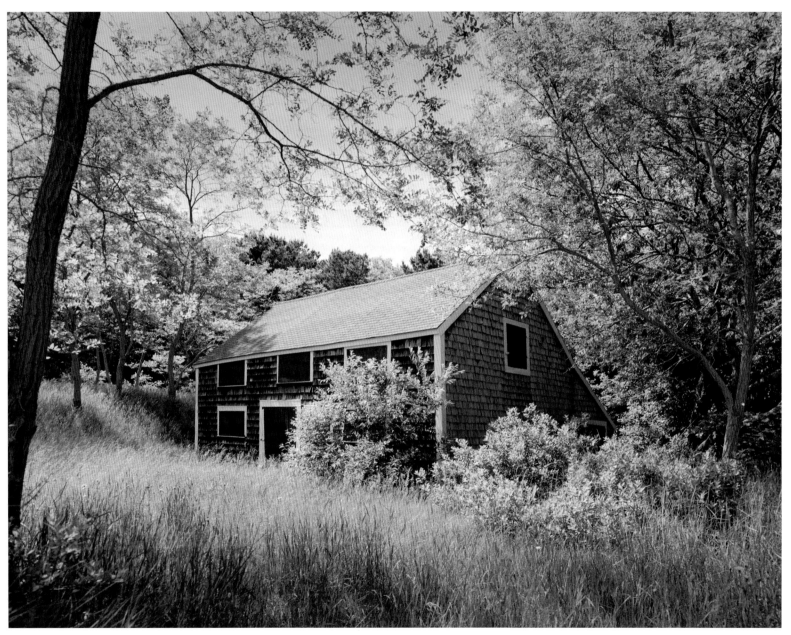

The Hamblen family farmstead has two barns on their property. The Wellfleet Historical Society records for 1906 recorded that two families of Hamblens lived in one house, with each half "having a kitchen, living room, borning room, cellar, etc. ... and the property was divided and each half has a barn." The nearby smaller barn was built in 1814 and housed two horses. The larger two-story barn was built one hundred years earlier in 1716 and housed fourteen cows. It was built using post and beam construction and fastened only with wooden pegs. The barn has a hay door, a saltbox addition, and a hip roof with a cupola. The tall sliding doors on both long sides of the barn indicate that large hay wagons were able to drive through the barn. This building is a superb example of pre-revolutionary barn architecture and has the rare advantage of having complete documentation.

TRURO

Truro

Truro has two areas: South Truro and North Truro. Like Wellfleet, sixty-seven percent of Truro's land is controlled by the Cape Cod National Seashore. Since development within the National Seashore property is prohibited, much of Truro remains as an unspoiled natural resource. There are miles of hiking trails on both the bay and the ocean sides of Truro. With a year-round population of 3,000 people, which swells to 20,000 in the summer, Truro leads all Cape Cod's towns with the most dramatic winter to summer population change.

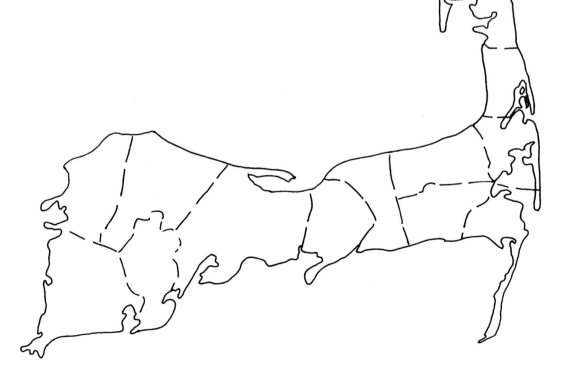

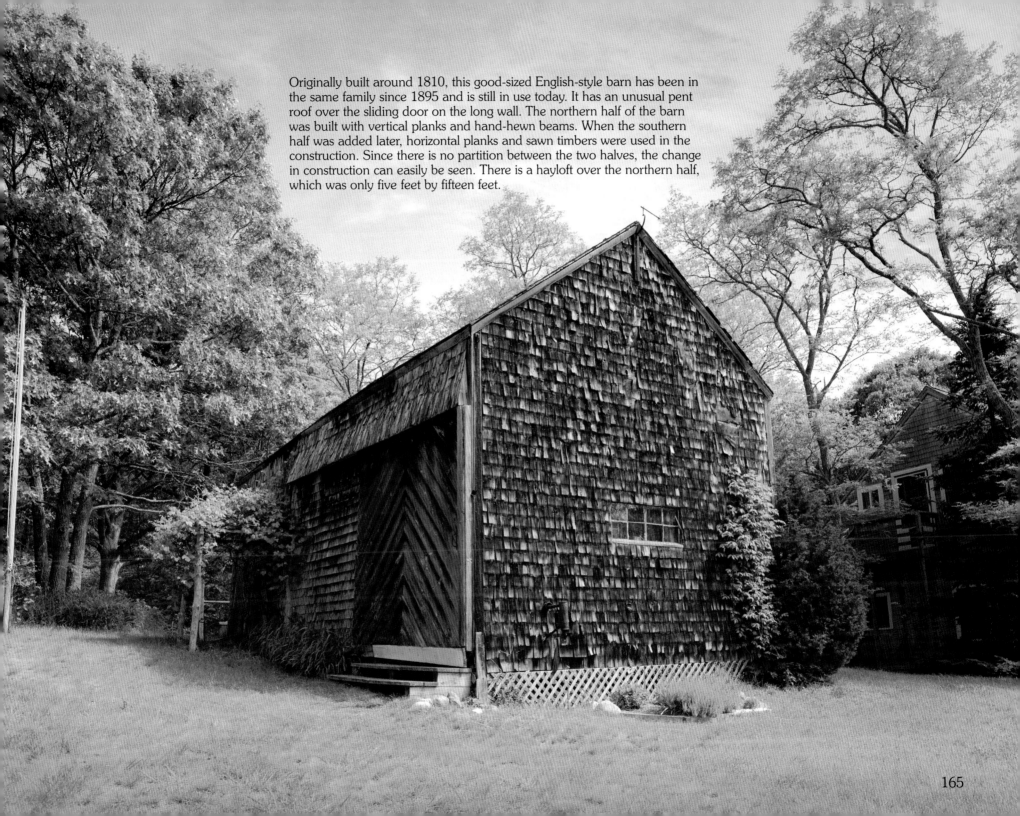

Originally built around 1810, this good-sized English-style barn has been in the same family since 1895 and is still in use today. It has an unusual pent roof over the sliding door on the long wall. The northern half of the barn was built with vertical planks and hand-hewn beams. When the southern half was added later, horizontal planks and sawn timbers were used in the construction. Since there is no partition between the two halves, the change in construction can easily be seen. There is a hayloft over the northern half, which was only five feet by fifteen feet.

TRURO

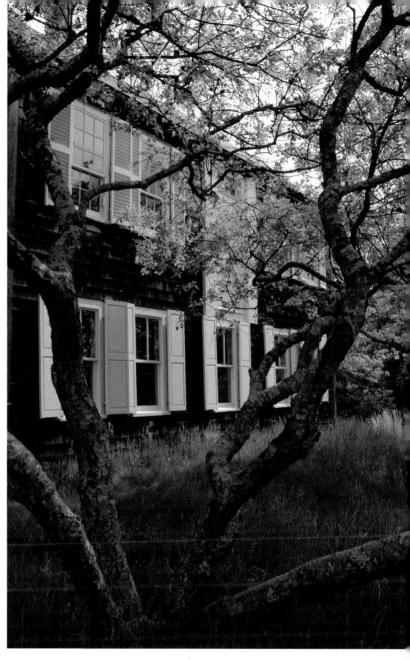

This barn is called "The Bog House" because it is adjacent to an early cranberry bog. Originally built around 1830, the barn was moved to this site around 1889. Because it has nine windows and a front door on the long side, this unique barn resembles a house more than a barn. The quirky main entry door on the second floor resulted when a new first floor was added underneath the original barn. Cranberries were sorted and screened on the new first floor. Cranberry growing ceased in 1958 and the Cape Cod National Seashore purchased this property in 1963.

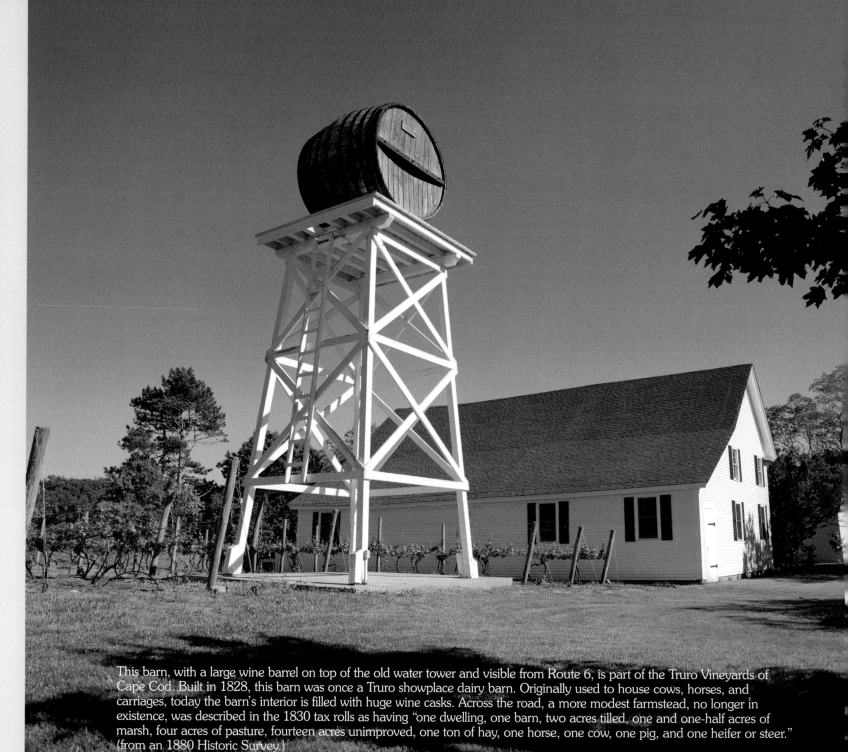

This barn, with a large wine barrel on top of the old water tower and visible from Route 6, is part of the Truro Vineyards of Cape Cod. Built in 1828, this barn was once a Truro showplace dairy barn. Originally used to house cows, horses, and carriages, today the barn's interior is filled with huge wine casks. Across the road, a more modest farmstead, no longer in existence, was described in the 1830 tax rolls as having "one dwelling, one barn, two acres tilled, one and one-half acres of marsh, four acres of pasture, fourteen acres unimproved, one ton of hay, one horse, one cow, one pig, and one heifer or steer." (from an 1880 Historic Survey.)

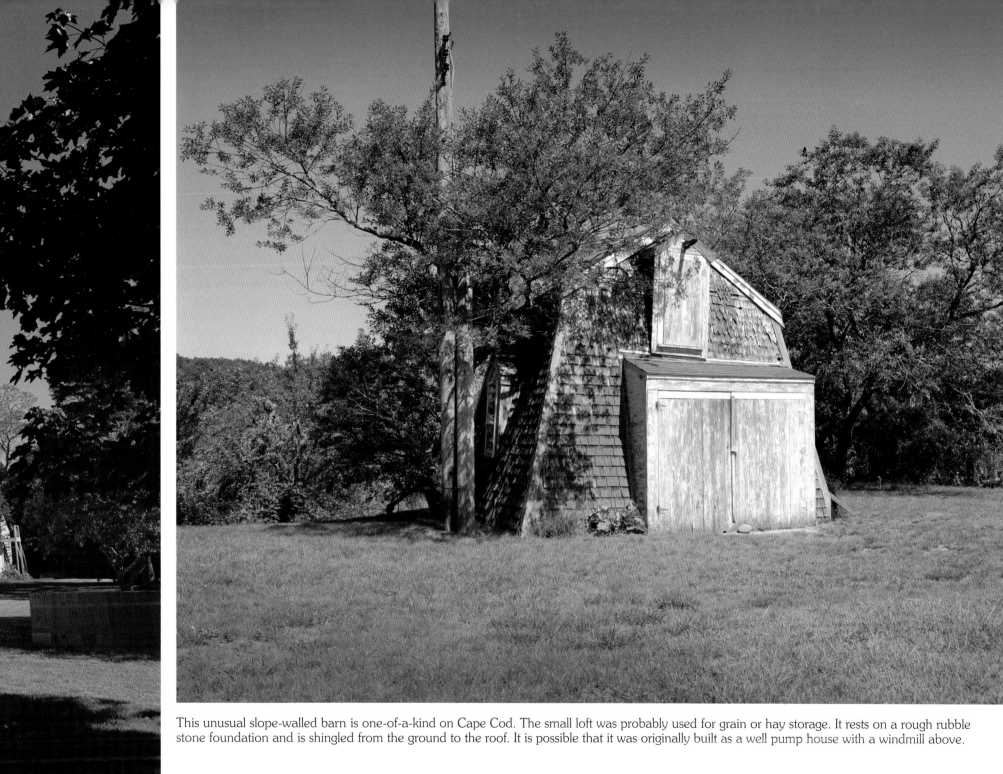

This unusual slope-walled barn is one-of-a-kind on Cape Cod. The small loft was probably used for grain or hay storage. It rests on a rough rubble stone foundation and is shingled from the ground to the roof. It is possible that it was originally built as a well pump house with a windmill above.

TRURO

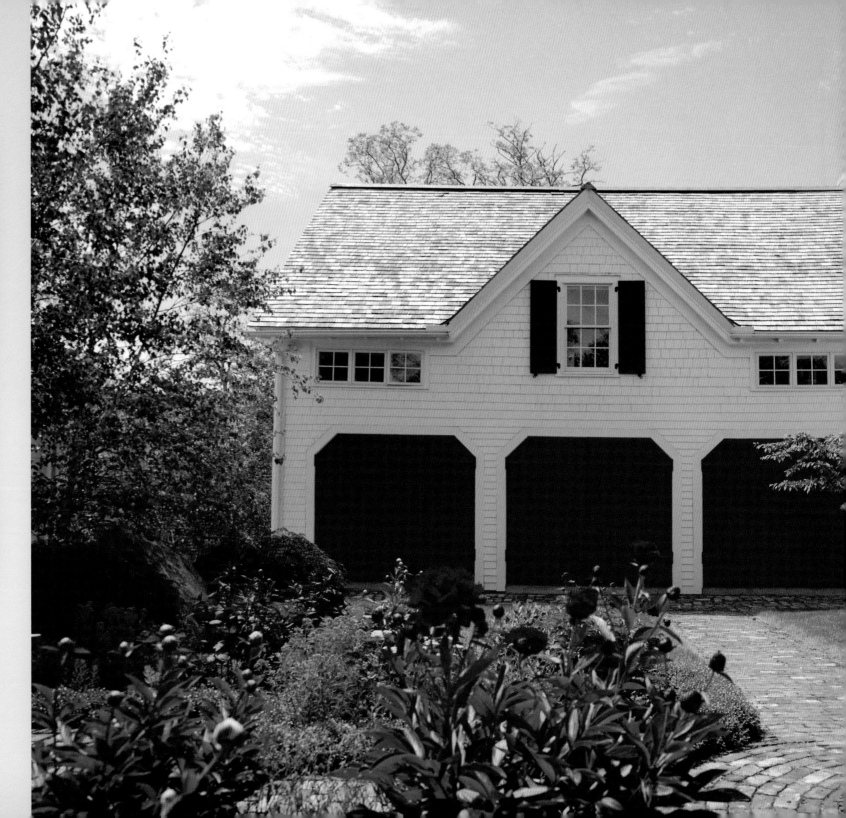

This English-style barn was built in 1850. According to local author Anthony Marshall in *Truro, Cape Cod, As I Knew It*, "this barn originally had stalls for a horse and two cows, a carriage stall, a grain room, a workshop, a coal bin, a pigeon cote and a hay loft." Outside the barn were a pigsty and a well. In 1940, the barn was converted into a living space, keeping the original carriage doors intact.

Provincetown

The Norse explorer Thorvald may have been the first to land at Provincetown, followed by Bartholomew Gosnold in 1602. The French explorer Samuel de Champlain first visited Provincetown as early as 1605. Then in 1620, the Pilgrims signed the Mayflower Compact in Provincetown's harbor, agreeing to settle and build a self-governing community here. The narrow town follows the curve of the shoreline from the bay to the ocean. Early bay front houses were built with their front doors facing the water, as the only main road was along the bay beach. Today two-thirds of Provincetown is part of the Cape Cod National Seashore. Perhaps best known as a party town, Provincetown is also a haven for artists (with a famous art school located in a barn). Provincetown's art and theater communities continue to thrive.

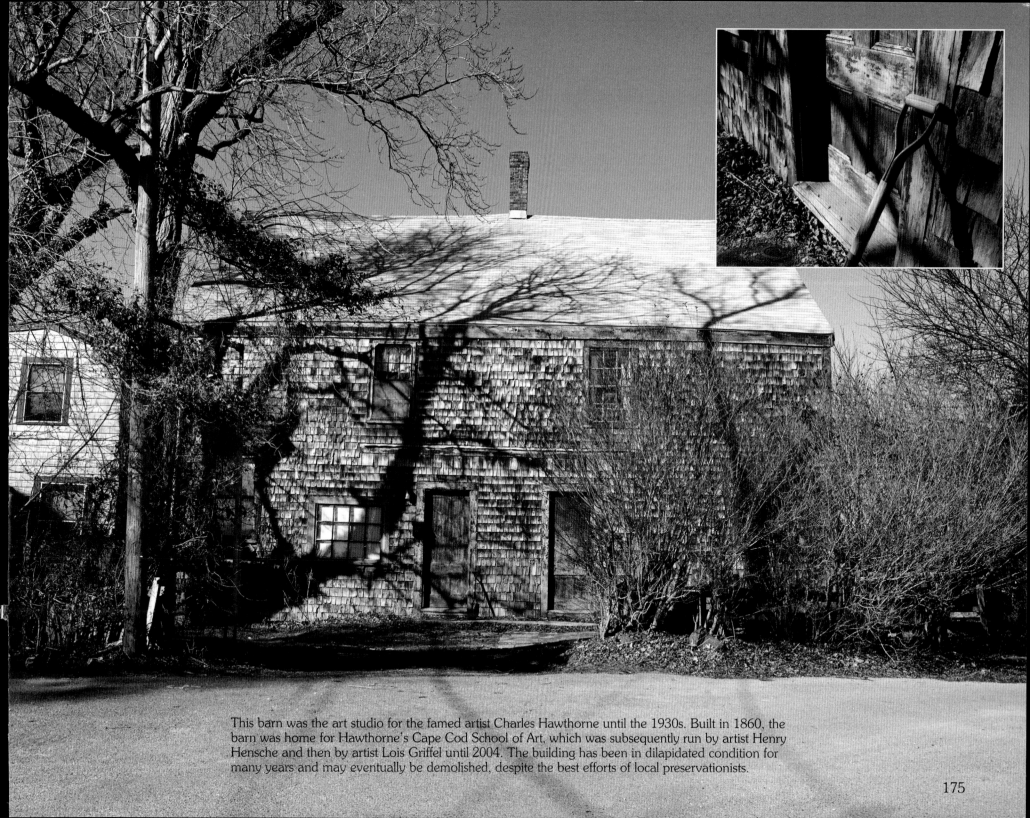

This barn was the art studio for the famed artist Charles Hawthorne until the 1930s. Built in 1860, the barn was home for Hawthorne's Cape Cod School of Art, which was subsequently run by artist Henry Hensche and then by artist Lois Griffel until 2004. The building has been in dilapidated condition for many years and may eventually be demolished, despite the best efforts of local preservationists.

The two small barns on this property were built in different styles. The barn on the left is a New England-style barn with a gambrel roof and the barn on the right is an English-style barn with a plain gable roof. The barns were probably built between 1870 and 1910 to house animals on this small farmstead.

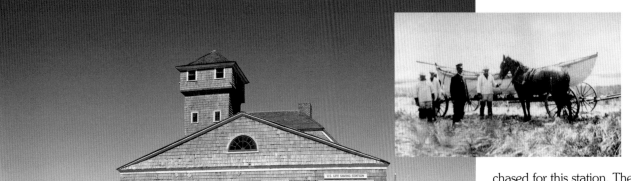

The Old Harbor Life Saving Station is a remnant of earlier times when horses or oxen were used to haul equipment from the seashore station. The station was built in 1897 and historical records show that horses were pur-chased for this station. The coastguardsmen kept animals in the lower part of the building and used them to haul the lifesaving equipment along the beach to the site of shipwrecks. If the seas were too rough to launch a surfboat, a cannon was used to fire a line to a grounded ship, establishing a breeches buoy used to rescue stranded sailors. Although the station is not a traditional barn, part of the lifesaving station served as a barn to house the animals. The station was deactivated in 1944 and is now open to the public at Race Point Beach, Cape Cod National Seashore in Provincetown. The old photograph is courtesy of the Chatham, Massachusetts, Historical Society.

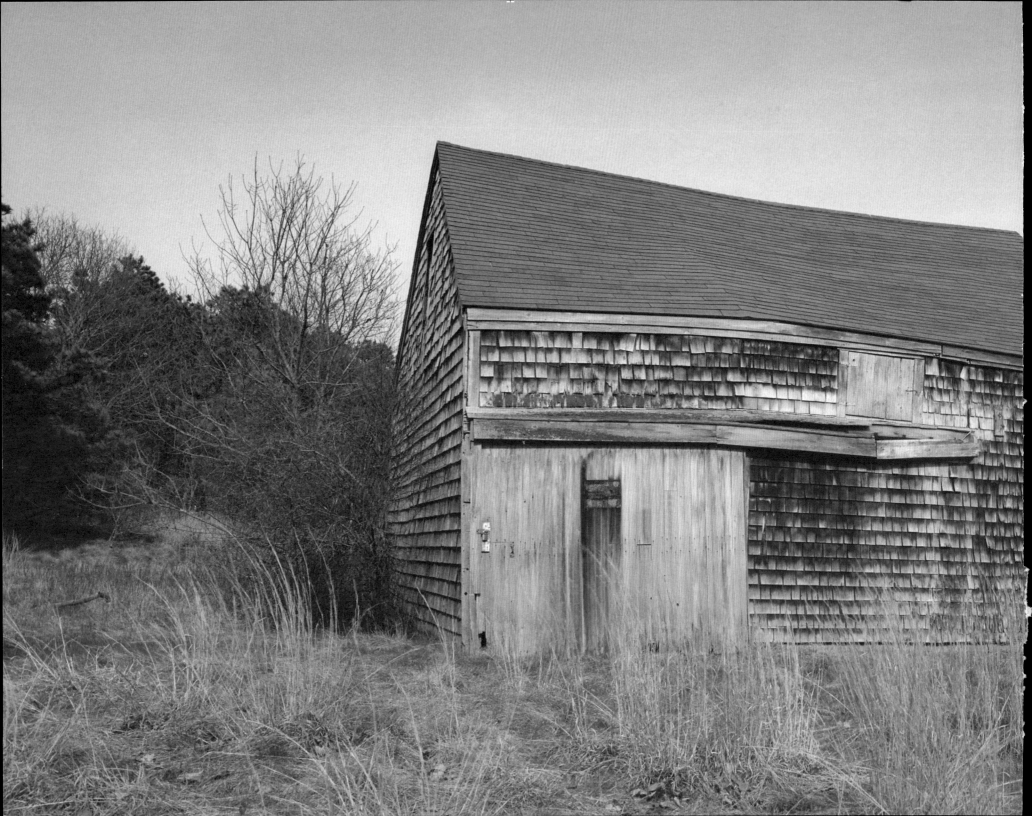